Exploring
Drawing

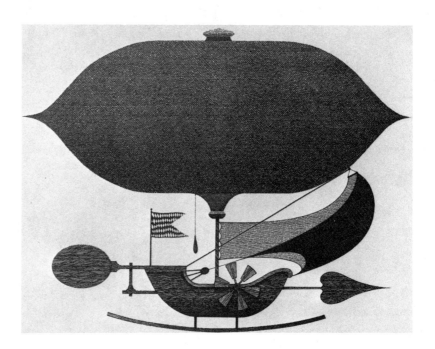

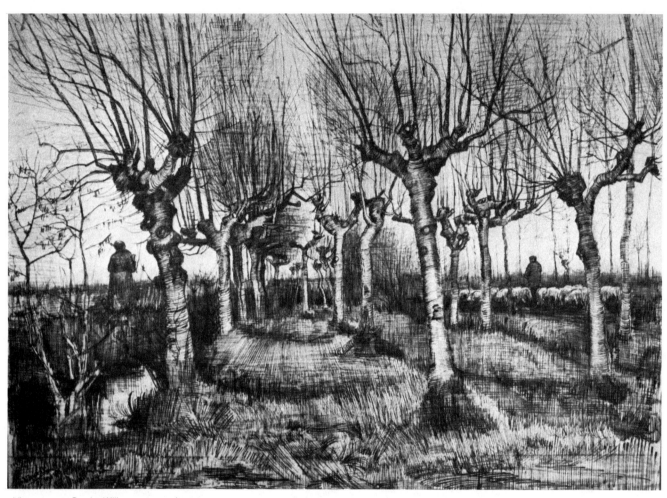

Vincent van Gogh. *Willowgrove and Shepherd,* 1885. Pencil, pen and ink, 16× 21″ (40.5 × 53 cm). Stedlijk Museum, Amsterdam.

Exploring Drawing

Gerald F. Brommer

Davis Publications, Inc.
Worcester, Massachusetts

Cover photography: Jacqueline L. Robinson
Halftitle page: *Fantasy Travel Machine,* 1986.
Paul Taylor. Pen and ink, 12 x 16″ (30 x 40.5 cm).
Title page: *Willowgrove and Shepherd,* 1885.
Vincent van Gogh. Pencil, pen and ink, 16 x 21″
(40.5 x 53 cm). Stedlijk Museum, Amsterdam.
Contents page: *Hollyhocks,* student drawing on
location. Stick and ink, 18″ (45 cm) high.

Right: *Still Life: Three Watermelons,* 1985.
William A. Berry. Colored pencil, 30 × 40″
(75 × 101.5 cm).

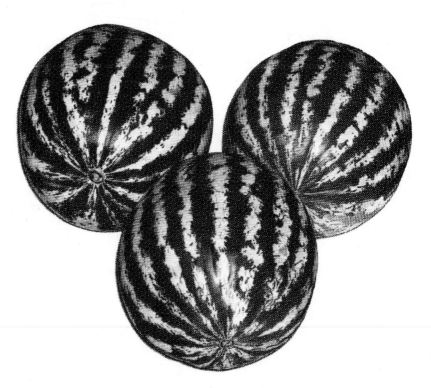

Copyright 1988
Davis Publications, Inc.
Worcester, Massachusetts U.S.A.

Printed in the United States of America

Graphic Design: Outside Designs

Library of Congress Catalog Card Number:

ISBN: 87192-192-8

10 9 8 7

Contents

BEFORE BEGINNING

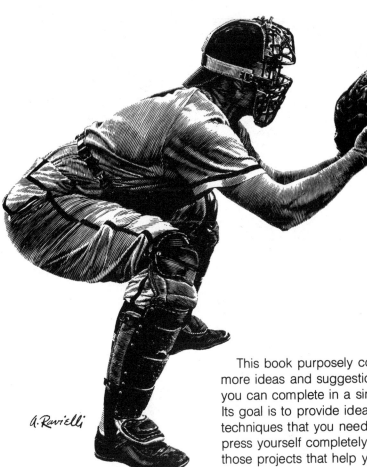

a. Ravielli

Del Crandell. Anthony Ravielli. Cover for Sports Illustrated. Scratchboard, 9″ (23 cm) high.

This book purposely contains more ideas and suggestions than you can complete in a single year. Its goal is to provide ideas and techniques that you need to express yourself completely. Select those projects that help you to grow and improve your visual communication skills.

The book is divided into three parts. The first part will help you understand what drawing is and why it is important. It examines the history of drawing and design. Where can you find things to draw? What are some art careers that involve drawing skills? The second section explores drawing media: dry, wet and mixed—and shows

you how to use them. The third section helps you discover subjects to draw and helps you to look and see selectively.

There are several ways to use the book. After exploring Part One as drawing background, you may wish to take a single medium (pencil, for example) and go through many kinds of subjects found in Part Three. Or you may take a single subject from Part Three and explore it in most of the media discussed in Part Two. Or you may wish to combine several techniques and subjects. Whichever way you choose to work, keep your eyes open and your pens and pencils busy.

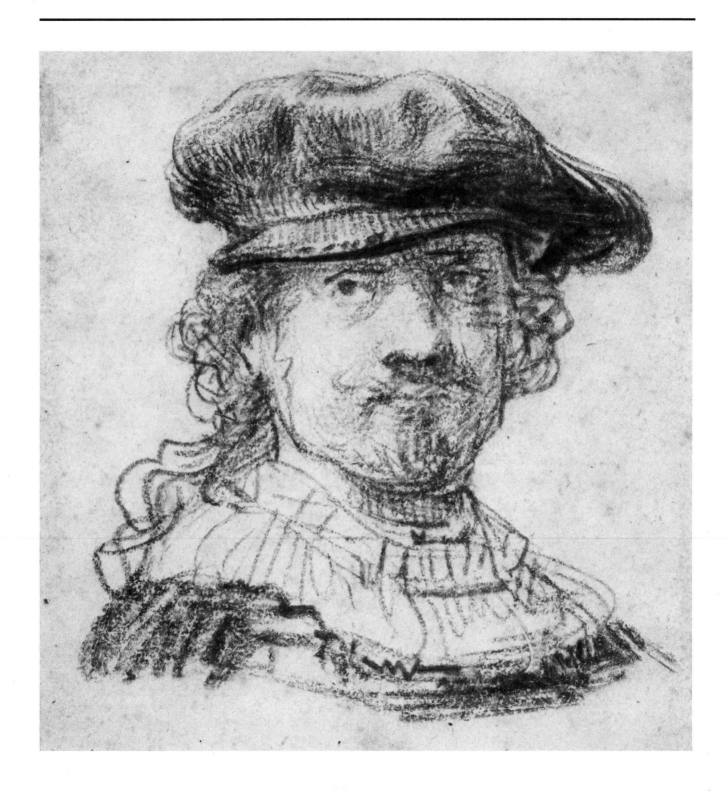

INTRODUCTION TO DRAWING

Drawing is the basic language of art. Sculptors, printmakers, painters, architects and fashion designers use drawing to communicate their ideas. Other artists and designers use pencils, pens or markers to doodle, make visual notes, express thoughts and otherwise communicate with their fellow workers. Drawing is *basic* to visual communications. Artists never stop drawing, no matter how skilled they become. It is their main method of visual communication.

Without an ability to draw well, artists (students and professionals alike) are limited creatively. Drawing is to the artist what words are to the writer. Both would be lost without their basic means of communication.

As you sharpen your ability to see and record, your confidence to express yourself visually also increases. If you stop drawing for any length of time, that ability lessens–just as a musician becomes "rusty" from lack of practice. This book will help you learn to see and record, but you must try to make these basic drawing activities a regular part of your daily life. Most professional artists and designers do some drawing every day. Their sketchbooks show how they continually improve their capacity to see, record and express themselves.

Drawing must be done constantly. A look back into history will show you that the greatest artists spent much time drawing. About 1522, Michelangelo wrote this note on one of his assistant's drawings: "Draw Antonio, draw and do not waste time." His advice is still crucial to artists today.

Student work: Collage, ink and crayon, 24 × 16″ (61 × 40.5 cm). Rembrandt, who made the self-portrait, was constantly drawing to improve his skills. Rembrandt: Red chalk, 5¹/₁₆ × 4¾″ (13 × 12 cm). National Gallery of Art, Washington DC, Lessing J. Rosenwald Collection.

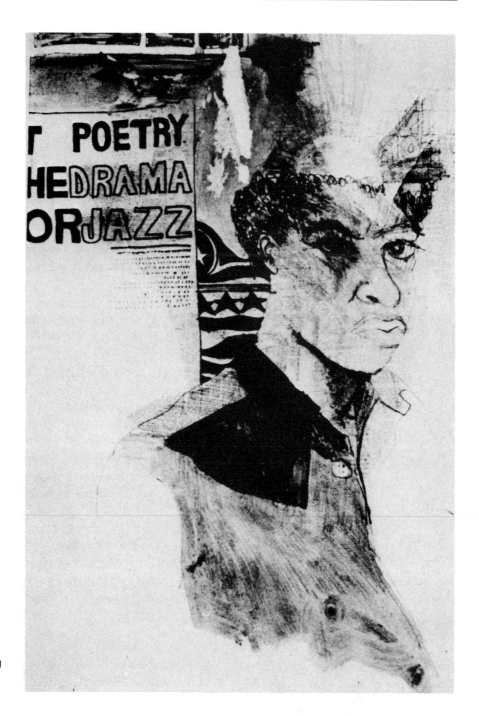

Drawing styles are the result of constant work and exploring. The student drawing reflects an active search for effective self-expression.

1

INTRODUCING DRAWING

You are about to begin one of the most exciting experiences of your life. Over the next few months, your artwork will be greatly influenced by your drawing experiences. Concern about what you see and do will change not only your art but your entire life. This is possible because learning to draw is based on learning to see. If you learn to see more completely, your life should be richer, more meaningful and enjoyable.

This book will emphasize the act and not the product—it will stress *drawing* and not *the drawing*. Drawing implies searching more than finishing. Of course there are finished drawings, but most drawings are appealing in their per-sonality and spontaneity. They often seem like fragmented statements that allow the viewer close contact with the artist. A drawing provides a look into the artist's mind, his or her mental organization and work-ing habits. Though craftsmanship should be encouraged through finished work, constant discoveries should also be recorded. Discovery involves searching and drawing.

These high-school students are seen in the act of *drawing*. They are looking carefully at a still life arrangement and recording what they see with pencil on paper. When each finishes searching, discovering and recording line, shapes and values, the resulting product will be a *drawing*.

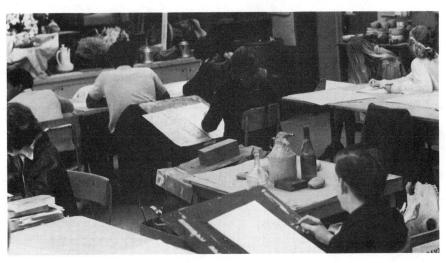

Charles White used a rapidly moving pen line to describe three views of a face. After years of looking and recording, the artist's hand becomes an extension of his eye. Notice the way lines were used to create value.

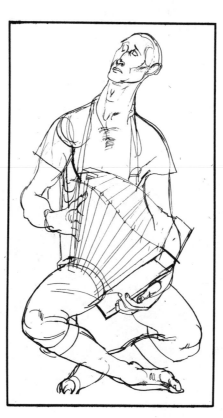

Rico Lebrun used sure but delicate pen lines to record how he saw and felt about the model. Accomplished artists continue to practice drawing as a way of increasing their observational skills. *The Accordian Player.* **Pen and ink, 25 × 18″ (63.5 × 46 cm). Los Angeles County Museum of Art.**

What Drawing Is

If you look carefully at a seedpod and record its structure, textures, values and shapes, you might really be seeing that seedpod in all its complexity for the first time. Look at your foot, your eye, a flower's delicacy, an elephant's bulk. Recording your findings and feelings is *drawing.*

There are other sources for subject matter. The artist can recall things and make sketches of them, or can visualize an idea or concept. Designing new products or buildings involves such visualization. This visualization on paper of nonexistent or imagined forms is *drawing.*

Charts, logos, cartoons, words and symbols are also forms of graphic expression. Small children develop a system of symbols in their drawing, and their intrigue with such visual representation stays with them all their lives. They are not describing or visualizing, but are symbolizing. Placing symbols on paper is *drawing* and the graphic product is called a *drawing.*

These three areas overlap and intertwine, but can be unraveled and separated for study. All of them will be covered in this book, but the first—recording what is seen—will receive the most emphasis because it is most important that you become searching, inquisitive people. Recording your visual discoveries with graphic media is an exciting process. It is *drawing.*

Becoming aware of your environment in both its intimate and all-inclusive aspects is a vital experience. If you look carefully at

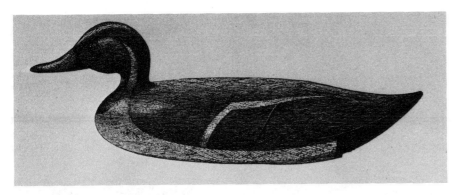

Paul Taylor used pen and ink to record the way his eyes saw this carved duck. His keen observation and technique suits the subject well. *Decoy,* **1985. Pen and ink, 9 × 24″ (23 × 61 cm).**

Richard Downer used his marvelous skills of seeing and recording as he drew this complex city scene. Notice how the open spaces give our eyes a chance to rest, and also keep the surface from becoming monotonous. *London Roofs.* **Fountain pen and black ink, 12 × 24″ (30 × 61 cm). Courtesy, Studio Vista Limited, London.**

van Gogh's drawing on the opening page of Part One, you can actually see and sense what he saw and felt. This awareness is strengthened by your own looking, seeing and becoming aware. One artist has said, "I am constantly wearing out my eyes," and his drawings show a fantastic concern with observed facts. The way you see and feel about your environment will help determine your ability to draw. Seeing and drawing are inseparable. Drawing is one way of seeing!

Learning To See

The first step in any kind of art is awareness—seeing, sensing and reacting to what is around you. Drawing is a way of learning how to see, and understand your immediate environment.

You pass many houses, buildings and store fronts on your way to school. If you were asked to describe their proportions, architectural details, doors and windows, you would be quite vague, unless you had really stopped to study them. Many of us are so accustomed to our surroundings that we don't truly see them.

Think of one of your best friends or a member of your family. Concentrate on his or her face. Can you describe it in detail? Can you describe the shape of the eyes, nose, mouth, chin, ears, eyebrows or hair line? It may be difficult. But if you try to *draw* that face—by looking carefully at it—you will be

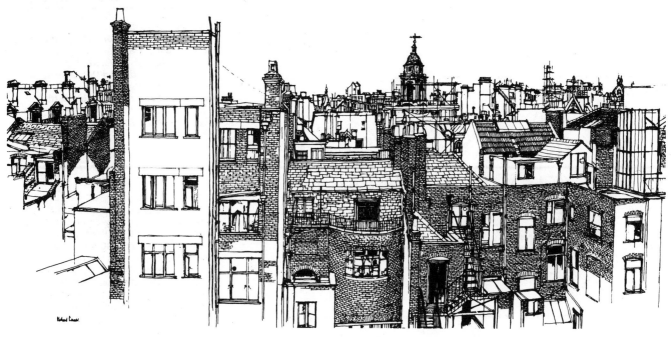

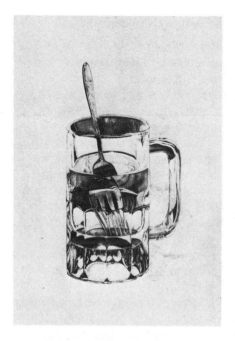

A student looked carefully to see the visual distortions that water and glass can create. The pencil drawing is the result of direct and concentrated observation.

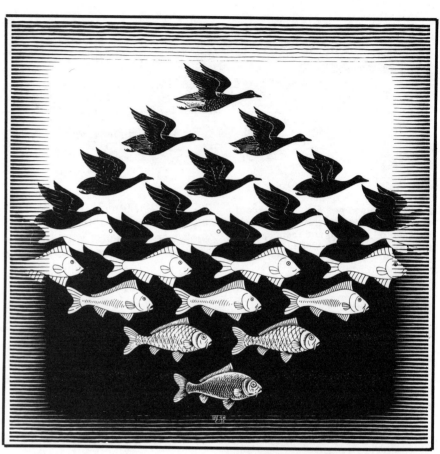

M.C. Escher toys with our perception as he uses his wonderful imagination to design positive and negative spaces. Look carefully at the negative spaces between the birds and fish and notice how they change. This type of image cannot be seen anyplace on earth— except with the inner vision of an artist. *Sky and Water.* Woodcut, 17⅜ × 17⅜" (44 × 44 cm).

Stuart Davis used a controlled brush line to draw this imaginary composition that might be a boat tied up at a dock. The delightful line encloses a wonderful variety of shapes that might or might not form a recognizable subject. *Composition #4,* 1934. Brush and ink, 21 × 30" (53 × 76 cm). Museum of Modern Art, New York, gift of Abby Aldrich Rockefeller.

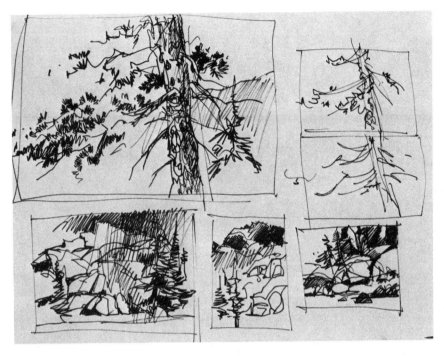

Sketches are often made to explore a subject in various ways before a painting is started. This group of small sketches was drawn on a sketchbook page, prior to beginning a watercolor on location in the Colorado Rockies.

Celeste Rehm uses pen and ink to make finished drawings that are exhibited in several art galleries. Her detailed drawing technique and unique wit combine to produce provocative fine arts products. *Washing the Drawing.* Pen and ink, 32 × 22″ (81 × 56 cm).

forced to find and record characteristic shapes, forms, lines, curves and profiles. You will then begin to really. *see* that face.

Drawing is a unique way of learning how to see—to become aware of light and shadow, line and shape, texture and perspective, relationships and proportions, general characteristics and specific details.

Learning To Imagine

But what about drawing things you cannot see? Gustave Courbet, the French Realist artist (1819–1877), was once asked to paint an angel. He replied, "I cannot paint an angel because I cannot see an angel." Yet many other artists have drawn and painted angels. How? By drawing from their imaginations.

Human beings use their inner thoughts to visualize ideas and record their visions on paper. Right now, you can probably draw some improbable creatures from other worlds, make a plan for a dream house, or design an imaginary car. Recording imaginary things and ideas is also part of drawing.

Kinds and Purposes of Drawing

Drawing is not only the simple process of picking up a pencil and making a few marks on paper. It is also recording ideas, illustrating stories and creating fine art. Drawing activities can be grouped according to their basic purposes. Many will be explored and explained in other parts of this book.

SKETCHING. Sketching implies quick decisions, rapidly made marks and usually temporary results. Sketches are made to:

- *record information*—in sketchbooks, on a trip, at the zoo, around the house, etc.
- *plan other art*—to place objects

and try value plans for paintings or prints (see the Escher woodcut in this chapter), to plan a sculpture or to explore ideas for other art expressions.

- *improve observational skills*— many artists sketch daily or weekly, alone or in groups, to retain and sharpen their drawing skills.
- *visualize ideas or concepts*— abstract concepts, personal insights and new ideas can be sketched and made understandable to other people.
- *doodle*—doodling is a kind of automatic, subconscious drawing, the kind you do in history class or while talking on the phone.

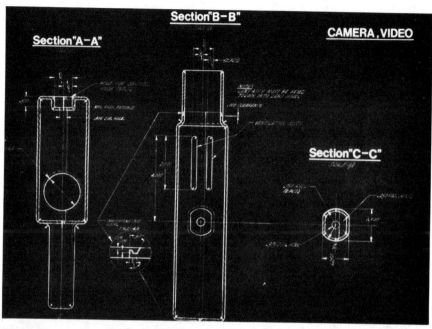

Robert Petersen is an industrial designer who explores and sketches new product ideas, and also develops working drawings for final production. This mechanical drawing is for the exterior design of a new video camera concept.

ILLUSTRATION. Drawing is essential in sketching, planning and, in many cases, producing finished illustrations for a variety of purposes. It is used in:

- *books, magazines and advertising*—to plan narrative illustrations, explore possible solutions and even to provide final artwork.
- *animation techniques*—to sketch ideas and provide final form for animated commercials, children's programs and feature films.
- *fashion illustration*—to provide illustrations for selling and visually describing clothing in magazines and newspapers.
- *cartoons and caricatures*—to explore ideas and make finished art for comic strips, cartoon features, caricature illustrations and editorial cartoons.

PRODUCT PLANNING. All products begin with *ideas* that must be made visible for analysis, under-

standing and development. Drawing is the method used for visualizing these ideas. It is used in:

- *industrial design*—to explore the shapes, forms and practical applications of proposed products.
- *graphic design*—to envision and finalize layouts, logos, symbols, type styles, advertising, television graphics, etc.
- *fashion design*—to explore new and unique clothing concepts and fashion statements.

TECHNICAL DRAWINGS. Not all drawing is quickly done or made with loose and expressive marks. Some needs to be technically accurate and carefully rendered. This type of drawing is necessary in making:

A cartoonist must have a fertile imagination, a sense of humor and expert drawing skills. The brush and ink lines, in this example, which are drawn with confidence, show an interesting thick-and-thin variation. *Grape Ape* is a product of Hanna Barbera Productions, Inc.

Francis de Erdely's work shows a wonderful strength of form, particularly in hands, feet and face. His personal drawing style (which carried over into his paintings) developed from careful observation, a knowledge of anatomy, and the ability to design and distort slightly for visual impact. *The Banjo Player,* 1951. Balsa stick and ink on brown paper, 30 × 24″ (76 × 61 cm).

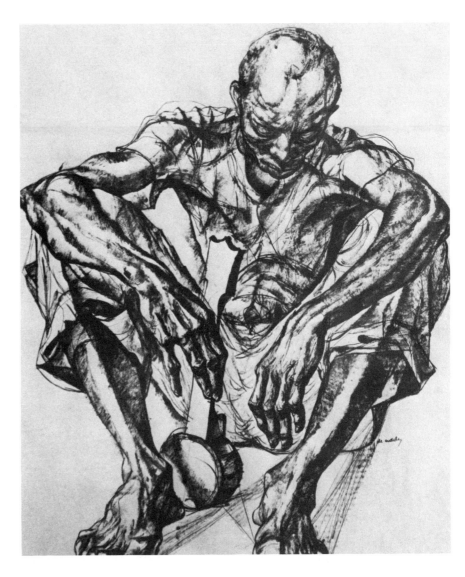

- *architectural plans*—final illustrations and plans from which the contractors will order materials and build the structure.
- *technical illustrations*—to show the construction of machines, the arrangement of wiring systems, the breakdown of engine parts, etc.
- *medical illustrations*—to show how a heart works, to illustrate medical journals and books, to visually describe operations, medical techniques and the like.
- *computer graphics*—to plan programs and software for computers that are used in many of the above drawing applications.

FINE ART. Drawings which appeal to our sense of beauty and which inspire strong emotions within us fall under the general category of fine art. Great drawings, like paintings or sculpture, grow out of a series of preliminary sketches. The distinction between fine art and other forms of art is not well defined. For instance, drawings done by Leonardo da Vinci in the fourteenth century as working sketches (applied art) are today considered fine art. The drawings themselves have not changed—just our attitude toward them.

Developing An Individual Drawing Style

I like Rembrandt's line quality. That looks like a van Gogh drawing! Ben Shahn's lines are easy to recognize.

How can you tell who made a drawing without looking at the name of the artist? Simple—by recognizing a *style* of drawing. Style is as much a part of the artist as his or her handwriting, way of pronouncing words or way of writing poetry. You know a Michelangelo drawing by his individual style. You are also developing an individual style, as are your classmates. Style takes years to mature, but even in the beginning it is recognizable. From the start, your drawings will stand out as your own because of your style.

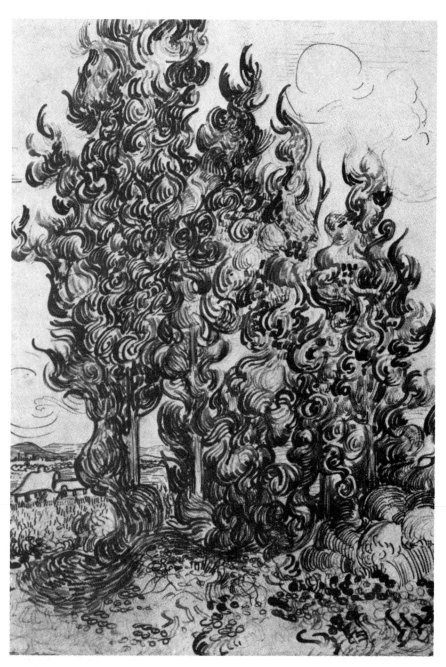

Vincent van Gogh's drawing style is easily recognized by those familiar with his paintings. Powerful jabbing, swirling and staccato marks dominate this tree study. *Grove of Cypresses,* 1889. Pen and ink over pencil, 24 × 18″ (61 × 46 cm). The Art Institute of Chicago, gift of Robert Allerton.

The search for an individual style begins in your drawing class by trying many ways of working. Use bold strokes or delicate lines; draw with vigor or with flowing lines; make dramatic statements or realistic renderings. Experiment and try new techniques and materials. You are not in class to make masterpieces, but to learn! Don't force yourself to stick to one method of expression. Enjoy the freedom of trying many styles. Your own personal style will develop from this searching and growing process.

You can also use outside sources to help develop your style. Everything you experience and study will have some effect on your work—movies, art shows, comic pages, books, museums, television.

Look at the drawings of artists of historical importance. What concerns of theirs are similar to yours? Visit local galleries to see what is happening now, or look through art magazines in the library. Study art wherever you see it and learn to analyze artists' ways of working. How do they interpret their environment? How do they design their work? What are your reactions to the artwork of others? Discuss your feelings with your classmates and teachers.

To all of this you must add your own cultural background, ethnic ties, family and friends. With all of these strong individual influences, how can your style look exactly like that of anyone else? It shouldn't! It will be your own personal statement about the subjects you draw, based on your own unique and personal experiences.

The search for individual style will take you in many directions. Here a student explores his immediate environment— the art room—in making this fine visual statement in ink line and wash, 24 × 18″ (61 × 46 cm).

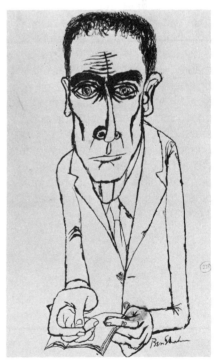

Ben Shahn developed a crabbed line (almost like barbed wire) to delineate his caricature studies and other drawings. The stark simplicity of line adds impact to the look of concern on the face of this noted atomic scientist. *Dr. J. Robert Oppenheimer,* 1954. Brush and ink, 19½ × 12¼″ (49.5 × 31 cm). The Museum of Modern Art, New York.

Charcoal

A Quick Look at Drawing Media

The variety of drawing media available today is astounding, but can be grouped for convenience into dry, wet and mixed, as seen in Chapters 6–8. Study and compare the marks that each group makes. Try to make similar marks on drawing paper. Artists choose their favorite media after much testing to see which work best with their styles and subjects.

The shape and size of the medium is also important. Pencils and charcoal vary in their length, width, thickness, roundness and darkness. Some feel more comfortable than others. The sizes of brushes differ, as do the sizes of marker and pen points. Full brushes and markers make different marks than partially dry ones. Some media crumble and make dust—others are solid or wet. Some are encased in wood—others are not. Some are contained in pens or holders of various types—others need brushes to transfer them to paper.

Drawing surfaces differ also. Papers can be soft, hard-surfaced, smooth, textured, absorbent, wet, dry or wrinkled. Each medium will react differently with each kind of surface. Experiment to determine which combinations you like best.

Marks will often vary if the same tool or medium is held differently. Hold a No. 2 pencil in several ways to see what it does in each position. Try long charcoal sticks and short ones. Hold a pencil at the end and near the point. Use broken and whole crayons, full lengths and stubs.

Experimenting with media and paper will turn up new combinations that can help you produce more interesting work. Here are some basic media and the marks they make.

Pencil

Pen and Ink

Brush and Wash

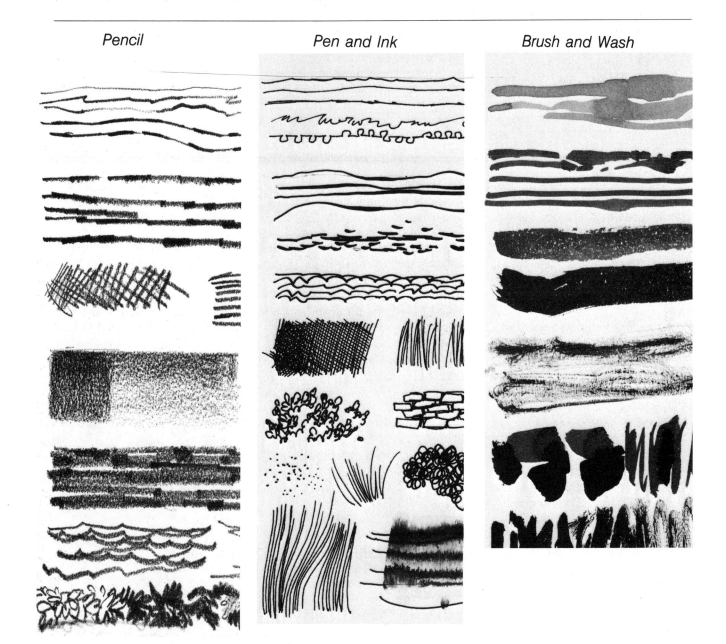

Activities

At the end of most chapters, there are activities that give you the opportunity to understand art and drawing more fully—from different points of view. A good way to study art completely is to approach it from four different directions.

1. *Art history* helps us understand art of the past and how it influences the kind of art we make today. It also helps us understand artists and how they think and work.
2. *Criticism/Analysis* helps us evaluate art and make judgments about it. By asking a few questions, we learn to look at a drawing more carefully, analyzing its composition and quality.
3. *Aesthetics/Personal sensitivity* helps us understand our personal responses to art. We learn to respond to a special mood or feeling in a drawing. Aesthetics concerns our own personal sensitivity and reaction to art and to the messages of artists.
4. *Production/Studio experiences* concerns our ability to make art. What we learn from history, criticism and aesthetics will help us make better drawings. But our ability to produce more competent drawings also depends on practice, observation and the desire to improve our technical abilities.

ART HISTORY

1. Several basic drawing media are illustrated on these pages. Select one of them and write a short paper on its history. Research can be done in encyclopedias or books on drawing media.

CRITICISM/ANALYSIS

2. Study the drawing *Willowgrove and Shepherd* by Vincent van Gogh opposite the title page. Then analyze it by discussing or writing answers to the following questions: What medium is used? How did van Gogh use line to create gray values? Describe the different kinds of line. Is the horizon above or below the middle of the sheet? How is vertical movement emphasized? How did the artist show us that the trees are rounded? How has he shown depth and space? How do you know if it is summer or winter? What is the most important subject? What other subjects can you notice?

AESTHETICS/PERSONAL SENSITIVITY

3. Again, study *Willowgrove and Shepherd* by van Gogh. (See second page of book, opposite title page.) Write several sentences in response to each of the following questions to help you understand your response to the drawing: What sort of mood do you sense in the drawing? How did the artist convince you of this? Do you feel comfortable looking at the drawing? Why or why not? Do you sense a warm or cold day? Why? Do you like *Willowgrove and Shepherd* or not? Why? How does the artist encourage you to "walk into the picture" along with the shepherd?

PRODUCTION/STUDIO EXPERIENCES

4. Use *charcoal, pencil* and a *marker* to make charts that illustrate the characteristics of each medium. Look at the marks on these pages for ideas. Then, try to make similar ones and additional ones to explore the range of expressive marks possible with each medium.

2 A BRIEF LOOK AT THE HISTORY OF DRAWING

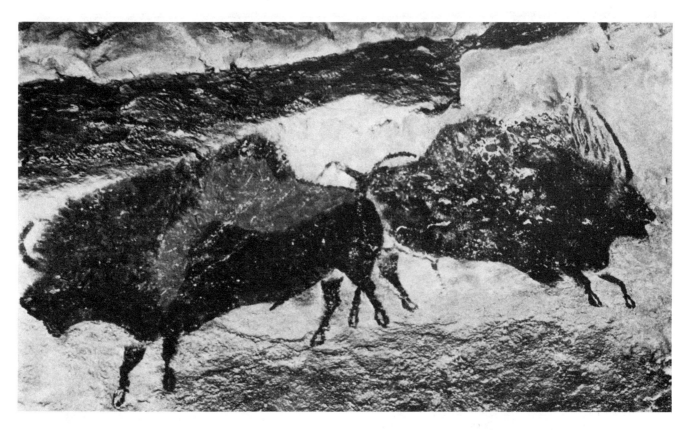

Artists of ancient times used pieces of colored earth and charcoal to draw stylized likenesses of bison and other animals on the walls of caves. These are from a cave at Lascaux, France.

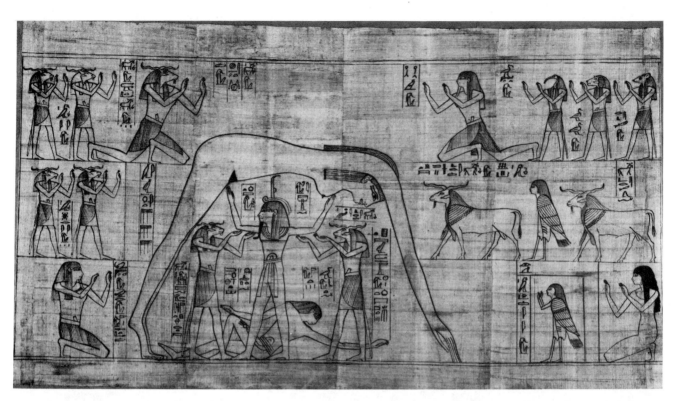

Egyptian artists used exquisite lines to draw on papyrus and carve on walls. Their linear depictions include gods, humans, animals and hieroglyphics such as these drawn with water-based pigments on papyrus with a brush and stylus. *Greenfield Papyrus,* about 1080 B.C., 19″ (48 cm) high. British Museum, London.

Chinese emperor Hsuan Ti (569–582) was drawn with his retinue of noblemen and servants. The artist used black ink and several colors on a silk handscroll. This detail is part of *The Thirteen Emperors* by Yen Li-Pen. Done in the seventh century, the entire scroll is about 200″ (508 cm) long and 20″ (51 cm) high. Museum of Fine Arts, Boston.

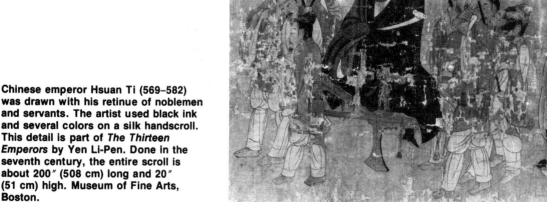

Beginnings to Byzantine

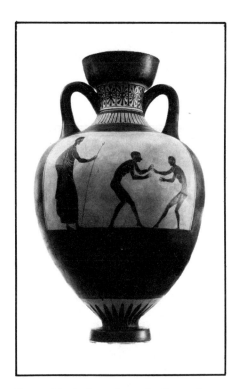

Geometric designs decorate the neck and base of this Greek vase, on which the drawing of two boys wrestling before a referee is the principal illustration. Greek amphora in terra cotta, 21″ (53 cm) high. The Baltimore Museum of Art.

The earliest known drawings are the Stone Age animal forms portrayed in the ancient caves of France and Spain. Paleolithic artists used chunks of colored earth and charcoal to make lines and marks characterizing the various animals around them. These marks, many thousands of years old, are the beginnings of drawing.

As far back as 4000 B.C., the artists of Sumeria (Mesopotamia) and Egypt used line drawing to show human and animal forms. By 3000 B.C., these were stylized into symbolic portrayals, designed to be decorative and yet clear enough to communicate ideas and concepts. Drawing systems were established to successfully represent human forms and show objects and people in space. These were recorded on stone and papyrus surfaces. Artists at this time were artisans and not creative people. The ideas and concepts for the drawing were prescribed by political leaders, and were not the personal graphic expressions of individual artists.

The earliest Greek drawing (prior to 800 B.C.) was not recorded on paper or stone, but on pottery surfaces. Vases were first decorated with geometric motifs, and later with human and animal figures. After 500 B.C., these drawings became quite realistic, with natural proportions and attention to detail.

Even though they were shown as silhouettes, without modeling or shading, line and shape were used with great skill.

Roman artists, about the time of Christ, drew and painted realistic likenesses (in line and color) on the plaster walls of their homes. They began to use gradations of dark and light to represent the three-dimensional forms of people, animals and objects. Drawing, as we know it today, had begun to emerge as a graphic form of expression, with personal interpretation and style.

In the Byzantine culture of eastern Europe and Asia Minor, following the fall of the Roman Empire, drawing degenerated into decorative formalism. The depiction of realistic human forms was abandoned in keeping with the religious teachings of the time. From the ninth century on, however, the artistic monks of northern Europe developed the art of manuscript illumination and revived the art of human representation and graphic decoration. Line, shape and color were used with sensitivity and skill.

From 500 to 1500, artists in other countries were also improving their drawing skills. In China, India and Moslem lands, line drawing and color were used effectively to describe visually important persons, places and events, and also to illustrate myths and stories.

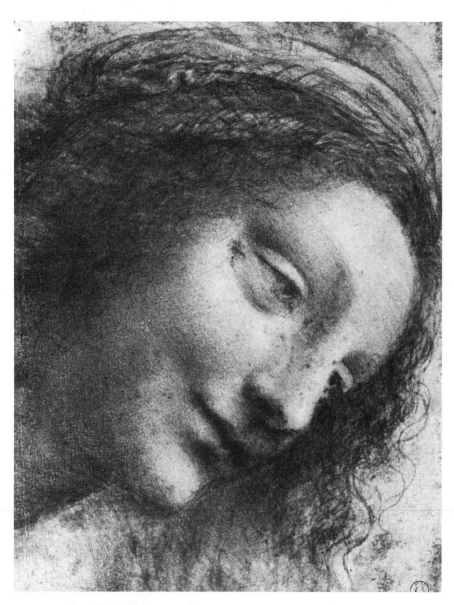

Leonardo da Vinci used red and black chalk to make this shaded drawing after careful observation. This convincingly three-dimensional drawing, *Head of the Virgin,* was research for a later oil painting.. The Metropolitan Museum of Art, New York.

Renaissance to Baroque

Drawing as we practice it today became established as the foundation of art training during the early Renaissance. It became important both as an artistic and investigative activity. Young artists copied the drawings of masters to learn techniques and style. Charcoal and chalk were used to make large studies. Metal point, pen and ink, and washes of watercolor and ink were used for smaller works. Some drawings were highlighted with tempera and chalk.

Early Italian drawings (fourteenth and fifteenth centuries) had firm contour lines and delicately shaded areas. Human anatomy and physical details were intensely studied and drawn with extreme care. Linear perspective was developed as a way of drawing objects realistically in space. Giovanni Bellini, Sandro Botticelli and Giorgione produced superb drawings, mostly of human figures.

Drawings during the High Renaissance in Italy (1475–1525) were heavier, with broadly massed tones of dark and light replacing the delicate linear qualities of earlier times. Rounded figures were easily drawn in space and were free and bold in style. Leonardo da Vinci, Michelangelo, Raphael and Titian were the leading draftsmen of their time.

Renaissance drawings in northern Europe were quite different from those of Italy. Artists in Flanders, France and Germany worked in small sizes with amazing detail. They used silverpoint as their favorite medium. Portraits and land-

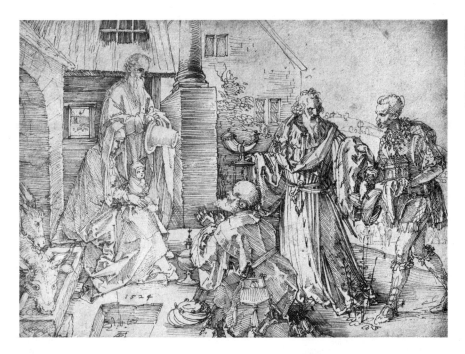

Albrecht Dürer used pen and ink to outline his figures, and to create values that suggest form. You can almost see his pen fly over the surface as he shaded selected areas with repeated and hatched lines. *Visit of the Wise Men* is in the collection of the Albertina Museum, Vienna.

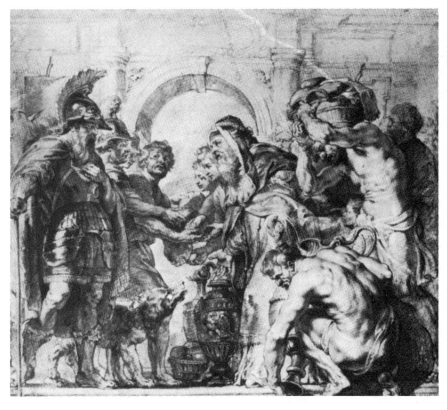

Peter Paul Rubens used pencil in this drawing of *Abraham and Melchizadek.* Several kinds of perspective were used to show depth of space, and carefully observed shading produced dramatic three-dimensional forms. Crowded figures, interlocking forms, swirling movement and intense activity are characteristics of Rubens's drawings as well as his paintings. Albertina Museum, Vienna.

Rembrandt used sketches to plan later compositional arrangements in his paintings. He drew continually, rapidly and surely, sketching all types of subjects around him, researching themes, subjects, people and concepts. *Rest on the Flight into Egypt,* **1655. Reed pen and bistre, 6⅜ × 8⅞″ (16 × 22.5 cm). Los Angeles County Museum of Art, The Norton Simon Foundation.**

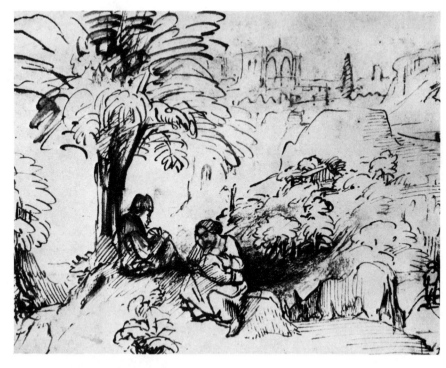

scapes were drawn with intricate lines and exquisite care. Jan van Eyck, Hans Holbein, Albrecht Dürer, Hieronymous Bosch and Pieter Brueghel produced hundreds of drawings as research for painting themes.

Baroque artists in all of Europe (seventeenth century) used drawing to explore ideas and concepts for paintings. Both quick sketches and detailed studies were made. Painterly wash drawings (using ink in various values) were used to make large-scale studies. In Italy, Giovanni Battista Tiepolo, Guercino and Francesco Guardi were the leading draftsmen, specializing in large religious and environmental works.

Northern European Baroque artists emphasized portraits and

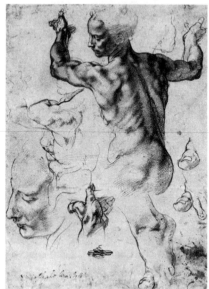

Michelangelo drew *Study for the Libyan Sibyl* **(1511) in red chalk on paper, as preparation for one of the figures in the gigantic Sistine Ceiling project. He drew from a model to study several features that might have given him problems. The sketch is only 11¼ × 8⅜″ (28.5 × 21 cm), yet seems much larger. The Metropolitan Museum of Art, New York.**

drawings from daily life in their detailed work. Rembrandt produced hundreds of drawings of many subjects, using pen and ink, wash, chalk and combinations of media. Peter Paul Rubens and Anthony van Dyck produced massive amounts of drawings in Flanders, while Claude Lorraine, Nicholas Poussin and Antoine Watteau were very active in France.

In England, literary illustrations and aristocratic portraiture were featured in drawings. William Hogarth, however, drew with satirical wit and social outrage. In Spain, Francesco Goya and Francesco Zurbaran drew with authority and conviction, using chalk and wash to portray religious and governmental themes, and the daily life of their fellow citizens.

Nineteenth Century

Paris became the artistic center of the world in the nineteenth century. Jean-Auguste Dominique Ingres led the way in sparking the revival of classical drawing. His pencil studies revealed technical virtuosity and disciplined observation. Eugene Delacroix, a Romanticist, charged his pen and ink studies with energy, indicative of the Romantic movement. At the same time, French Realists were drawing their environment with humor, satire, and sympathy. They were led by Honoré Daumier, Camille Corot and Gustave Courbet. Charcoal, crayon, ink, chalk and mixed media drawings were vital parts of their visual vocabulary. Artists in England and America reflected the drawing techniques and styles of these leading French artists.

Impressionism and Post-Impressionism emerged from the work of these Realist artists. The Impressionists were a group of Paris artists who exhibited together and were united in protest against the academic art of their time (1860–1900). Edouard Manet used pen, brush and ink to make quick, impulsive statements about his models. Claude Monet sketched with charcoal and chalk to capture the light and texture of the French countryside. Camille Pissarro drew continually in his search for subjects for his paintings. Edgar Degas, a student of Ingres, was the master draftsman, and his well-trained eye and hand captured the characteristic gestures and attitudes of his models. He used every drawing medium available in exploring

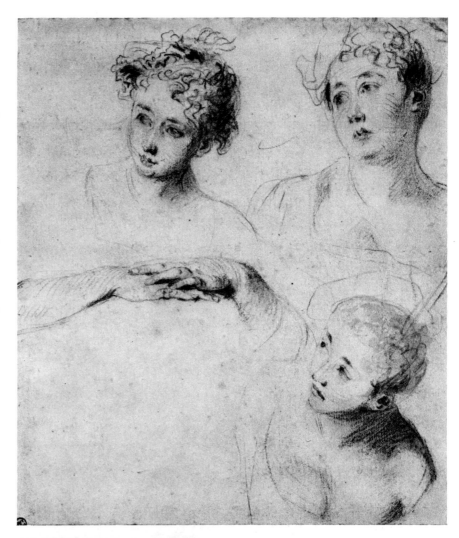

Antoine Watteau was an eighteenth century master at drawing people, yet he practiced constantly. This small page contains three tiny head studies, each about 2″ (5 cm) high. *Study of Heads,* 1715. Red and black chalk, pencil, brown wash, 7¼ × 6⅜″ (18.5 × 16 cm). National Gallery of Art, Washington DC, Samuel H. Kress Collection.

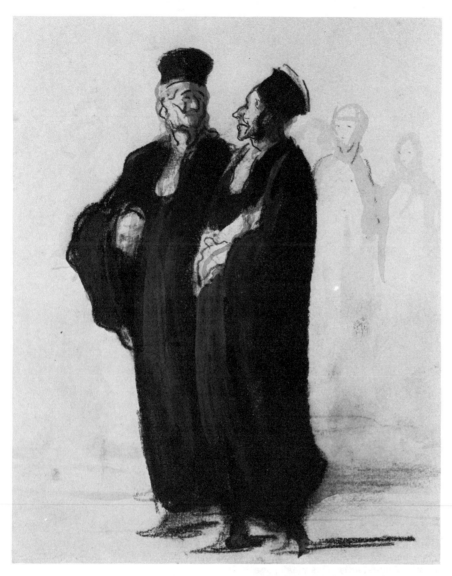

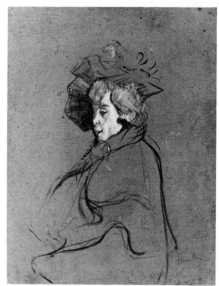

Henri de Toulouse-Lautrec often thinned oil paints to draw quickly with a brush. In this work, he drew on cardboard, adding color when modelling the face, but using a broad sketching technique elsewhere. *Jane Avril,* 1892. Oil on cardboard, 27 × 21″ (68.5 × 53 cm). National Gallery of Art, Washington, DC, Chester Dale Collection.

subjects for his work in color (oils and pastels). Mary Cassatt, an American, drew with charcoal and pastels in her sensitive portrayals of both women and children.

Post-Impressionism emerged during the last twenty years of the nineteenth century. Several artists at this time expanded the trends established by the Impressionists, but added their personal insights and feelings. Henri de Toulouse-Lautrec continued the careful observational drawings of Degas, but with dynamic personal inter-

Honoré Daumier worked quickly and surely to establish a sense of movement in these two chatting figures. His gestural lines are characteristic of his witty observations. *Two Lawyers* (about 1870). Black crayon with brown washes, 10½ × 9¼″ (26.5 × 23.5 cm). National Gallery of Art, Washington, DC, Chester Dale Collection.

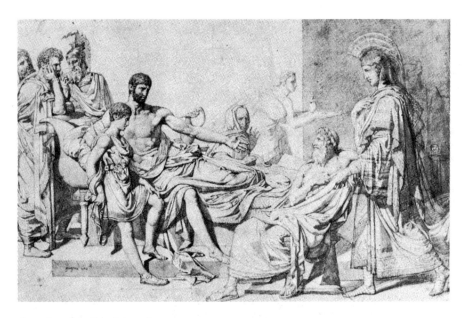

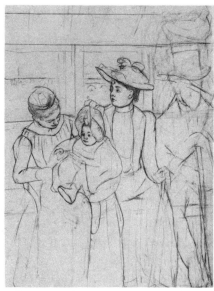

Jean-Auguste Dominique Ingres crammed many people into this small pencil drawing. All were carefully planned and drawn from actual models, one by one, in classic poses. The drawing seems much larger than its actual size. *Scipio and His Sons with the Envoys of Antiochus.* **Pencil, 9 × 15″ (23 × 38 cm). Norton Simon Museum of Art, Pasadena.**

Mary Cassatt drew this sensitive sketch of a group of people in a Paris streetcar. Searching and sketchy lines are followed by definite dark lines, which capture the attitude and interplay of the figures. *Tramway,* **about 1891. Black crayon, 14⅜ × 10⅝″ (36.5 × 27 cm). National Gallery of Art, Washington DC, Rosenwald Collection.**

pretations. Five other artists developed individual directions at this time, and led art into the vast variety of styles to follow in the twentieth century: Paul Cézanne, Auguste Renoir, Vincent van Gogh, Paul Gauguin and Georges Seurat.

Cézanne pushed drawing toward a Cubist feeling by faceting space and form. Renoir used soft edges and lines with subtle shading to delineate his figure studies. Van Gogh often used pen and ink to jab at his papers. He created agitated surfaces similar to those of his Expressionistic oils. Gauguin drew as a way to plan his paintings, and used broad simplification and outlined forms. Seurat used the flat sides of charcoal to create simplified, soft-edged studies with intense value contrast.

In England, at the turn of the century, Aubrey Beardsley used the contemporary Art Nouveau style. He created decorative pen and ink illustrations, brilliantly original in concept and technique, using delicate line and large black shapes in unique combinations.

Twentieth Century

The explosion of artistic expression in the twentieth century originated in Paris and spread over Europe prior to World War II. Following that war, the United States surged to the forefront of world art. It remains there today. All the major art movements of this century (and there are many) are reflected in the *drawings* of the major artists.

Expressionism is represented by the Fauves in France (1900–1910) and the Expressionists in Germany (1910–1930). Henri Matisse's beautiful lines describe the contours of graceful figures and objects. Paul Klee's delicate lines, Emil Nolde's bold marks, Oskar Kokoschka's powerful shading, Kathe Kollwitz's social realism, and

Piet Mondrian drew this tree many times, trying to simplify it to a few basic lines. *Tree II,* **1912. Charcoal, 30 × 48″ (76 × 122 cm). Gemeentemuseum, The Hague.**

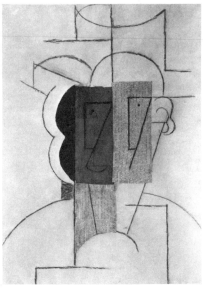

Pablo Picasso used lines (charcoal) and shapes (ink and collaged papers) to simplify and abstract this portrait of a man. *Man with a Hat,* **1912. Charcoal, ink and collage, 25 × 19″ (63.5 × 48 cm). Museum of Modern Art, New York.**

George Grosz's biting satire are all part of Expressionist drawing in this century.

Abstractionism originated with Cubism (1910–1925) and eventually evolved into the Abstract Expressionist movement in the United States in the 1950s. Pablo Picasso made drawings of every type, but started the trend toward abstraction with his cubist studies. George Braque and Juan Gris continued these geometric and cubist directions. Marcel Duchamp splintered forms into pieces. Stuart Davis flattened things into shapes. Piet Mondrian simplified and simplified to reduce subjects to straight lines

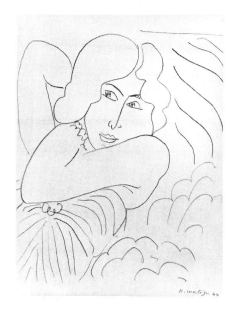

Henri Matisse used a flowing linear style to simplify his subjects. Few artists can express so much with so few lines. *Woman,* 1944. Pencil, 24 × 18″ (61 × 46 cm). Los Angeles County Museum of Art.

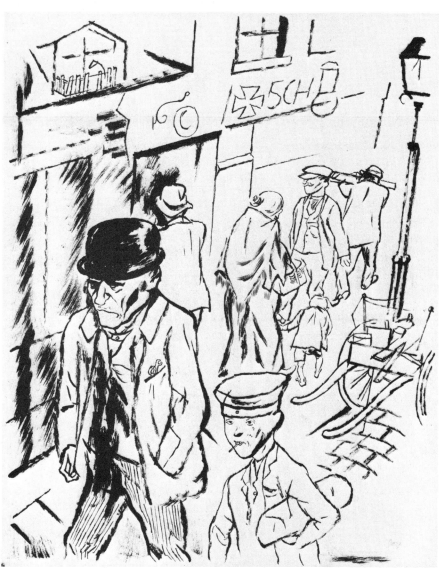

George Grosz used agitated lines to describe the social struggle in American cities during the depression. *Street Scene,* 1931. Ink and brush, 24 × 18″ (61 × 46 cm). Los Angeles County Museum of Art, Mr. and Mrs. William Randolph Hearst Collection.

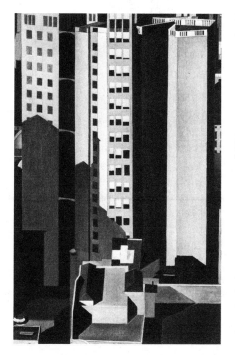

Charles Sheeler drew American cityscapes, emphasizing structure, surface textures and volume—things that always intrigued him. *New York,* 1920. Pencil, 16½ × 11″ (42 × 28 cm). The Art Institute of Chicago, Gift of the Friends of American Art.

and geometric shapes. Abstract Expressionists like Willem de Kooning and Hans Hofmann drew with powerful emotions and dynamic gestures.

Surrealism started in Paris in the 1920s and explored psychoanalytical subjects and ideas. Dreams and fantasies played important roles in the drawings of Max Ernst, Joan Miró, Yves Tanguy, Marc Chagall and Salvadore Dali.

Realism took many forms during this century, from Social Realism to Super Realism. Social Realists in America (1920–1940) included George Grosz, Ben Shahn, William Gropper and the Mexican artists Diego Rivera and José Clemente Orozco.

Robert Indiana obtained a striking graphic image in this stencil rubbing work, by allowing individual pencil marks to remain visible and important. *The American Hay Company,* 1962. Pencil, 25 × 19″ (63.5 × 48 cm). Los Angeles County Museum of Art.

Contemporary Drawing

Realists who worked in traditional ways include Charles Sheeler, Edward Hopper, Rico Lebrun, Charles White and Andrew Wyeth. They all developed personal styles of realism that helped communicate their feelings to the American public.

Super Realists like Robert Cottingham, Alfred Leslie, Richard Estes and James Rosenquist produced carefully detailed value studies in preparation for photo-like paintings in various media.

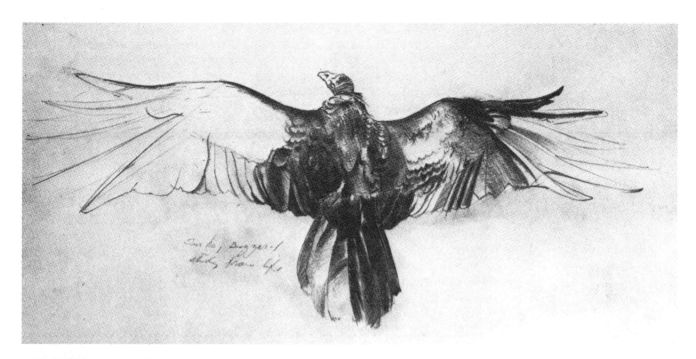

Andrew Wyeth was searching for visual information with line and value when he drew this study from life, by careful observation and recording. *Turkey Buzzard.* Pencil, 18 × 30″ (46 × 76 cm). Museum of Fine Arts, Boston, M. Karouk bequest.

Other contemporary artists draw in a variety of ways, usually reflecting their painting styles. Jasper Johns, Robert Indiana, Roy Lichtenstein, Richard Diebenkorn, Wayne Thiebaud, Chuck Close, Larry Rivers and Robert Rauschenberg explore personal themes in characteristic drawing styles.

Throughout all art from the beginning to the present, drawing remains the foundation for most artistic expression.

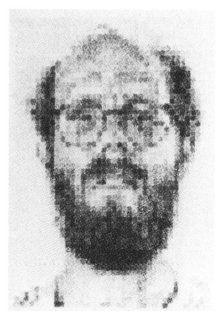

Charles White was a master draftsman who used various media to create powerful drawings that expressed the artist's concerns and feelings. *Seed of Love,* 1978. Ink applied with balsa sticks, brush and pen, 50 × 40″ (127 × 101.5 cm). Los Angeles County Museum of Art.

Chuck Close divided a large sheet of paper into small squares and used conté crayon to fill the squares with different values. Squint your eyes to sense the effect of distance from the work. *Self Portrait,* 1982. Conté crayon, 48 × 36″ (122 × 91.5 cm). Pace Gallery, New York.

Activities

ART HISTORY

1. Select one of the artists from this chapter whose work you like, and write a short paper on his or her life. Include some vital statistics, but also something about how the artist interacted with society and fellow artists.

2. After looking through this chapter, write a short essay on the role of drawing as a form of art. Has it changed much over several thousand years? Why do you think so?

CRITICISM/ANALYSIS

3. Write a short essay on "The Difference between Stylization and Realism in Drawing." Use several examples from the first two chapters as illustrations to back up your statements.

4. Write a detailed description of one of the following drawings: *New York* (Sheeler); *Seed of Love* (White); *Two Lawyers* (Daumier); *Abraham and Melchizadek* (Rubens). These are all finished drawings (not made as studies for paintings). Discuss media, size, composition, texture, use of line, amount of detail and value contrasts.

AESTHETICS/PERSONAL SENSITIVITY

5. Compare and contrast the drawings by Rubens and Rembrandt on page 27 and 28. Consider the purposes, degree or finish, use of realism, quality of line and value, etc. Which do you like better? Why?

6. The drawings by Matisse and Toulouse-Lautrec in this chapter are both of single figures. Write or discuss briefly how they are alike, and how they are different. Describe the quality of line used by each. How did each handle the problem of detailing the face?

PRODUCTION/STUDIO EXPERIENCES

7. Look at the drawing of Chuck Close, Charles White, Charles Sheeler, Henri Matisse, Albrecht Dürer, etc. Then make five identical drawings of a single object (pear, bottle, volley ball, for example). Shade them, each in the technique of one of the artists. Put each artist's name below the appropriate example.

8. On a 9 × 12″ (23 × 30 cm) sheet of drawing paper, make one of the following objects in the style of the artist named: pine tree (Mondrian); a bowl of fruit (Matisse); a kitten (Close); a football player (Daumier); a bunch of flowers (Rembrandt); a house (Dürer). Or make up other combinations.

3

DRAWING AND THE GRAPHIC ELEMENTS

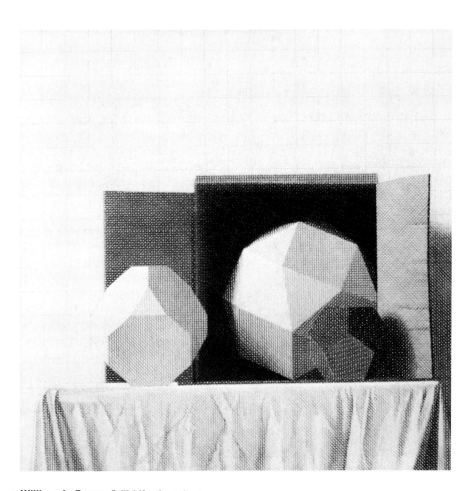

William A. Berry. *Still Life: Lunch at McDowell,* **1984. Colored pencils, 30 × 30″ (76 × 76 cm).**

The graphic elements include *line shape, form, color, value, texture* and *space*. These elements are often called the *elements of art* or the *elements of design*. Artists manipulate and arrange them to make all works of art. They are the basic vocabulary of creative, visual expression.

William A. Berry (preceding page) used colored pencils, a straight-edge and hundreds of lines to make this drawing. Although he used only *line,* he employed that single graphic element to create all the others: *shapes* (geometric and organic; *forms* (shaded volumes); *value* (variety of grays -- from white to dark); *color* (the color of the pencils and their combined effect); *texture* (simulated — created by crossing lines; and *space* (depth — shown by overlapping volumetric forms and the interior space of the box.

The word *design* refers to the structure of art. Just as verbal language needs structure (grammar) to make it comprehensible, visual language needs structure to make it understandable and effective. If the elements of design are our visual vocabulary, then the *principles of design* are the grammar we need to use the elements most effectively. These principles are *balance, unity, pattern, contrast, emphasis, movement* and *rhythm.* The elements and principles are used in concert to produce effective visual statements. Some elements may be emphasized or omitted at times, but not often.

An awareness of the principles of design and the graphic elements should help them become part of your own style. Examples in this book will constantly draw attention to the design principles. These examples will strengthen your knowledge of the design concepts until they are finally *seen* and *felt.* In the art criticism activities (at the ends of the chapters), these principles will be discussed and used to analyze drawings – providing repeated opportunities to make them an integral part of your study of art.

Using the graphic elements effectively is what this book is all about. The element of color is studied mostly in the realm of painting, but will be discussed in later chapters as it relates to contemporary drawing media. The following pages will offer an overview of the other graphic elements and provide a few examples of their effective use.

Donna Berryhill's free-running line differs greatly from that of William Berry. After studying her pen and ink drawing, analyze how she used all the elements and principles of design to make an effective and attractive drawing. Her basic element is a searching *line,* which is thick and thin, used alone and massed. *Shapes* are outlined (pillows, background, figure, foot, etc.). *Form* is indicated by curved lines on the pillows and figure, and the weighted lines in the figure. *Value* is implied on the pillow patterns and with the cross-hatched background shape. *Texture* is shown by the line treatment on the background and the pillows. *Space* is felt because the figure reclines back into space and overlaps the pillows (which also overlap each other). The part of the figure nearest us is proportionately larger than the head, which is farther away. This exaggerated foreshortening

also indicates depth of space. Color is not included (although it is inferred by the patterning of the pillows), but all the other elements of design are used.

The artist arranged these graphic elements by observing the principles of design. She used asymmetrical *balance* (not the same visual weight on both sides of a median line). *Contrast* is seen in value differences (gray and white), pattern variety (pillows and figure), and treatment of shapes (positive and negative). *Emphasis* is placed on the face because of its contrast with the background, and because the visual *movement* (from foot to head) over the figure directs us there – to the center of interest. *Pattern* is easily evident in the pillows and in the detailing of the clothing. *Rhythm* can be felt in repeated lines in the pillows and in the repeated soft curves of the figure. *Unity* is established by the use of similar line quality over the entire drawing and allowing white spaces to remain evident in the major components – figure and pillows.

Although the drawing may at first seem to be a simple picture of a girl leaning against some pillows, the artist has used the principles of design with care and knowledge to arrange the graphic elements for maximum impact and sensitivity.

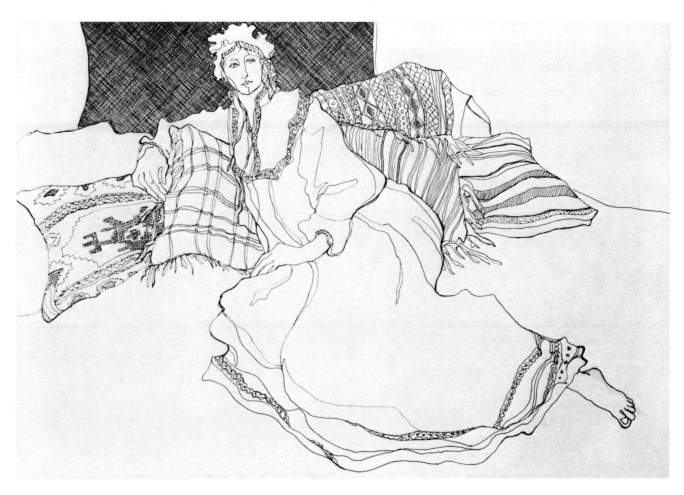

**Donna Berryhill used free-running line in
this portrait of a seated woman.**

Jackson Pollock used lines as the subject itself—not to make trees or bottles. He dribbled line from a container rather than use a brush or pen, hence his line is a free and organic entity. *#4-1949,* 1948. Gesso and enamel on paper, 22⅝ × 30⅞″ (57.5 × 78.5 cm). Collection, Frederick Weisman Company.

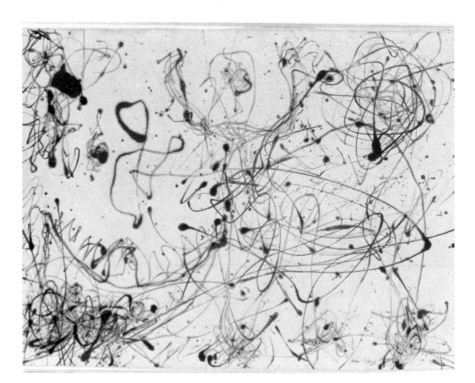

The mechanical lines of a marker are ideally suited to the robot subject in this student work. The difficulty of multiple perspectives seems easily handled in this 24 × 18″ (61 × 46 cm) drawing.

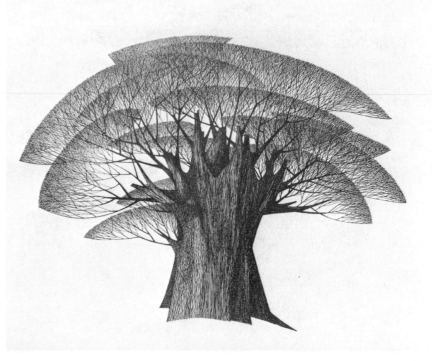

Paul Taylor's lines are perfectly controlled, varying from very thin to thick and bold. He uses them singly and masses them to create textures and tone. Pen lines often have a mechanical feeling, but here they produce a graceful elegance *Tree,* 1986. Pen and ink, 12 × 18″ (30 × 46 cm).

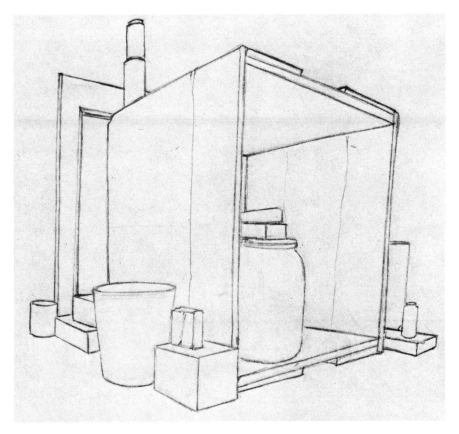

The weighted line (thick and thin) in this drawing was made with a thin stick (applicator stick) dipped in ink, and drawn on the rough surface of oatmeal paper. The student drew two overlapping views of a single lampbase sculpture. Stick and ink, 24 × 18″ (61 × 46 cm).

Soft pencil lines differ in character from those made with pen and ink or markers. In this student drawing, the value (tone) of the lines vary with the pressure applied—a quality that is not possible with ink. Pencil on newsprint 18 × 20″ (46 × 51 cm).

Line

Line is the most important of all graphic elements. It is the most convenient device for dividing, containing, directing, describing or expressing. It can be thin, thick, varied, straight, curved, agitated, broken, solid, wiggly, hard, soft, fuzzy. It can be made with any of the drawing media and can be sketchy, emphatic, searching, carefully controlled or free. It makes letters and numbers as well as leaves, eyes and hair. It can show depth, simulate texture, indicate stress and produce excitement. It is the most versatile and necessary of all the graphic elements.

There are three basic kinds of line:

1. *Mechanical*—unvarying width; impersonal; made with mechanical or technical pens and many markers.
2. *Impulsive*—made with no thought for quality; gestural; rapidly made responses, using charcoal, pencil, crayon, steel pens and brushes, and some markers.
3. *Virtuoso*—consciously controlled lines that are often thick and thin, expressive and sensitive; made with any of the drawing tools, but always expressive of the artist's intent.

Line will be fully explored in later chapters, but the examples on these pages provide a preview of line quality and use. Some artists who were especially adept at using various kinds of line include Paul Klee, Jean-Auguste Dominique Ingres, Edgar Degas, Peter Paul Rubens, Rembrandt, Paul Cezanne, Rico Lebrun and many of the Chinese and Japanese artists of past centuries.

The student who made this drawing, first used line to make the simplified shapes of leaves. He then filled the resulting negative shapes with pencil. A feeling of depth is created because of the overlapping shapes, but the overall feeling is of shape and not form.

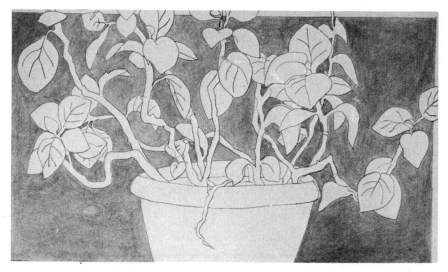

Ralph Hulett first outlined shapes (you can see some outlines in the background) and then used graded values to suggest form. Can you sense the roundness of the forms? *Wash Day, Puerta Vallarta,* 1972. Charcoal, 24 × 18″ (61 × 46 cm).

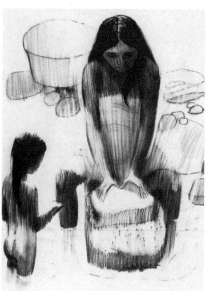

Linda Doll has disciplined herself to see large flat shapes when she looks around her. These shape sketches were made in Mexico as exploratory studies for paintings. She eliminated graded values and drew simple contours to be finished as dark and light shapes. Gray marker, 12 × 9″ (30 × 23 cm).

Shape and Form

Shapes are often contained by lines, but can be solid or textured. They occupy an area of the drawing and can be described as *geometric* (round, square, triangular) or as *organic* (pear-shaped, free flowing, leaf-like and a multitude of descriptive shapes). Shapes can feel solid, wiggly, strong, weak, angular, smooth, thin or fat. If they are overlapped or shaded, they will feel three-dimensional, and we call them forms. Shapes and forms can occupy positive or negative space in a drawing, each as important as the other. They can be outlined, graded or solid, and made in any media by line, texture, value or color.

Form refers to the three-dimensional character of objects. The simplest forms are spheres, cubes and pyramids. Most objects such as a human head, a chair or an animal are more complex forms. We are made aware of form in nature by light and shadow. In drawing, we show form by changing value (tone) from light to dark to indicate the light and shadow in nature. As light flows across the surface of a three-dimensional form, it illuminates projections and areas facing it. Recessed areas and areas hidden from the light fall into shadow. This change in value reveals form to our eyes.

First, we usually draw the contours of forms to make shapes. We then use shading (value changes) to suggest three-dimensional forms.

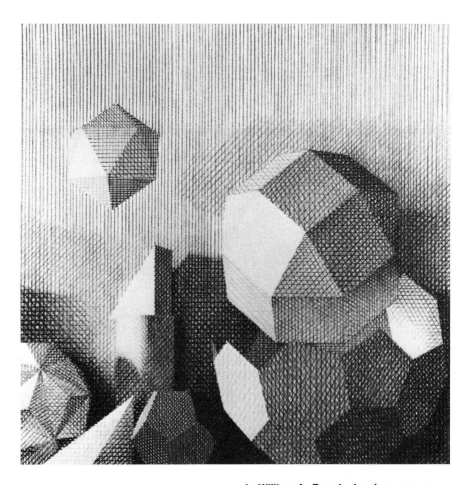

In William A. Berry's drawing, you can see many geometric shapes. But he has shaded them with a variety of values to create an unmistakable feeling of three-dimensionality. Can you sense the source of light? *Still Life for Pacioli I,* **1982. Colored pencil, 32 × 32″ (56 × 56 cm).**

The student who made this drawing
used dot patterns to produce gray value
areas. The gray and white areas are in
stark contrast with the flat black shapes.
Some gray value changes are gradual
and some are sharp, suggesting an ar-
bitrary design approach mixed with the
gradual changes of realism. Detail of a
larger drawing in pen and ink; this sec-
tion is about 14 × 18″ (35.5 × 46 cm).

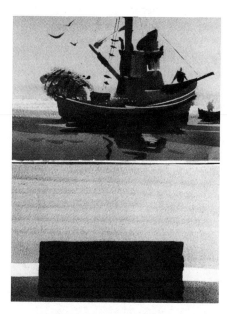

Robert E. Wood used three basic value
groups (light, medium and dark) to dem-
onstrate the wash drawing of a boat. His
three-value scheme is shown in the
lower illustration.

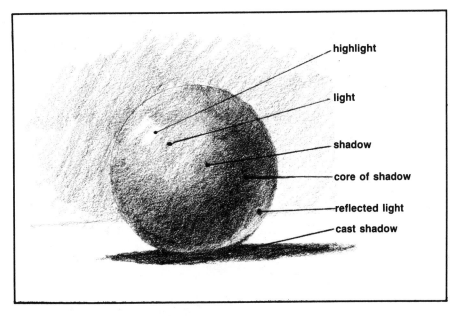

Sphere, illustrating light and shadow system (chiaroscuro).

- highlight
- light
- shadow
- core of shadow
- reflected light
- cast shadow

Value (Tone)

Value (or tone) refers to the relative lightness or darkness of objects and surfaces. Light values (high keyed) usually seem delicate while dark values (low keyed) generally show strength. A strong contrast in values often produces drama. Value, form and space are so inter-related that they are often studied together.

White is the lightest value and black is the darkest, with all the intermediate values forming grays. There are value systems designed to organize relative gray values on scales of 1 to 10. Most values are made by shading or by using gray washes. Lines, patterns and even dots can also be used to produce a feeling of gray.

As light moves over a three-dimensional object, it changes in value from light to dark. Illustrating this change in value is called *chiaroscuro* (a system of light, shadow, reflected light and cast shadows). Gradual value changes on a surface indicate rounded forms while abrupt changes infer hard edges, corners or cast shadows.

Values are not absolute, but are relative to other values nearby. What seems a middle value in one situation may be a dark or light value in other relationships.

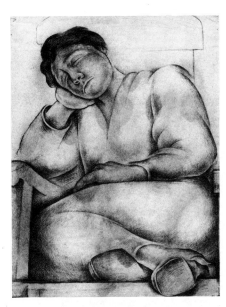

Diego Rivera used value carefully and with reserve in this drawing. The figure appears rounded and solid, even though the values remain high keyed except for a few accents. *Sleeping Woman,* **1921. Crayon, 23 × 18″ (58.5 × 46 cm). Fogg Art Museum, Harvard University, bequest of Meta and Paul J. Sachs.**

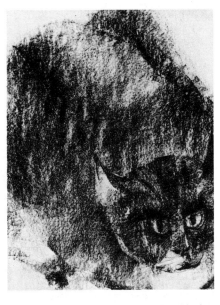

This drawing of a cat was made with the side of a black wax crayon without an outline—just feeling the form—resulting in soft edges. Value is the major element because the shape is not defined. Crayon on newsprint, 24 × 18″ (61 × 46 cm).

Texture

Texture refers to the tactile quality of a drawing—either actual or simulated. Actual textures can be felt on the rough surfaces of some papers and boards, in work that has collage in it, in drawing done on gessoed surfaces, and on rubbings made over relief surfaces. Most drawn textures, however, are an illusion produced by artists on smooth surfaces, many of them formed by patterns created by the artists. Careful observation and practice provide the successful methods for creating simulated textures.

Some artists attempt to represent accurately on paper the textures of the objects they are drawing—rocks, tree trunks, fabric, etc. Others stress the textures that develop as a result of their methods of making marks. Such

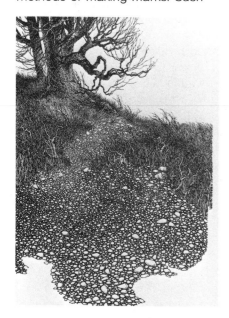

Paul Taylor's pen and ink techniques include careful attention to the quality of simulated textures. Here he uses lines to represent the mixed textures of tree trunks, various grasses, shrubs and several kinds of rocks. *Rocky Hillside,* **1985. Pen and ink, 24 × 18″ (61 × 46 cm).**

Linda Doll took advantage of the pebbled surface of mat board to provide an overall textural quality to her location drawing. *Morning Market,* **1982. Marker pen on mat board, 20 × 14″ (51 × 35.5 cm).**

stylistic elements become the characteristic handwriting of each artist. Examples include the scribble textures, linear textures, broad-stroke textures and curvilinear textures of artists like van Gogh, Daumier, Jasper Johns, Larry Rivers, Rembrandt and Dürer.

Media help determine textural quality. Charcoal is often coarse and bold; pen and ink is richly linear; pencil is subtle and adaptable; washes are painterly. Mixed media drawings are often rich in both actual and simulated textures.

Wonderful sensitivity is evident in this student's large drawing. The young artist used pencil to represent some actual textures, but also to record marks as personal handwriting. Pencil on drawing paper, 30 × 24″ (76 × 61 cm).

Activities

ART HISTORY

1. In art history books, art encyclopedias, or other reference sources, find examples of drawings by the following artists. Identify the single art element each used *mostly* in drawing. For example: Rembrandt — line.

Kathe Kollwitz	Rico Lebrun
Claude Lorrain	George Grosz
Hokusai	Paul Klee
Charles Sheeler	Henri Matisse
Georges Seurat	Ben Shahn
	Lyonel Feininger
	Vincent van Gogh
	James McNeil Whistler
	Antoine Watteau
	Albrecht Dürer

CRITICISM/ANALYSIS

2. Study Diego Rivera's *Sleeping Woman,* illustrated in this chapter, and discuss or write short answers to the following questions: What art elements did Rivera use in this drawing? What is the subject? How does he emphasize the feeling of relaxation? What is the center of interest? How does the artist emphasize it? Describe the outer edges of the figure. Are they solid lines? Describe the visual movement from foot to face. Is it direct? Does it zigzag? How would you describe Rivera's use of space? How is the drawing balanced? How has the artist emphasized form? Is this a high-keyed or low-keyed drawing? Have you seen people sleep like this before? Where?

AESTHETICS/PERSONAL SENSITIVITY

3. Study the charcoal drawing by Ralph Hulett shown in this chapter *(Wash Day, Puerta Vallarta).* What is the woman doing in the drawing? What is her daughter doing? Describe the environment. Where is the work being done? Does it look like hard work? Does the drawing seem quickly done or studied? Was the artist concerned with detail? How do you know? Why might he not have wished to use detail? How did he indicate skin color? Sunlight? Water? Do you like the sketchy quality of this drawing? Is it appropriate for the subject and action? Why or why not? Do you like the arrangement of the figures? Would you change the drawing in any way, if you could? If so, what might you do?

PRODUCTION/STUDIO EXPERIENCES

4. Make some small charts on typing paper (similar to those in Chapter 2) that show a wide range of lines, shapes, forms, values and textures. Use only one medium (pencil, marker, or ballpoint pen) to see what variety you can create with a single tool.

5. Duplicate the chiaroscuro demonstration of the sphere in this chapter, using an egg, apple, tennis ball or golf ball as the subject. Show at least light, shadow, reflected light and cast shadow. Use a pencil or ballpoint pen and make the object about 3″ (7.5 cm) high. Do *not* label the parts of the drawing.

4

RESOURCES FOR DRAWING

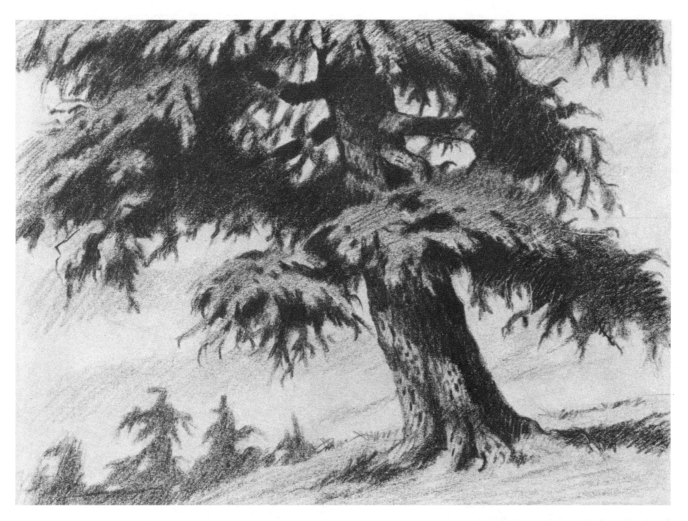

Paul Edwards used a dark, broad-pointed pencil and paper on location to explore the forms and values of this old tree. The broadly drawn masses are the result of direct observation and interpretation. *Old Tree.* **1983. Pencil, 12 × 18″ (30 × 46 cm).**

One of the questions that students ask most frequently is, "What can I draw?" And one of the most frequent answers is, "Look around you!" All the people, places and things in your world are potential subjects. There are hundreds of subjects in this book alone. This chapter is a partial, illustrated answer to the question, "What can I draw?"

Traditionally, artists have found subjects in three major areas— nature, studio and imagination. Photography is another way to bring subject matter from outside sources into the studio for study and drawing.

A felt tip marker with a broad point was used by a student to make a contour-like drawing (no middle values) of a complex subject. Using a thick line encourages simplification.

Clarice Embrey fills her small sketchbooks with pencil drawings of scenes near her home. Notice how the pencil marks are patterned strokes that give a feeling of massed foliage without imitating actual forms. Pencil, 8 × 5″ (20 × 12.5 cm).

Nature/Location

Nature is an important source for drawing. After all, it is nature that provided the subject matter for the first drawings done by prehistoric people. We react strongly to the elements of our natural environment. Mountains appear to us like huge sculptures. Trees present wonderful variations in texture and form. Large open spaces such as oceans or deserts offer scenes pleasing to our eyes.

Some drawings are finished on location. Others are either started there and finished in the studio, or are sketched on location—with the finished work done in the studio from the sketches. Sketchbooks and pencils, markers or pens are the usual materials used for drawing on location. Subjects may range from trees, streams and flowers to buildings, boats and various combinations of natural and structural subjects.

Artists often use their field sketches and drawings as sources for paintings, or for completed drawings done in the same or other media than the sketch. The encounter of artist with nature, and the artist's reaction to nature is a vital resource for drawing.

The student who made this large pencil drawing observed shape, texture, form and value carefully to make a finished drawing. Perspective, reflections and light are treated with sensitivity. Pencil, 18 × 28″ (46 × 71 cm).

Studio/Classroom

Most drawing is done in studio situations. Here models, plants, still lifes, flowers and other arrangements can be carefully lighted for maximum effects of light and shadow. For centuries, the studio has been the place where young artists learned about drawing and art. Today, the drawing classroom (in high school and college) is the studio for thousands of young artists.

Still lifes can be drawn of just one object or many objects in complex combinations. Plants, furniture, machinery, musical instruments, tools, sculpture, pottery and drapery can be set up in endless combinations. Try basing your still

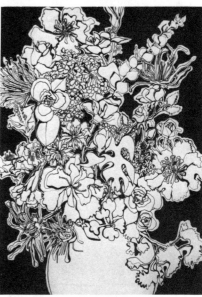

Artificial flowers were drawn in contour and surrounded with a wash of black ink to create this dramatic interpretation of a studio bouquet. Pen and ink, 23 × 18″ (58.5 × 46 cm).

lifes on themes from movies and books or on personal experiences. Or try putting a mirror behind your arrangements?

Models can be posed alone or with objects, plants or furniture. They can be dressed in everyday clothing, fancy or period costumes, or athletic gear. They can be partially clothed or in aerobic gear, and college and art school classes will often draw from a nude model.

Controlled light can be used to define three-dimensional form and emphasize the importance of chiaroscuro in drawing. All materials and techniques can be used to make studio drawings of an infinite variety of subjects.

All the drawings on these pages were done in high school drawing classrooms.

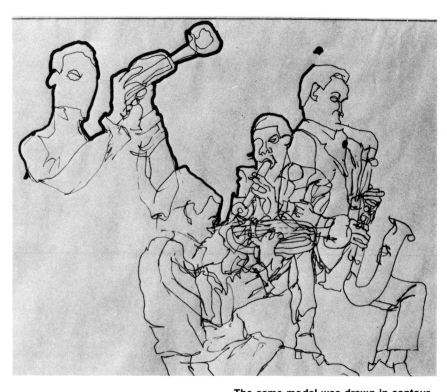

The same model was drawn in contour several times holding different musical instruments. The overlapping figures created a larger shape that was partly outlined with a heavy line. Pen and ink, 18 × 24″ (46 × 61 cm).

A tightly arranged still life (made of live plants, a log and several kitchen items) was carefully lit to provide maximum light and dark contrast. Charcoal, 18 × 24″ (46 × 61 cm).

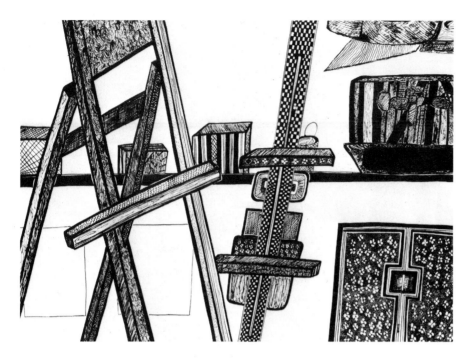

Studio furniture was first drawn and then filled in with decorative patterns. Imaginative use of studio situations can expand the normal function of studio drawing classes. Pen and ink, 18 × 24″ (46 × 61 cm).

Directionally controlled lighting provided an easily discernable pattern of light and shadow for this self-portrait study. Pencil, 18 × 24″ (46 × 61 cm).

After sketching the model in studio, and indicating the pattern of light across the torso, the student completed the shading by cross-hatching. Several hatching patterns were used to show different gray values. Pen and ink, 24 × 18″ (61 × 46 cm).

The top half of this illustration is a collage of magazine photographs that the student prepared. The lower half is an unfinished drawing of the collage, a project that emphasizes awareness of proportions, values and interacting elements. Each image is 9 × 12″ (23 × 30 cm).

Photographs and Slides

Ever since photography became popular (about 1840), artists have used cameras and film to complement their sketchbooks as sources of visual information. In fact, American artist Thomas Eakins (1844–1916) was instrumental in developing photo techniques that showed human figures and animals in action. Photos helped him to realistically draw and paint muscles and limbs in action. Artists who draw athletes in action rely extensively on photographs for visual information.

Photography can also provide images that might otherwise be impossible to observe. Artists use film

to help them draw people who are no longer alive, or to study multiple views of people who cannot sit for portraits. Artists often wish to draw subjects that are impossible to sketch directly: sailboats at sea, skiers on a downhill run, a pole vaulter in mid-jump, a dog leaping for a frisbee, a bird flapping its wings, a view from the steeple of a church. Artists who travel extensively may opt to combine photos and sketches of their observations, simply to conserve time and allow

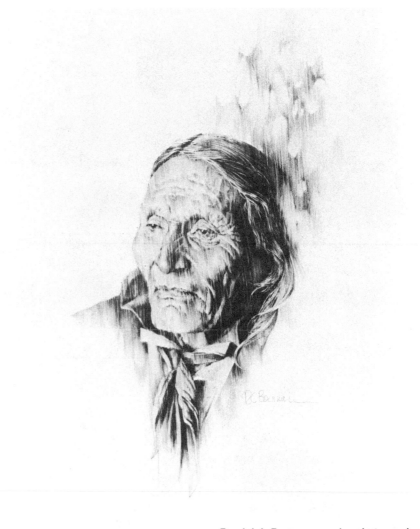

Randolph Bowman used a photograph of a Yankton Sioux Indian (no longer living) as information for this drawing. The artist's technique of using only repeated vertical lines does not imitate the photograph but interprets it in a personal way. *Thunder Horse,* 1972. Ballpoint pen on toned paper, 24 × 18″ (61 × 46 cm).

for more views than a single drawing would provide.

At times, it may be worthwhile to learn about light, shadow, values, textures, proportions and movement by working directly from photographs. Most artists, however,

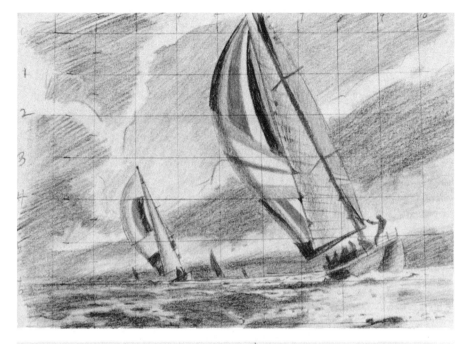

Paul Edwards needed photographic assistance to sketch this tilting and tossing boat. The sketch has been squared off for help in planning a large watercolor painting. Pencil, 12 × 18″ (30 × 46 cm).

prefer to use photographs as they would nature itself—sketching in studio from the visual resource and then working from the sketches. Use your usual drawing style and technique when working this way. Try not to imitate the photograph, but use it as a guide to expressing your own ideas about your subjects. As the French Realist painter Gustave Courbet (1819–1877) once said "The camera is my sketchbook." It is a tool to make us more observant, not a substitute for personal reactions to our environment.

This student drawing, made with a marker, was sketched from a slide projected on a classroom wall. Reaction to the slide can be drawn as if actually on location. Marker, 14 × 20″ (35.5 × 51 cm).

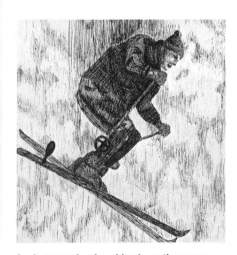

A photograph of a skier in action was the source of information for this student drawing. Cross-hatching was used to make the gray value areas, providing a personal approach that is no longer photographic. Pen and ink, 12 × 12″ (30 × 30 cm).

Imagination

Imagination is an unlimited resource for visual subject matter, but should be accompanied by practiced drawing skills to be effective. We spend much of our lives storing images, and our imaginations can recall them as needed. Our imaginations can also combine stored images, both realistic and abstract, and record them at will. We can conjure up scenes that no one has ever seen before. We can place recognizable objects in impossible situations.

All art uses imagination or creativity. We take in visual sensations, filter them through our creative system, and record them as our personal responses. Some drawings come only from our imagination and are not based on recognizable visual imagery. Such drawings can be difficult to understand. Some are simply explorations of media, also not based on things that are visible. Some drawings combine several images to shock or enthrall the viewer.

Surrealism is a type of art in which artists explore fantasy or dream-like imagery. Look up the work of Salvadore Dali, Joan Miro or Yves Tanguy. Other artists whose drawings are often based on fantasy images are Paul Klee, Marcel Duchamp, Pieter Brueghel, Jean Dubuffet and Marc Chagall. Some artists, such as Piranesi and Peter Blume, make drawings that look realistic, but are actually pure imagination.

The examples on these pages illustrate several approaches to using only imagination in drawings. You may already be planning your own approaches.

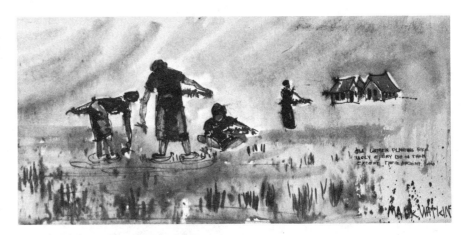

This student drawing was imagined as an illustration for a Japanese haiku: "The women planting rice / Ugly every bit of them / Except their ancient song." (Raizan). Literature and poetry can often suggest imagined subject matter. Ink wash and pen line, 12 × 24" (30 × 61 cm).

Invented organic shapes are patterned to express the pure joy of line and value in this student's mixed media drawing. Pen and ink, pencil and white conté crayon on gray paper, 18 × 24" (46 × 61 cm).

Richard Parker deals with imaginative forms and yet is convincing in his use of light and shadow. The simple invented forms are shaded with dramatic value contrasts. *Untitled*, 1983. Charcoal and chalk, 28 × 22″ (71 × 56 cm).

Enormous imagination was tapped by the student who invented the characters, locations and situations in this science-fiction comic strip. The panels shown are only a small part of the complete sequence. Pen and ink, section shown is about 9 × 12″ (23 × 30 cm).

Celeste Rehm distorts normal physical situations in some of her work. Here, walls and windows bend as if made of plastic, and normal figures are placed in unnatural situations. Humor and surrealism are combined in *Background Wrap*, 1986, a 32 × 22″ (81 × 56 cm) pen and ink drawing.

Your own feet (with or without shoes) and hands (a movement study) are easy to record in your sketchbook. Use a variety of techniques, lines, tools, shading and media to explore many ideas, as these students did.

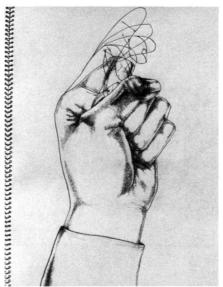

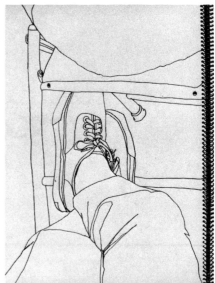

Keeping a Sketchbook

Most artists keep sketchbooks the way authors keep diaries. They record visual impressions for future use. You should consider doing the same. Record in sketch form trips, people, or daily happenings around you. Write notes to go with your sketches. You can page through this diary for ideas, to recall information, or to find detail studies or color notes.

Sketchbook pages are excellent places to "troubleshoot" or practice things that are giving you problems. If the human form is difficult for you, sketch your friends or family. Look in mirrors. Keep working until specific problems are solved. Then move on to something else.

Sketchbooks should contain your visual thinking—thoughts and rehearsals on paper—not finished work. The *act* of drawing in the book is important—not the drawings. Make dozens of thumbnail sketches, try out new techniques, doodle, work out patterns for paintings. Fill up a notebook. Then look back and study your growth in looking and seeing.

Probably the greatest sketchbooks were those of Leonardo da Vinci. He recorded his ideas, plans and inventions. You may wish to look in an encyclopedia to see how the pages looked. Pablo Picasso filled over 175 sketchbooks (that we know of) with his visual thinking, planning and doodling.

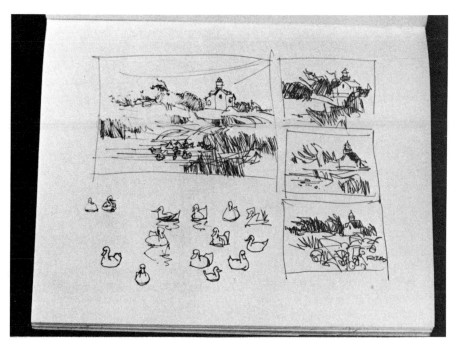

Thumbnail sketches (2 to 3″—5 to 7.5 cm—wide) can be made quickly, and are valuable in trying out ideas for drawings or paintings. This single page (8½ × 11″—21.5 × 28 cm) is used to explore four compositional arrangements and some duck studies.

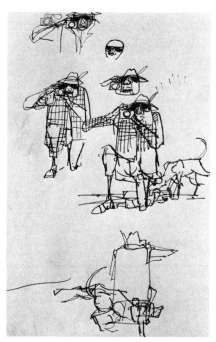

Joseph Mugnaini explored several aspects of a single idea on this sketchbook page. Such visual thinking will often lead to a finished drawing or painting.

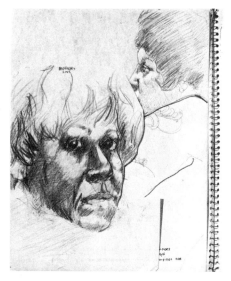

Some sketchbook subjects can be explored in detail, as these portraits of a student's mother illustrate. Pencil was used as line and shading on this 8½ × 11″ (21.5 × 28 cm) sketchbook page.

Activities

Art History

1. Leonardo da Vinci left thousands of drawings, sketches, scribbles and notes that art historians have studied. Research these in encyclopedias and books on Leonardo or the Italian Renaissance. Make a list of the subjects that Leonardo explored, such as bridges, anatomy, storms, etc. What did people of that time think about Leonardo's ideas? List your sources of information.

2. Giovanni Battista Piranesi sketched architectural subjects that look incredibly detailed and real, yet are completely imaginary. Find an example of his drawing. Write a description of it, and also describe his technique (how he used his medium). Include in your report the drawing title, size and medium used.

Criticism/Analysis

3. Study the student self-portrait earlier in the chapter and the student portrait sketch on the previous page. Both students used the same medium. Compare lighting, shading, detail, finish, purpose, value, line, form, etc. Do not judge which is better, but analyze their respective features.

4. Study the drawing *Old Tree* by Paul Edwards (first illustration in this chapter) and answer (discuss) the following questions: Is this a high- or low-keyed drawing? What medium is used? How is the concept of *form* made evident? How would you describe the edges of foliage? How has the artist made the tree seem *active?* How has he shown distance? Why are the air holes important? How is shadow indicated? Are individual leaves drawn? How is *foliage* indicated?

Aesthetics/Personal Sensitivity

5. Write a short essay (one page) developing one of these thoughts:

- Nature provides inspiring subjects for sketching
- Imagination—without it, there would be no art
- Photographs give us images for sketching that we might otherwise never see
- Drawing makes us see the world in fine detail.

Production/Studio Experiences

6. Use three objects (bottle, tennis ball and book, for example) and make your own still life setup. Draw it in outline only (no shading). Then, rearrange the objects and draw it again. Draw five different arrangements in line, each with pencil or marker on a sheet of typing paper.

7. Use a marker (one color only) to make an imaginary drawing that is nonobjective (no recognizable subjects). Use only lines, shapes, values and pattern. Do not use textures or create a feeling of form. Fill a 9 × 12″ page.

5 DRAWING AND CAREERS IN ART

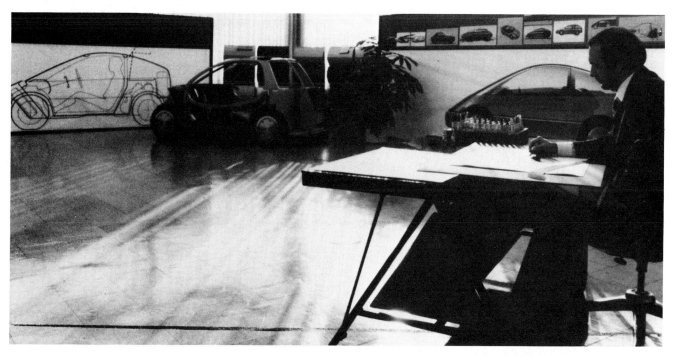

Experimental automobile designers begin with sketches and eventually build mockups of their imaginative creations. Drawings line the walls of this General Motors design studio.

Interior designers work from detailed drawings to plan their materials, accessories and space. A university student used markers in this carefully drawn presentation.

The one skill that is required in almost every art career is *drawing.* Clothing, stage sets, buildings, magazines, all manufactured things and most fine artwork begin with an idea—an idea made visible by a sketch or drawing.

Sketches are often refined into concept drawings that help designers and engineers understand the ideas. Technical drawings and blueprints help manufacturers produce the final products. Both preliminary and final technical drawings are often drawn using a computer aided design (CAD) system.

Artists and designers consider drawing an essential skill in the design and construction of new products. Without drawing there would be little manufacturing—and without manufacturing, we would live very meager lives. Drawing, then, is a vital ingredient in twentieth century life. A few pages of illustrations will help you understand how drawing is used in our contemporary world.

Environmental Planning and Development

Environmental planners work to enhance living space. From concept to sketches to development, they plan and construct buildings and the spaces around them. They design, decorate, furnish, plant and pave according to the drawings of other artists.

Advertising illustrator Roger Hagen's wash drawing (left) was used by a graphic designer in an advertisement (right).

An architectural rendering gives the architect and client an idea of the look of their planned project. Delineators use several media; this presentation was drawn in pen and ink.

Robert Petersen's industrial designs are used by clients around the nation. This concept rendering of a video camera involves both accurate line drawings and a three-dimensional value study.

Structures begin with the sketches of architects and the renderings of architectural delineators. Their work is followed by that of building contractors, engineers, interior designers, space planners, facility planners, detailers, landscape architects, furniture designers and architectural graphics specialists.

Commercial Art and Design

Commercial art overlaps career areas in television, film, education, publications and theater, and reaches into interior design and architectural areas. But three major career areas are usually considered part of commercial art: graphic design, industrial design and fashion design. Artists in these fields create designs and products that appeal to specific audiences. Commercial art is meant to be attractive and functional enough to sell products. Drawing is essential to the design and production of all commercial products.

Graphic design covers the planning and design of books, magazines, advertisements, packages, record jackets—all printed materials. Computer graphics design is essential in this area of art, especially in television advertis-

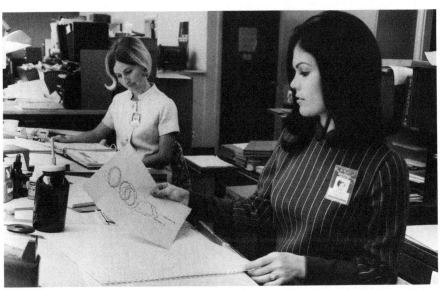

A technical illustrator is working with an exploded view drawing that will be used in a parts catalogue. Three-dimensional accuracy is essential in such drawings. Courtesy, LTV Aerospace Corporation.

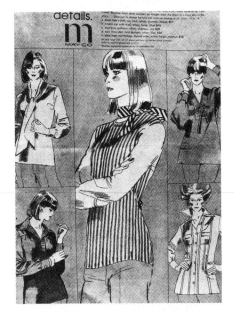

The difference between a fashion designer and fashion illustrator can be seen here. The designer actually imagines and draws the design for new products (above). The illustrator draws clothing already in production, usually for newspaper advertisements (below) or fashion magazine illustrations.

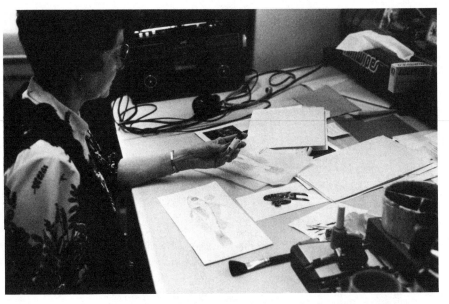

Mary Butler is a scientific illustrator, here working on a large drawing of a tiny fish (it is in the tube in her hand). Her drawings are made in pen and ink for the Los Angeles County Museum of Natural History.

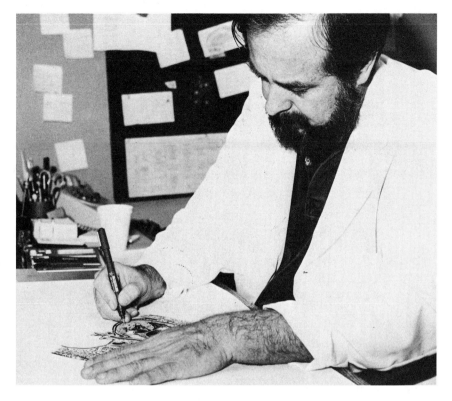

Wesley Bloom is a medical illustrator who is shown working on the detailed drawing of a heart. His large illustration, made with a technical drawing pen, will be reduced in size for publication in a book.

ing. The type that we read in books, magazines and in computer-generated designs was initially drawn by an artist. All graphic designers use their drawing skill extensively. Sketch artists can draw most anything in any medium. They are employed to do what they do best—sketch quickly.

Industrial designers shape products. From concept to sketch to final packaging, they are responsible for the quality, aesthetic appeal and function of the items consumers purchase and use. They work mostly with three-dimensional form, but their ideas start with two-dimensional sketches. Areas of industrial design include package, product, toy and furniture design, as well as communication, automobile, aircraft and rocket design.

Fashion design naturally deals with clothing—from idea sketch to final production. Fashion designers work with original ideas and plan the development from concept to product. Fashion illustrators draw and sketch existing clothing products to use in advertising and display.

Entertainment and the Media

We are a media-oriented society and depend on films, television, books, magazines and theater to entertain and educate us. Many types of career artists are needed to bring us the media products that we use and enjoy. They visualize, conceptualize, design and produce the illustrations, ideas and settings that keep us informed and entertained.

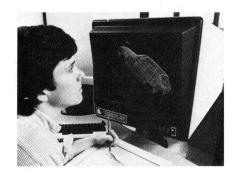

An industrial designer works on an electronic tablet, placing an automobile design on the screen. The image can now be turned, rotated and analyzed from any angle the designer desires.

Film products and television programs also start with ideas that must be visualized through drawings. Film animation makes use of countless artists who must be able to draw well. Theater and stage productions need artists to draw sets and costumes. Editorial design includes all the planning and illustration for books, magazines, comic strips and editorial cartoons. Careers in illustration include jobs as medical, botanical and technical illustrators.

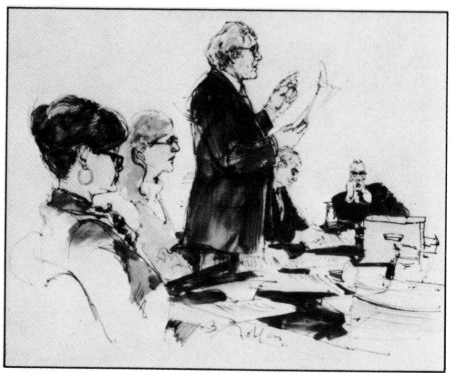

Bill Robles sketches quickly and surely. His work appears on television news broadcasts because he can draw in places (this is a courtroom scene) where television cameras are not permitted.

An animation director (above) uses a pen to sketch an idea for a caricature of a Harlem Globe Trotter for an animated feature. Another artist is sketching to develop characters for a new animated film. Both photos, Courtesy of Hanna Barbera Productions.

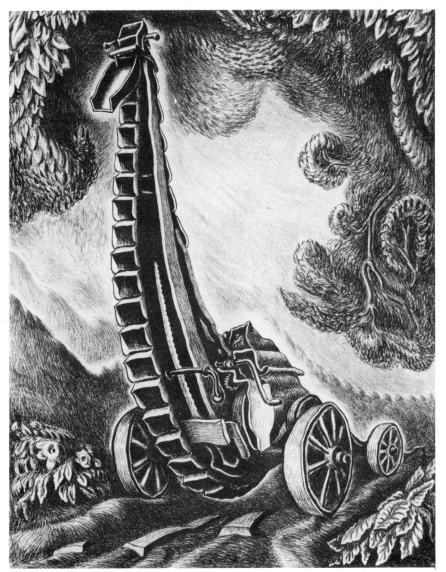

Stone Crusher, **1929. Wanda Gag.**
Lithograph, 14⅜ × 11⅜″ (36.4 × 28.7 cm).
Philadelphia Museum of Art.

Cultural Growth and Enrichment

When we talk about art and drawing, the fine arts immediately come to mind. Fine artists make drawings and paintings to enhance our lives. Their drawings are not made to sell products or to entertain, but to enrich. Although their work is not generally practical, it is extremely beneficial.

The drawings of professional artists in this text are pieces of fine art, as are the drawings of Rembrandt and Picasso and the work done by many student artists. They are made for our visual enjoyment. All artists (commercial, industrial and fine artists) begin their careers by learning to draw, just as you will be doing in this course. Drawing is the basic tool of all artists.

Many artists use their drawing skills to teach others about art, and thereby perpetuate the practice of drawing. Instructors teach drawing at all levels, from kindergarten through graduate school, and help their students to see the world with greater clarity and awareness.

Gerald F. Brommer. *Amiens Cathedral,*
1977. Pen and ink, 9 × 12″
(23 × 30 cm).

MATERIALS AND TECHNIQUES: DRAWING MEDIA

Drawing media can be divided into two convenient groups: **dry media and wet media.** Each has its own qualities that make it a favorite of various artists. The rich velvety blackness of India ink is in sharp contrast with the silver gray of a 6H pencil. The grainy texture of a dry brush sketch is quite unlike the drippy wetness of a slurpy wash drawing.

The dry media are basically graphic and the wet media are sometimes more painterly, ranging from wash drawing with water or oil to various applications of ink, ballpoint pen and markers. The dry media range from charcoal and chalk to crayon, pencil and even scratchboard.

The characteristic qualities of various media–roughness, smoothness or wetness, for example–can be used to advantage by the artist. Media can also be mixed in endless combinations. Materials can be presented and demonstrated, but what you do with them is your own decision and will be part of your personal style.

6 DRY MEDIA

Mary Cassatt used side-by-side pastel strokes to build her surface with color and texture. Her high-keyed drawing emphasizes the carefully modelled forms of a mother and child. *Sleeping Baby,* **1910. Pastel, 25½ × 25½″. Dallas Museum of Art, Munger Fund.**

The dry media (pencil, charcoal, pastels, chalk, etc.) are very convenient to use. They are self-contained, need no other materials to make them workable, and are usually easy to manipulate. Some can even be erased. When *drawing* is mentioned, pencil usually is the medium that comes to mind first.

Pencil

You have been using pencils for much of your life and probably look down on them as being very elementary. But the lowly pencil (from the Latin *penicillum,* meaning "little tail") has a rich history. It is a direct descendant of *silverpoint,* the metal stylus used by the Romans. Silverpoint makes a delicate gray line and must be drawn on specially prepared abrasive paper. Still used today, it is generally too demanding for ordinary school use.

In Italy, about 1400, a sort of pencil made of lead and tin was used for sketching on sheets of inexpensive paper. Later Baroque artists were interested in large works with strong value contrast, however, so this pale line-producing tool was in little use. When graphite replaced lead, pencils became more popular. In 1795, the French inventor Conté

developed a pencil material by baking a mixture of graphite and clay. The Germans and English discovered economical methods of production and encased the product in wood—forming basically the tool that we still use today.

Most artists of the past have used pencils to sketch ideas for paintings. Today, its unique abilities to be delicate, strong, vibrant and

Andrew Wyeth emphasized line and used subtle value changes to create a sense of form in this sensitive portrait. The carefully observed details are emphasized because they are set against negative white space. *Becky King,* 1946. Pencil, 30 × 36″ (76 × 91.5 cm). Dallas Museum of Fine Arts.

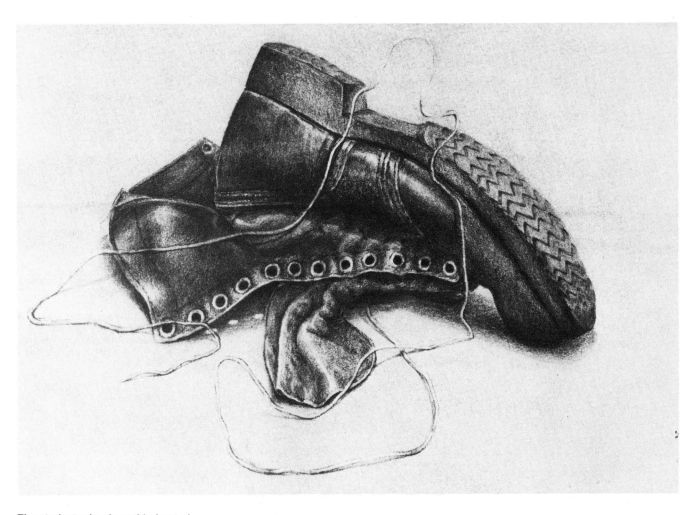

The student who drew this boot ob-
served textures, values and form care-
fully, using an effective value range from
white to black. Pencil, 14 × 18″
(35.5 × 46 cm).

Careful observation and directional pencil marks are combined in this student still life. Such line treatment provides a feeling of texture when compared with the Wyeth drawing on p. 71. Pencil, 21 × 16″ (53 × 40.5 cm).

sensitive have made it a versatile and vital drawing tool.

The pencil is the most immediate of contemporary drawing materials. It is used to record lines, tones, feelings, moods and ideas. It can show immediately the delicate face of a child ballerina, the tension of a street demonstration, the tenderness of a hand-in-hand couple, the crash of two football players.

Pencils come in an almost infinite variety: graphite, charcoal, carbon, conté, lithographic and a variety of colored pencils. The most useful, graphite, comes in different shapes (round, flat, hexagonal) and hardnesses (from 6B, the softest, to 9H, the hardest). Though called a lead pencil, it is composed of graphite mixed with clay; the more clay, the harder the pencil and the lighter the line.

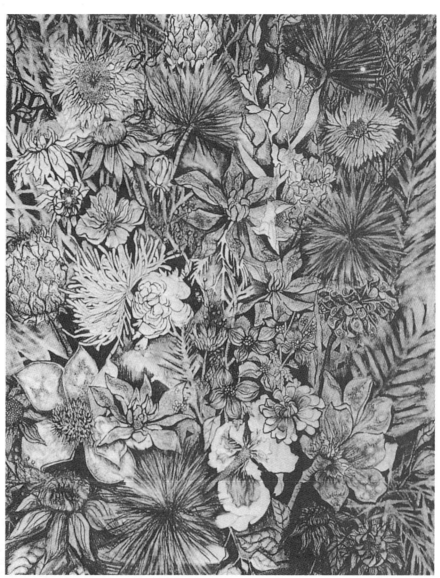

Each flower in this work was held separately in one hand and drawn with the other. The entire surface was then reworked by the student artist to establish unity. Pencil, 22 × 17″ (56 × 43 cm).

Almost every type of paper can be used with pencils, but smooth papers that border on being slick should be avoided. A slight tooth (grain) is preferred. Bond paper, drawing papers of various weights, oatmeal paper and newsprint work well. The same contour drawing of a still life can be drawn on successive days with the same pencil; but if different papers are used, the result will be different, and the drag of the pencil on the surfaces will offer different sensations. Try several combinations.

Paper size need not be a limiting factor. Some pencil techniques call for small sheets while others require very large sizes. Delicate drawings can be done several inches wide and powerful works can be drawn on 4 × 8′ sheets.

Pencils can be held between the thumb and first two fingers, or across the palm of the hand. They can be held close to the point or manipulated from the opposite end. Changing positions in the hand provides completely different drawing sensations and vitalizes the act of drawing.

The more pressure that is exerted, the darker the line will be, up to a maximum darkness for each hardness of lead. When darker lines or masses are needed, softer pencils must be used. Drawing pencils also vary in thickness of the leads. Usually, the harder the lead, the thinner the diameter; very soft pencils have very thick leads. The softer lead cores break more easily than the harder ones, so special care should be taken with

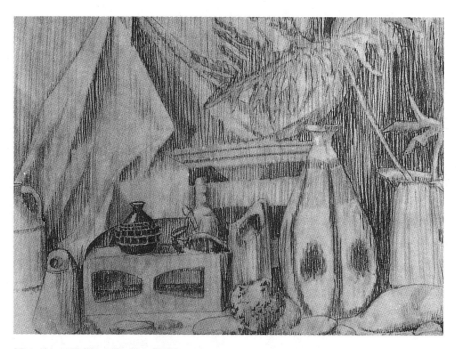

After this still life was sketched in outline to check on proportions, the student artist shaded it with *only* vertical lines. Pencils with several degrees of hardness were used to ensure value contrasts. Pencil, 18 × 24″ (46 × 61 cm).

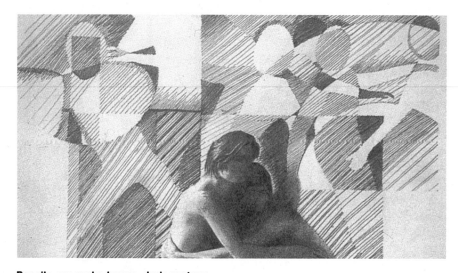

Pencils can make heavy, dark contour lines (left) and also delicately shaded values (right). This project emphasizes the medium's versatility. Pencil, 18 × 24″ (46 × 61 cm).

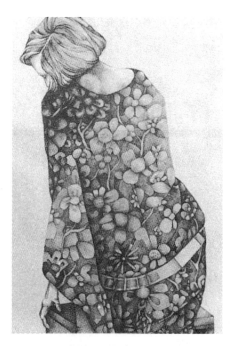

Tom Sylwester emphasized pattern in
this drawing, setting the sensitively
shaded figure against a white back-
ground. *Girl,* 1978. Pencil, 24 × 16″
(61 × 40.5 cm).

After a friend took his photograph, this
student drew a self-portrait. He observed
values carefully, used his eraser ef-
fectively, and toned the background to
emphasize light hitting the front of his
body. Pencil, 13 × 18″ (33 × 46 cm).

Pencils are effective sketching tools.
The student who sketched her friend
decided to leave the drawing in this
"loose" form, rather than finish it as the
self-portrait next to it. Pencil, 23 × 18″
(58.5 × 46 cm).

them. To sharpen, rotate the pencil
and slowly shave off the wood with
a single-edged razor blade or knife.
Sometimes you will want a sharp
point—at other times a blunt end
will be better. Graphite also comes
in sticks and in flat chunks for mak-
ing "broadside" marks.

The fact that pencil lines can be
erased is appealing. In reality,
erasability is also one of the pencil's
few drawbacks since the marks are
easily smudged. The pencil is

useful for making quick sketches,
for producing finished drawings or
for starting a composition that will
be finished in another medium.

If you wish to study the pencil
drawings of some great artists, find
examples by Ingres, Edgar Degas,
Henri Matisse, Theodore Gericault
and contemporary artists Andrew
Wyeth, Larry Rivers, Paul Hogarth,
David Hockney, Ferdinand Petri
and Paul Calle.

Charcoal

Charcoal is probably the oldest drawing material. Cave dwellers undoubtedly drew on their walls with chunks of burnt wood. The Greeks and Romans also used charcoal. But until fixatives were invented (about 1500), such drawings could not be kept. Charcoal now comes in several forms: stick charcoal (dry carbon—the result of burning all organic material from twigs or sticks), compressed charcoal (charcoal ground into powder and formed under pressure into sticks), and charcoal pencils (compressed charcoal sheathed in wood). The compressed sticks range from 00 (softest and blackest) through 0 to 5, the lightest and hardest. The pencils run from 6B (softest) through 2B to HB (hardest and lightest). The pencil is naturally the cleanest way to use charcoal, but only the point can be used effectively. With other types, the sides as well may be used, allowing more methods of working and, therefore, greater flexibility.

It is this flexibility that is appealing. If you are timid about drawing on a large scale, use charcoal and large sheets of paper (both in liberal doses). Because charcoal is easily erased with kneaded rubber erasers and easily smoothed with a cloth or chamois, you can work rather freely with it. This erasability is also a drawback, however, since the material smudges easily. But this also can work to your advantage and encourage you to experiment. With a little purposeful smudging, you can create beautiful soft edges and tones. Hard lines can be drawn with a sharpened point.

Richard Parker is a master at using charcoal to produce large areas of even tone without texture. His invented forms are dramatically shaded and make use of a full range of values. *Untitled,* **1983. Charcoal and chalk, 22 × 28″ (56 × 71 cm).**

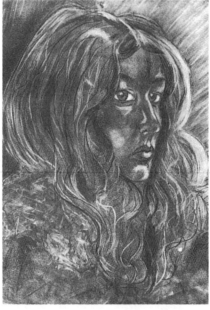

Working on gray paper, a student artist smudged and rubbed the applied charcoal to get smooth areas. She used a kneaded rubber eraser to lift some areas, providing dramatic highlights. An overall softness lends unity to the surface. Charcoal on gray paper, 24 × 18″ (61 × 46 cm).

When the drawing or sketch is finished, it must be *fixed* to be preserved, or else the work will smudge. Several companies produce the required fixatives. Some artists spray their work at several stages, while others wait until finished before fixing the drawing.

Papers are again a matter of personal choice, and several should be tried. Newsprint is good for quick sketches; drawing papers, bond paper and charcoal paper are all excellent. Charcoal paper will take the most punishment by way of erasing, but each paper has a quality that makes it attractive. Papers that are smoother than bond paper will not have enough tooth to grab the powder from the

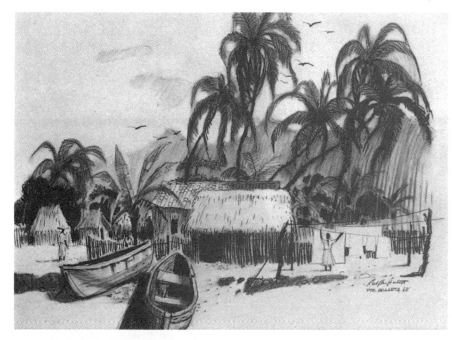

In Ralph Hulett's location sketch, the artist used charcoal in a completely different way than Richard Parker did. Lines and textures are evident as the feeling of the actual location is captured. *Puerto Vallarta Beach,* 1968. Charcoal, 18 × 24″ (46 × 61 cm).

stick. Papers that are too rough may grab too much.

Rubbing the charcoal after it is applied will produce various effects. A small square of chamois will make a very soft tone; a finger, hand or arm will give another effect; a kneaded rubber eraser will clean out a small area; and paper stumps or tortillons (pencil-shaped rolls of soft paper) can be used to rub small areas to produce even, gray tones. Powdered charcoal can be used with fingers, bits of cloth or paper stumps to draw and shade.

Before beginning any drawing, experiment a bit. Hold a variety of charcoal materials in different ways. Fill scratch paper with broad strokes, using the sides of sticks. Use a round-shaped piece, a soft or hard pencil. Sketch lightly, press firmly, scribble, cross-hatch, try tiny detailing. Then, use the tools and techniques that work best for you.

Artists who have used charcoal effectively include Jean Francois Millet, Odilon Redon, Edgar Degas, Henri Matisse, Vincent van Gogh and Joseph Stella.

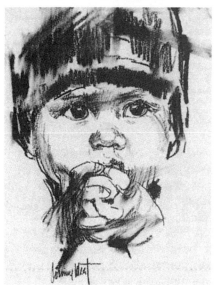

Corinne West combines sensitive observation and thousands of drawings to catch the look and feel of children. Charcoal is purposely smudged to soften some lines and provide tone. *Apache Child,* 1972. Charcoal, 7 × 5″ (18 × 12.5 cm).

A detailed blowup of a portion of a face provides a student an excellent chance to use shading and strong values. Charcoal, 24 × 18″ (61 × 46 cm).

The student who drew this portrait of her classmate applied many layers of pastel, until the surface had a painterly quality. Pastel, 24 × 18″ (61 × 46 cm).

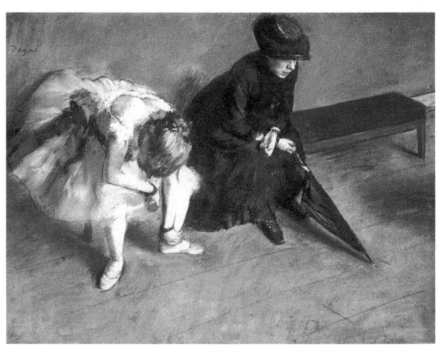

Edgar Degas used strong value contrasts (black and white) against a neutrally colored background. Note the variety of his edges: soft, crisp, smudged, fuzzy, and outlined. *Waiting,* **1882. Pastel, 19 × 24″ (48 × 61 cm). Norton Simon Museum of Art, Pasadena.**

Pastel

Pastels are often treated as both drawing and painting media, depending on the purpose and techniques of the artist. If the textures of paper and pastel sticks remain visible, this medium fits appropriately into the graphic realm of drawing.

Pastel is ground pigment mixed with gum and formed into sticks. Unfortunately, the word *pastel* is often used to describe pale tints of colors. But pastel sticks are available in brilliant, saturated colors. Traditional pastels have been used since the sixteenth century, but first became popular in the mid-1600s. Interest lessened gradually until the French Impressionists and others revived its popularity in the late 1800s. James McNeil Whistler, Edgar Degas, Mary Cassatt and Henri de Toulouse-Lautrec used it extensively as a drawing medium. Today pastel is used mainly by portrait and studio artists. It is also used widely by mixed media specialists. Pastels are available in stick and pencil form, the latter helpful for making fine lines and details.

A recent innovation is oil pastel or "hard pastel," in which pigments are ground into oil instead of gum. This more durable medium can be used alone, or combined with water- and oil-based media to heighten color, texture and value contrasts. Pastel work must always

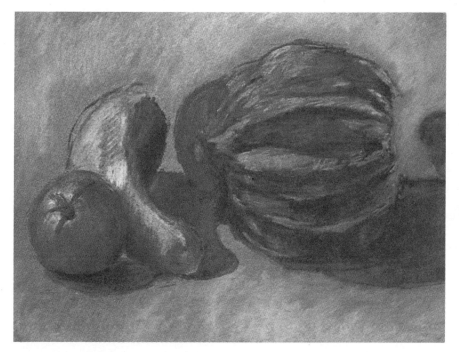

Vigorously applied strokes are an important aspect of this student drawing. Directly colored vegetable forms are dramatically grouped and shaded in a powerful composition. Pastel, 10 × 14″ (25 × 35.5 cm).

The student who drew this sensitive portrait worked light and dark pastels on a dark surface. The heavily textured paper contributes to the feel of the finished drawing. Pastel, 24 × 18″ (61 × 46 cm).

be sprayed with a fixative to assure permanence and to hinder smudging. More color can be drawn over sprayed areas, if desired.

Each of the many surfaces for pastel drawing provides a different "feel." Pastel papers are favorites, but heavy drawing paper, charcoal papers, velvet-surfaced papers and even sheets of fine sandpaper are useful. The ground (support) must have tooth to take the color. Use a sheet of paper over the finished

work to prevent unwanted smudging.

To become familiar with pastel's possibilities, experiment with various colors on various papers. Apply color alone and over or next to another hue. Rub one color into the next. Apply color softly and with vigor, and note the effects.

A few basic pastel techniques include:

- *the direct approach*—sketch first to outline; cover the whole sheet quickly with local, basic color; use fixative; finally, add details.
- *the smudging approach*—sketch; apply color lightly in *about* the right areas; smudge with fingers to soften; add other colors and smudge; when close to correct proportions, add details.
- *the traditional approach*—work on toned (colored) paper; sketch; add colors in light and dark

values, using the paper as the middle value.

- *the pointillist approach* — sketch; use dots, dashes or lines of color, applied next to each other; gradually build the textured surface colors.

Application techniques include diagonal hatching (side-by-side lines), smudged hatching (use fingers); using the blunt end or side of pastels (broad strokes); smudging with kneaded eraser or tortillon; rubbing areas with newspaper; adding detail with pencil or charcoal. Study the examples for possible techniques and experiment on your own.

Pastels are applied to gray charcoal paper in this still life. Some pastel drawings can be very smooth, but this student allowed the lines and marks to remain visible. Pastel, 24 × 18″ (61 × 46 cm).

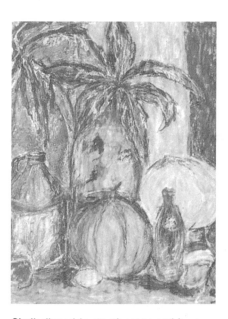

Anthony van Dyck used black and white chalk on gray paper to draw this study for the painting *Procession of Knights of the Garter.* His major emphasis was on the elaborate costumes rather than on the faces. *Two Heralds,* about 1630. Black and white chalk, 20 × 11″ (51 × 28 cm). Albertina Museum, Vienna.

This drawing by Albrecht Dürer is one of the most recognized in the world. He used the hands of his best friend as a model, drawing with black and white chalk on blue paper. *Praying Hands,* 1508. Chalk, 12 × 18″ (30 × 20 cm). Albertina Museum, Vienna.

Chalk dipped in starch was used by a student to draw a classroom still life setup. This technique provides an almost painterly surface. Chalk and starch, 24 × 18″ (61 × 46 cm).

Chalk

Chalk, like charcoal, is an ancient drawing material, first used in cave drawings. Chunks of chalky earth materials were used just as they were taken from the ground. Natural carbons made black; iron oxides produced reds; umbers, browns; ochers, yellows; chalk, whites. During the Renaissance, sticks were formed of these materials and artists made large drawings of red and black with highlights added in white chalk. Often these works were drawn on tinted papers that added another color and value to the work.

Like charcoal, chalks vary in hardness and permanence, as well as their oil content and color intensity. Hard chalks are usually worked in a linear fashion, like charcoal. Chalk drawings are most effective when the colors are limited. Try using black and white chalk on colored construction paper to find ways to emphasize form. Or limit the drawing to one or two colors with black chalk mixed in for shadow, tone and dark values.

Chalk drawings must be sprayed with a fixative to prevent smudging. Chalk may be dipped in starch (which makes it a wet medium) and applied to paper, thus eliminating the need for a fixative. Chalk sticks may also be dipped in water or applied to a dampened paper surface, but drawings made in this way must be fixed when completed.

All the papers that work with charcoal are acceptable for chalk drawing. The harder the chalk, the more tooth the paper must have. Regular charcoal or pastel papers (which come in many colors and grays) are best if much reworking is anticipated. The tooth of these papers will cause more color to be left on the paper. Bond papers and various drawing papers are also quite suitable. Construction papers (in many colors) and bogus paper (in large sizes) provide interesting color and textural surfaces on which to draw.

Conté and Lithographic Crayons

Conté is a finely textured, oily material that has a more adhesive quality than chalk, charcoal or pastel. It is made expressly for drawing and comes in stick form, about one-quarter of an inch square and three inches long, and also in pencil form. Three degrees of hardness (and therefore three degrees of intensity) are available: no. 1, hard; no. 2, medium; and no. 3, soft. Conté also comes in four colors: white, black, sepia and sanguine, an earthy reddish color that is the most popular. Though the techniques of working with conté crayons are similar to those for charcoal, the added colors and smoother texture are often a welcome relief from the powdery charcoal.

If a more greasy material is required, lithographic crayons (made for working on lithographic stones for printmaking) or oil crayons may be used. Lithographic crayons are black and are also made in several degrees of hardness and intensity. Each material has qualities that are uniquely appealing. Only by working with each of them can you determine your preferences.

Try several kinds of paper. Bond paper and heavy drawing paper are excellent. Charcoal papers in several textures and colors are attractive with the conté colors. Lithographic crayons will make marks on any surface, even smooth papers, matboard, metal, plastic or glass, so any papers will work with them. Shading techniques will vary, depending on the surfaces, so you will need to fill several pages with experimental marks before you begin a drawing project.

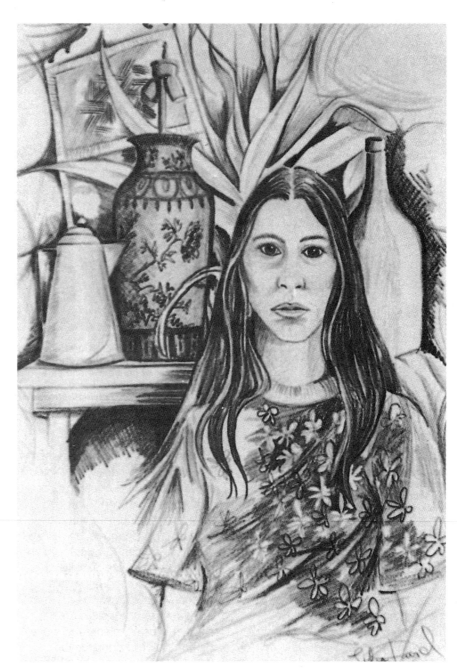

A student artist drew her self-portrait as seen in front of a classroom still life. Drawing paper was the ground for the conté crayon work, and several shading techniques can be seen. Conté crayon, 24 × 18″ (61 × 46 cm).

**Mel Bochner constructed this large work
by drawing ruled lines over each other
many times. A feeling of depth is estab-
lished, as overlapping lines keep push-
ing the earlier and lighter valued lines
farther back in space.** *Untitled,* **1982.
Conté crayon and charcoal, 29 × 70″
(73.5 × 178 cm). Sonnabend Gallery,
New York.**

Careful observation and a sensitive awareness of color and value are evident in this student drawing. Subtle blendings produce a convincing sense of form, even in such a high-keyed relationship. Prismacolor, 15 × 15″ (38 × 38 cm).

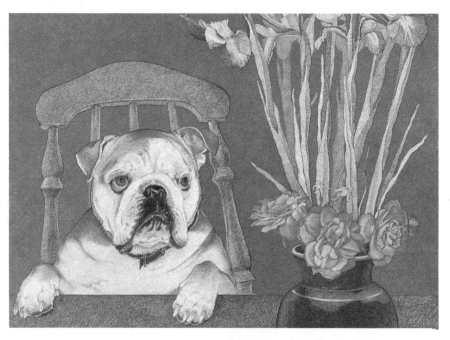

Bet Borgeson takes advantage of the semitransparent nature of colored pencils to create complex new hues by layering colors one over another. To achieve whites, the paper is left uncolored (as in the whites of the bulldog). *Good Girl*, 1984. Prismacolor, 17½ × 24½″ (44.5 × 62 cm).

Colored Pencils

Colored pencils are a recent addition to the list of drawing media. Since the mid-1970s, many changes have taken place to make them more appealing. There is now a tremendous range of colors, and new compounds have been introduced that can be dissolved in either turpentine or water. Each type of pencil is used differently and you may have to try several before you find one brand that works best for you.

Although they look and feel like graphite pencils, colored pencils are completely different tools, and must be used differently. You must learn to think in color (hue, value and intensity). You can blend these soft colors together to produce smooth surfaces, almost like painting. You can lay one color over another to produce complex blend-

ings and combinations. Experiment. Put color down smoothly and draw another "layer" lightly over part of it. Try drawing textures. Try hatching with several colors. Fill a page with sample experiments and see how many different effects you can get.

You can draw on a variety of papers—try many scraps. But you can also work on "nonpencil" surfaces, such as frosted Mylar (use it in layers, on both sides of double-frosted surfaces, over papers and colors); gessoed surfaces (textured with white acrylic gesso brush-marks); plywood (gessoed or sanded smooth); fine sandpaper (small sheets in several colors); printer's aluminum plates (with or without inked images); cotton or linen canvas (prepared or gessoed). The variety is endless and the results are visually exciting.

Some pencils are made with compounds that dissolve when wet

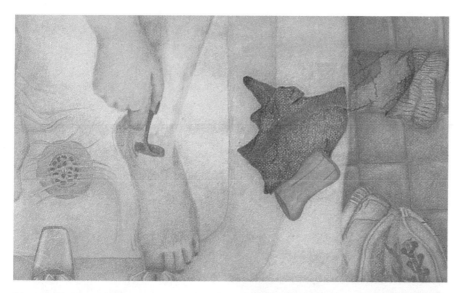

The student who turned this mundane subject into art observed colors and values closely. She combined several media to obtain the subtle variations. Prismacolor and watercolor, 15 × 26″ (38 × 66 cm).

Walter A. Berry used colored pencils and a straightedge to tease our eyes into seeing curved lines and shadows. His straight lines create cross-hatching that in turn creates color blendings and value contrasts. Look carefully in the rectangles that seem transparent—and notice how the artist permits us to study his unique technique. *Still Life: Code 017,* 1985. 30″ (76 cm) square.

By using overlays of colors, values can be changed to indicate shadows and light on a surface, as on the flowers and leaves of a plant. This student drawing is with Prismacolor, 14½ × 12″ (37 × 30 cm).

Richard Wiegmann develops fantastic textures by using Prismacolor and graphite sticks, both in liquid and dry ways, on a Mylar surface. This is one of a series of drawings dealing with underwater subjects, a theme that transparent Mylar enhances. *Tidepool Dawn,* 1985. Graphite and Prismacolor on Mylar, 26½ × 18″ (67.5 × 46 cm).

with appropriate solvents. Prismacolor, Derwent and Spectracolor dissolve in turpentine; Mongol, Caran d'Ache and Conté mix with water. Sketch first, block in colors quickly, brush on solvents and work the surface, and redraw with pencils. Experiment. You can also blend some colors with the colorless blender (unpigmented marker) made to blend the colors of art markers.

Because some pencils have an oil base and others dissolve in water, you can also experiment with some resist techniques that involve mixing several types. The result is that you can develop more ways to draw differently with colored pencils than you have ever drawn with graphite.

The rough texture of pebbled mat board is the ground for a colorful and decorative crayon drawing (card design by the author). Watercolor washes, some ink lines and a little scratching increase the textural quality and help delineate certain shapes.

Wax Crayons

Because of their familiarity and use in early school years, wax crayons are often neglected as an art medium. But this versatile material can be a valuable addition to your drawing experiences. Paraffin is used as the binder in wax crayons. Crayons come in a wide range of colors and sizes, from pencil size to sticks one-half inch in diameter. They come with paper wrappers (which should be removed) and without. They can be used in bold and vivid techniques or in subtle and delicate ways. Color can be applied with the tip of the crayon or with vigorous broad strokes, using

A student, working from a classroom model, used cubist techniques to fracture the surface of the drawing. The ends and sides of black crayon were used in the 24 × 18″ (61 × 46 cm) drawing.

Rubbing and contour drawing are combined in this student work. After drawing with pencil, the lines were drawn over with white crayon. Black crayon lines echoed the white lines and some spaces were filled in. Crayon on colored paper, 18 × 12″ (46 × 30 cm).

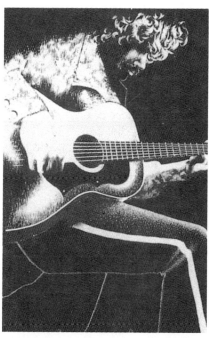

Dramatic value contrasts and textures are produced by scratching white areas and lines into a black surface. This guitar player was done on an 11½ × 9″ (29 × 23 cm) board by a student.

the side of the stick. One color can be worked into another. Colors can be blended and polished by rubbing with a paper towel, soft cloth or small paper squares.

Color can be applied in heavy doses and then scratched through to the paper in a sgraffito effect. You can apply a heavy coating of color in patterns, and then cover the sheet with a solid application of poster paint or India ink. (The ink will adhere better if a light dusting of talcum powder is made on the crayon surface.) Lines can then be scratched through the black (or colored) surface to reveal the gleaming color beneath. This *crayon etching* method is similar to the

scratchboard technique discussed next.

Draw on paper with heavy lines and then cover the sheet with a *wash* of black or dark value watercolor. This is a wax-resist technique, discussed more fully in Chapter 8.

Wax crayons can be used to make rubbings, if you are searching for textures. Their marks can be ironed, melted, rubbed, scratched, covered and mixed with other media in many techniques. Make color and texture swatches, using wax crayon in different ways or combined with different materials. You may come up with twenty or more techniques—such is the versatility of the lowly wax crayon.

Scratchboard Techniques

Scratchboard is basically an engraving process, relying on an incised line to produce the image. The scratching will reveal a white line on a dark ground—the reverse of most drawing processes. Prepared scratchboards, in smooth or textured surfaces, may be purchased but are rather expensive. Suitable boards can be made in the art room by coating a piece of illustration board (or other heavy board) with several layers of acrylic gesso, perhaps fine-sanding each coat a bit to keep the surface smooth. When dry, apply one or two coats of India ink with a large soft brush. When dry, the board is ready to use.

Any sharp tool—needle, stick, paper clip, knife, etc.—can be used for making lines. A few will require some kind of holder. Experiment with varying amounts of pressure and kinds of tools on a scratchboard to determine best techniques and results.

If you intend to have large white areas in your drawing, leave these areas white when coating the board with ink. Original drawings may be transferred to the board either before or after inking. These lines may be placed on the inked surface with a soft pencil, but will be difficult to see. The drawing to be cut should be planned ahead and sketched rather completely. As you gain confidence, your scratching can be more spontaneous and direct. All pen and ink techniques (stippling, cross-hatching, hatching, line, textures) may be used on the scratchboard.

Activities

ART HISTORY

1. Art history is not only concerned with the history of artists or artworks but also the history of media. Study encyclopedias or drawing books to find material on the origin and development of one of the following dry media: pencil, charcoal, chalk or pastel. Write a one-page report, and include the names of several important artists who have used the medium.

CRITICISM/ANALYSIS

2. What dry medium would you choose to create the following situations, and why? Answer the question for ten items. 1) hard-edged line; 2) smooth black shape; 3) blurred and smudged edges; 4) soft and subtle colors; 5) blended color edges; 6) textured gray areas; 7) delicate gray calligraphy; 8) lines on a very smooth surface; 9) dry-looking yellowish grass; 10) strong white and black value contrasts; 11) white lines on a black background; 12) very loosely sketched figures; 13) tightly drawn buildings in perspective; 14) a still life with directional line shading.

AESTHETICS/PERSONAL SENSITIVITY

3. If you wanted to establish a somber mood in a landscape drawing, which media would you choose? Why? What techniques might you consider? What kind of surface would you establish? What kinds of marks would you make? What values would you use? Discuss or write your thoughts.

4. Use the same questions as in Activity 3, and develop your thoughts about *one* of the following moods or feelings: wonderful joy, delicateness, power, a warm evening, vacation time, rainy day. You may also select your own mood or feeling and establish ways of visualizing it in a drawing medium.

PRODUCTION/STUDIO EXPERIENCES

5. Look carefully at the visual examples in this chapter and study the techniques used for making marks. Then make a chart showing five ways to make lines appear like middle value grays with each of these media: pencil, charcoal, black wax crayons.

6. Make a similar chart showing five ways of blending colors with each of these media: pastel, colored pencils, wax crayons.

7. Make a chart showing as many variations of mark making as you can with a single medium. Use *one* of the following: pencil, conté crayon, charcoal pencil, chalk.

WET MEDIA

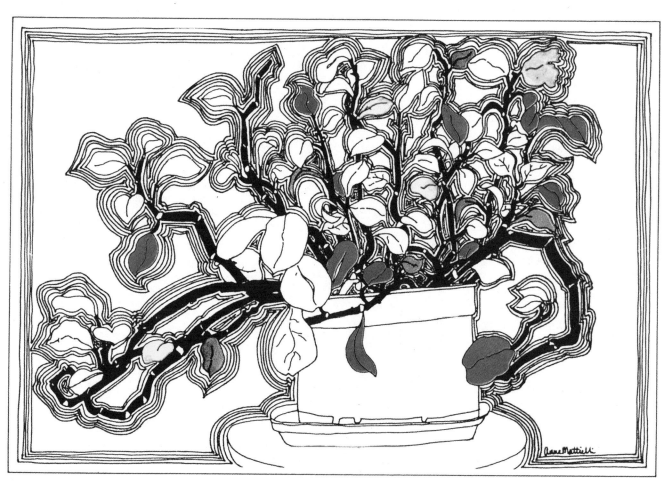

A simple contour drawing with a marker
was surrounded by five more lines. The
student added a few color spots and a
strong, heavy line to complete the draw-
ing, 12 × 18″ (30 × 46 cm).

Most artists try many kinds of media before choosing those that work best for them. Students also need to experience various media to know what possibilities are available. Often changing media requires a change in style, and, therefore, growth in understanding about personal expression. Except for ballpoint pens and markers, the wet media require different approaches to drawing.

Wet media can be divided into three categories: ink, washes and self-contained tools. All of these are permanent and erasing is nearly impossible. Decisions should be made prior to putting the pen or brush to paper. The pencil can search and explore, and a wayward line can be erased. Wet media are more direct and demanding than dry media.

Ink

Inks come in liquid, paste (for printing) and solid (sumi) forms, but only the liquid type need be considered. Early inks were made from oak galls, treated with iron salts and air cured, producing a dark liquid. The reddish brown bistre, popular in Renaissance times, was made by collecting the soot of burned woods and making a solution. Sepia inks were made from cuttlefish excretions. India inks, made with lamp-black (soot), were introduced in the nineteenth century.

Nance Ohanian uses pen and ink to draw editorial illustrations for the *Los Angeles Times.* This medium is popular with illustrators because it reproduces so well. Notice how line is used to create value. *Sadat and Begin,* 1978. Pen and ink, 18 × 24″ (46 × 61 cm).

Many colored inks were used with Speedball C-6 nibs to draw the feathers of this brightly colored bird. Toothbrush spatter with India ink was used in places to give the illusion of shadow and form. Pen and ink, 30 × 24″ (76 × 61 cm).

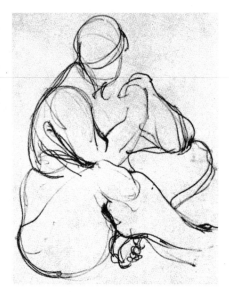

Ink lines can be mechanical at times, but this young artist used a beautifully free-flowing and organic line in this figure study, Pen and ink, 20 × 24″ (51 × 61 cm).

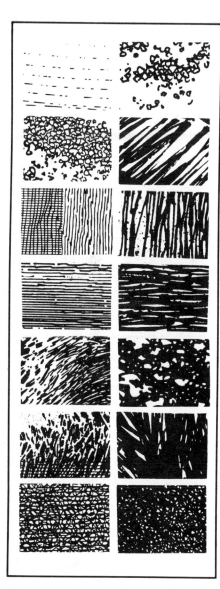

These pen and ink marks were clipped from some of Paul Taylor's drawings. Notice how they are used to create texture and gray values. Such marks become part of an artist's visual vocabulary.

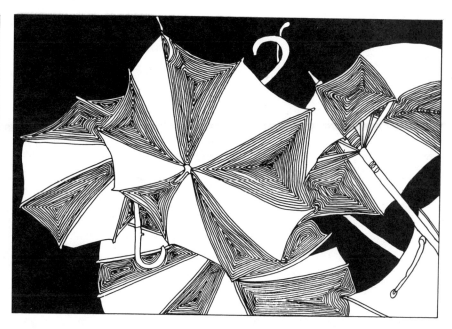

Line creates the gray value in this dramatic student arrangement of lights and darks. A simple concept becomes a strong drawing. Pen, brushes and ink, 12 × 18″ (30 × 46 cm).

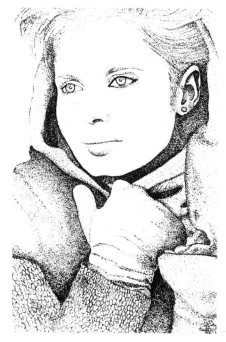

After drawing lightly with pencil, a student artist used dots, applied with pen and ink, to establish values and lines. Pen and ink, 24 × 18″ (61 × 46 cm).

Two basic types of ink are available: **waterproof,** which is nearly indestructible, and **soluble,** which can be washed away if desired. Both can be diluted with water if necessary. There is a variety of black inks, and many colored inks are also available. Special inks for working on special surfaces (acetate or film) or with special colors (gold, silver, white) are also on the market.

Included in the area of ink drawing are traditional pen and ink work with a variety of points, reed pens, quills and brushes. Unconventional drawing tools include sticks, twigs, cardboard and other kinds of equipment.

PEN AND INK. Drawing with pen and ink resembles working with ballpoint pens, which are familiar, so it is an easy introduction to wet media. One of the most important things to remember is that your drawing needs to be planned, because ink lines are not erasable. Generally it is best to sketch a light framework in pencil before beginning to apply ink. Inking can begin anyplace on the surface, as long as you are careful not to smear or smudge lines that have not dried completely. Develop a vocabulary of lines and shading techniques to contrast with solid areas to keep your drawings full of interest.

Steel points (nibs) became popular in the eighteenth century, nearly replacing the reed and quill pens that had been used since before the Christian era. Today, art catalogs display an overwhelming variety of points, but not all of them need to be used. The Speedball selection comes in four basic shapes: A, square; B, round; C, flat or chisel shapes; and D, oval. Each style has six or seven sizes, varying from fine to heavy. Although designed as lettering pens, they are extremely useful for drawing. The C-6 is the finest point and the B-0 makes the boldest lines. Experiment to find which suits your current needs.

Keep a variety of points available. Traditional pen and ink work is done with fine steel points that must be dipped often to keep a ready ink supply. Such points vary in rigidity, flexibility and size. Usually the rigid ones will be more

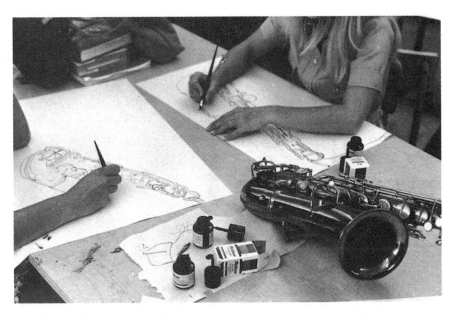

Students are using broad-tipped Speedball points to make ink contour drawings of a saxophone. Care must be taken to allow lines to dry without smudging.

useful and will last longer than delicate and flexible points. Get some samples and try them.

Very fine steel points, patterned in a hollow manner after the long-used quill points, are delicate and sensitive tools, requiring careful techniques. These crowquill and hawkquill points require special holders, because of their small, round shapes.

The best holder for the nibs is simply one that is most comfortable. They vary from thin to fat, and all points (except the quills) will fit any of them. Holders come in wood, aluminum and plastic.

Pens should be cleaned carefully after use, since a buildup of dried ink will inhibit the flow of ink. Commercial fluids are available to clean

points that become clogged. Scraps of paper towels make excellent pen cleaners.

There are several types of technical pens that come in a variety of sizes. Ink must be added to them, but they need not be dipped when used. Some types clog easily and might cause maintenance problems. Their lines are even and mechanical, and do not have the flexibility of lines made with steel nibs.

Steel pens work best on hard-surfaced papers; softer papers produce fuzzy effects (which are sometimes desirable). Bristol board, charcoal and bond papers, coquille and illustration and railroad boards provide excellent surfaces for pen and ink drawing. Try several

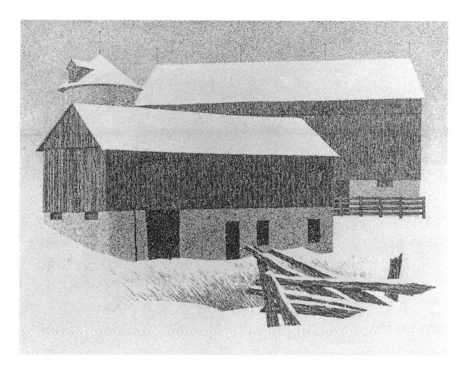

Paul Taylor used several techniques to apply ink to paper in this drawing: spatter with a toothbrush; stencils to retain the whites; several hatching and line techniques with different nibs. *Winter Barns*, 1985. Ink, 24 × 18″ (61 × 46 cm).

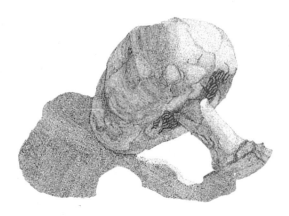

Tiny pen dots (pointillism) were used by a student to establish gray values in this mushroom drawing. Note how the edge is indicated on the light part of the mushroom.

papers before making decisions, and have small swatches available for trial with different points.

It is useful to have blotting paper or paper towels handy to pick up excess ink that might spill or drop unexpectedly from pens.

Even with the current emphasis on markers as clean and easy drawing tools, most artists and illustrators still prefer the versatility of steel and technical pens for their work.

INK WITH STICKS, TWIGS,

ETC. Experiment with a variety of wooden sticks on various papers. Every stick has its own feel and may be sharpened to a suitable point. Applicator sticks (available from doctors) and narrow wooden barbeque sticks (from grocery stores) are long and flexible and make fine drawing tools. They can be twisted and turned in the hand to produce organic lines, and can be laid down almost flat to make wide marks.

Try twisting a popsicle stick to a splinter point. How about a toothpick? Sharpen a chopstick or brush handle. Francis de Erdely and Charles White produced masterful drawings using balsa wood (sticks and chunks) in a variety of ways.

Most wooden sticks need to be sharpened to an obtuse point with a knife or razor blade. If cut too thinly, the wood will soften and make brush-like lines. Soft papers, such as drawing, rice, construction, bogus and oatmeal papers, provide excellent grounds for stick and ink drawings.

Quill and reed pens are cut and sharpened from natural materials, and have been in use for centuries. Nature provides a more immediately available drawing tool, however. Twigs and thin branches can be used just as they are found. Gather a bunch of them and break off unwanted side twigs. Save everything between 8″ and 15″ long and you have a box of drawing tools. Dip them into ink and draw on soft or dampened sheets

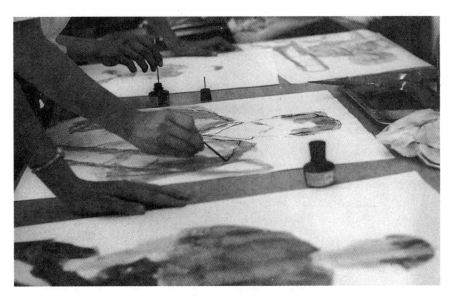

A student, working from a model, is applying ink with a stick over roughly drawn washes.

to enjoy a stimulating graphic experience.

Explore many avenues of expression. Put ink into a tray or shallow dish, dip cardboard edges into it and draw. You can make drawings with ink and scrap metal, pieces of wire or bone, bits of dried leather—nearly anything that can be dipped and applied to paper. Have a blotter or paper towel ready to pick up excess ink. Also, try drawing on unconventional materials, such as pages from newspapers or magazines, wallpaper, cloth, acetate, plywood or Mylar. The possibilities are unlimited.

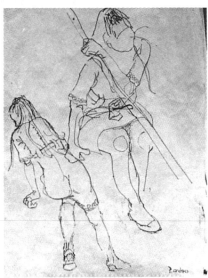

A twig was the tool selected for this student figure study. The resulting line is beautifully responsive to the subject. Twig and ink, 24 × 18 inches (61 × 46 cm).

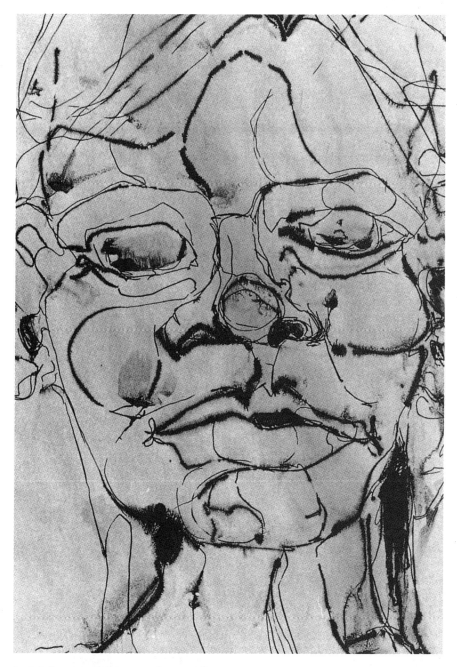

An ink line was drawn on a dampened
sheet of drawing paper to get this active
and fluid line. As the paper dried out,
the lines became more crisp. A student
work, it is 18 × 24″ (46 × 61 cm)

A stick and ink were used on oatmeal
paper, in this student drawing. The gray
areas were the result of an almost dry
stick used on its side. Note the variety
of line qualities. Stick and ink, 24 × 18″
(61 × 46 cm).

BRUSH AND INK. There is a much longer history of brush drawing in the Orient than in Western cultures, because the brush was also the main writing instrument. *Sumi* (Japanese black watercolor) techniques use the same brush strokes and ink supply that are used in writing. Chinese and Japanese brushes are still valuable tools when working with ink. They vary in size from 000 (smallest) to 6. Their hairs are longer than watercolor brushes, hold more ink and come to a very fine point. By using the brush in a vertical position, a line can be varied dramatically with a slight change in pressure on the paper. Watercolor and bristle brushes provide their own texture and feel, and can also be used for brush and ink work.

A textured line or tone can be achieved by using a brush from which much of the ink has been blotted. This *dry-brush* technique provides exciting textures and subtle tones, especially when used on textured papers. Try blotting brush lines with Kleenex or blotting paper, and note the *textured line* that results.

Brushes work well on softer papers, such as drawing, rice, oatmeal, construction and bogus papers. Smooth papers provide sharp contours and rough or absorbent papers tend to provide softer edges. Try a loaded brush on dampened paper and watch the effect. With practice, many effects as well as bold lines can be handled with ease.

Brush drawings can be finished works in themselves, value studies for other drawings or paintings, or excellent subjects for woodcuts. The calligraphic effect of brush drawn lines, done freely and with sensitivity, provides some of the most brilliant linear passages in drawing history. However, relatively few people have truly mastered the medium.

Using a watercolor brush and ink, a student brushes directly and freely to draw an expressive face.

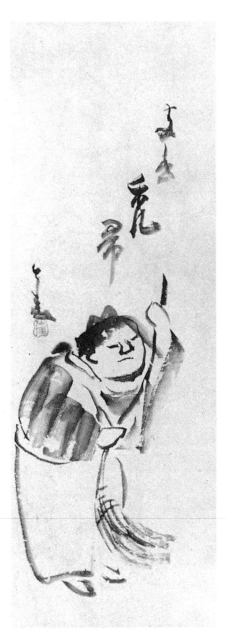

Sengai (1751–1837), a Japanese artist, was a master at drawing quickly and surely with a brush. *Jittoku Scroll*. Ink on paper, 35 × 12″ (89 × 30 cm). Los Angeles County Museum of Art.

Robert E. Wood brushed ink directly on paper in making this sketchbook drawing, intended as a value study for a watercolor painting. Brush and ink, 9 × 12″ (23 × 30 cm).

Saul Steinberg made delightful comments about life around him. Here he used a brush (dark lines) and pen to help us experience a monumental chicken. *Hen,* 1945. Pen, brush and ink, 14½ × 23⅛″ (37 × 58.5 cm). The Museum of Modern Art, New York.

Thomas Eakins used the values of ink washes to dramatize the light patterns in a darkened room. His masterly technique results in a painterly work. *Gross Clinic,* 1875. Ink and wash on cardboard, 25⅝ × 19⅛″ (65 × 48.5 cm). Metropolitan Museum of Art, New York, Rogers Fund.

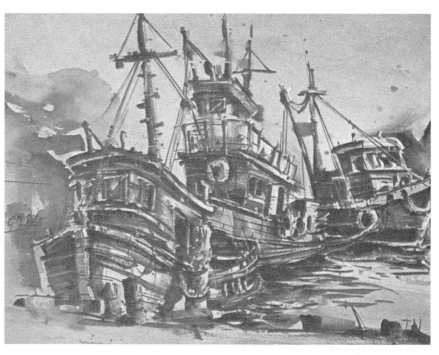

Guenther Riess brushed sepia washes first, then drew lines with brushes, sticks and pens. Some white lines are scratched through the washes. *Tugboats,* 1974. Ink and sepia washes, 18 × 24″ (46 × 61 cm).

WASH. Unlike brush and ink drawing, which relies on solid black ink application, wash drawings provide a full range of gray values (tone). The gray values are created by diluting ink with water. The quality that makes wash drawing popular is the ease with which darks and lights can be achieved. The spontaneity and technical variety make it a vital part of the drawing vocabulary, especially when it is combined with other drawing techniques.

Watercolor brushes are the most useful tools for applying washes. However, bristle, Chinese and Japanese brushes also are good choices.

India ink is the most commonly used medium for preparing washes. A tray with several compartments, or several small containers, can be stocked with a variety of value washes—from light to dark—produced by diluting the ink with varying amounts of water. Add water to a few drops of ink to make three basic wash values. These can be used over each other to make as many values as you need.

Although black normally is used, earth colors (sepia, umbers or siennas) also can be used individually or mixed with black for extremely rich surfaces. Explore the possibilities. Try thinning black tempera, watercolor or acrylics to make washes. Mix several media, or mix colors with black. Explore different directions and combinations.

A student is laying down gray washes with a bristle brush as the start of a still life drawing. Note the tray with several washes.

Charles White used a few lines to sharpen the facial detail in his sepia wash drawing. However, several layers of washes of various values are carefully used to develop a feeling of form in both the face and the bulk of the figure. *Figure,* 1978. Sepia and black ink and wash, 36″ (91.5 cm) high.

A full range of values (white to black) was used by the student who drew a classroom model placed into still life material. Crisp pen and ink lines and solid black shapes contrast pleasantly with broadly brushed washes. Ink and wash, 30 × 24″ (76 × 61 cm).

The white of the paper used is vitally important, as it is in most drawing techniques. White paper shimmers through the transparent washes and sings out alone when left untouched. Fresh and sparkling work is the result of your control of such areas.

Experiment with papers: oatmeal, drawing and bogus papers; tagboard and canvas; watercolor, charcoal, bond, and rice papers. Each contributes unique effects to exploratory wash drawing. You will get fewer puddles and smoother washes if the paper is kept at a moderate slant when working.

Wash drawings seldom stand alone, but often are used in combination with line—pen and ink, stick or twig and ink, brush and ink. Renaissance and Baroque artists delighted in working the softness of the wash against the hard quality of a pen line. It is in the contrast between the soft wash and the hard line that the medium speaks best.

Before starting a still life or a figure drawing, spend some time experimenting with ink washes and explore possible combinations of medium, tools and papers. This exercise will eliminate some inhibitions and promote a sense of freedom.

Self-Contained Tools

Self-contained ink tools come in a wide variety. They include fountain pens, ballpoints and markers of all kinds.

FELT-TIP PENS AND MARKERS.

A trip to an art store will bring you face to face with displays full of dozens of marker pens in a vast array of colors. From their simple beginnings in the 1950s, markers have become incredibly complex. There are models with tips of felt, fiber, rolling ballpoints, nylon, brush materials and others. One brand offers seventy-two colors and nine warm and nine cool grays (plus black and white). Some colors are available in five different values. Some brands have *two* drawing ends—a fine tip and a brush—both using ink from the same contained source. Some tips are round and others chisel shaped; some are fine and others broad.

All markers are convenient to use, because the inks are self-contained. Some are water soluble (and can be brushed over with water to make variations in the marks) and others are spirit-based. Some inks are permanent and others fade rapidly.

Markers make wonderful sketching tools because you can work rapidly and the marks dry quickly. Colors are intense in value and are not erasable; once put down, the marks are there to stay. They penetrate the fibers of papers and some will stain through thin, soft papers to make marks on underlying surfaces. Smooth-surfaced drawing papers or heavyweight papers work best. Some paper companies make sheets especially suited for markers.

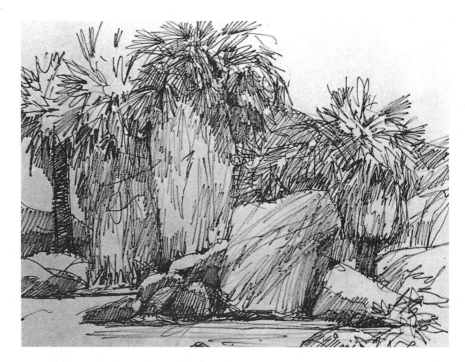

These two sketchbook pages show several uses for markers. The top page was drawn on location with an almost-dry broad pen. The lines are soft and gray, much like pencil. The lower page was drawn with a fine-line marker, and includes detail studies, value trials, compositional thumbnails, and some linear movement studies for paintings. Both pages are the same size, 10 × 14″ (25.5 × 35.5 cm).

Colored markers were used directly in this drawing, after a light pencil sketch was put down. Both chisel and pointed tips were used and some colors were drawn over others. Markers, 8 × 11″ (20 × 28 cm).

Al Porter added colored markers to this direct line drawing in his sketchbook. The finished shirt contrasts with the sketchy black marker lines. *Aloha Shirts Adjust to Most Shapes*, 1978. Markers, 8½ × 11″ (21.5 × 28 cm).

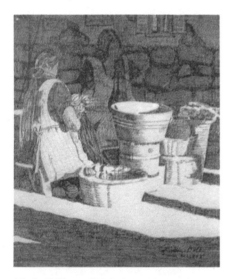

Linda Doll used a dark brown marker on rough paper. By using the side of the marker and drawing lightly, she developed a variety of values. Notice how the white space was left untouched. *Market Series*, 1984. Marker, 18 × 14″ (46 × 35.5 cm).

Cross-hatching with colored markers can develop interesting textures and color combinations. Complex surfaces result when hatching is done many times.

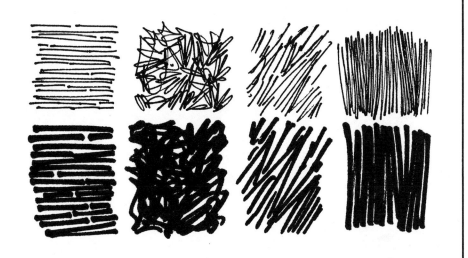

These marks were made with two different pens. Similar motions were used but the top row was made with a medium point, the bottom with a fine-line tip. Marks are about actual size.

Move a broad-tipped pen slowly over a paper and notice the dense, even marks. Move and stop, move and stop, and notice the marks. Move the pen quickly and notice that the color is lighter—less intense. Practice a bit to see what effects these variations in application can achieve. If you look at some of the examples, you will see that scribble marks seem to be very effective. Markers have an immediacy about them—they are sure, solid and vibrant. Very rarely can you achieve subtle, studied effects, unless the pens begin to run dry. Then the marks have a different, open quality.

Some artists prefer to work with black markers, or those with dark gray values. These come in a wide range of tips and sizes, and are especially useful for sketching on location and for work in sketchbooks. Test the pens before you buy them, because some will stain through sketchbook pages. Water-based inks are not generally permanent, but are easier to control.

Working with colored markers is a direct, often exhilarating, drawing experience. The vivid colors are usually transparent, so you can achieve wonderful complexities by overlapping them. You need only eight or ten colors and black to give yourself a wide range of possibilities. Select the primary and secondary hues, and add a few others depending on your subjects

Colored marks are used without mixing colors—just exploring line possibilities. Can you recognize some of the marks used in the accompanying drawings?

and style. Earth colors are helpful if you are drawing landscapes; exotic colors are useful if you are working with flowers, with decorative designs or with fashion drawings. By overlapping colors, you can obtain many variations.

Commercial artists find colored markers especially appealing because they look for immediate results that can be photographed for reproduction, and they are not interested in permanence. They use colored markers for idea sketches, concept studies, visualizations, trial projects and finished art.

The student who drew this horn made the colors as vibrant as the sound. Three primary and three secondary colors plus black and white are included. A thin black contour line was embellished with lines of riotous color. Markers, 18 × 12″ (46 × 30 cm).

These flowers were drawn directly, with no sketching. You should find ways to use markers to make personal responses and direct statements. Markers, 11 × 8″ (28 × 20 cm).

As with any other drawing medium, you will need to spend some time trying out the tools. Make pages full of marks, similar to some of those in the charts on these pages. Try side-by-side lines, hatching, cross-hatching, shading, broad strokes, fine edges, scribbling, flat shapes, staccato marks, and so on. Experiment to become familiar with the possibilities. Then select a subject, sketch loosely with a pencil, and start applying color (light values first). The marker is a pen, and lines are still an important aspect of the medium—even if they are in full color.

If you are interested in seeing more examples of marker art, check some of the books listed at the back of the text.

Small studies (like this student drawing) are excellent projects to help you understand markers. If they are kept nonobjective, you will try more techniques that take advantage of the medium. Markers, 12 × 6″ (30 × 15 cm).

A richly patterned still life was drawn by a student using a blue ballpoint pen on bond paper, 18 × 24″ (46 × 61 cm).

Guenther Riess drew on bond paper to sketch the engines in a travel museum. His ballpoint pen was used for cross-hatching to produce a complete range of values. *Engine,* 1976. Ballpoint, 18 × 24″ (46 × 61 cm).

SELF-CONTAINED PENS. A pen that carried its own ink supply was once just a dream, until John Sheaffer, an Englishman, patented the first reservoir pen in 1809. In 1884, Lewes Edson Waterman designed a practical fountain pen, but early models needed specially thinned inks to be useful, and drawing inks with great intensity were out of the question.

Today, *fountain pens* are durable and function beautifully with specially designed intense inks. They come with an infinite variety of points—some for writing, but many especially for drawing and sketching. There are also models designed for using India inks. These often come with screw-in nib units that can be changed easily and often, depending on the thickness of the lines desired. Some fill directly into the unit, others by cartridge. All come with a variety of nibs.

Ballpoint pens are constantly improving, and come in a wide range of styles. One make uses India ink and has a replaceable cartridge. Ordinary ballpoints are especially useful for sketching, and some students use them to make finished drawings. The inks dry immediately and the pens with permanent inks make excellent tools in the art room.

Technical pens, used by illustrators and drafters, use special inks and have sophisticated nibs that allow drawing in any direction. *Calligraphy pens* can also be used for drawing by artists, once they have learned to take advantage of the shapes and marks of the special nibs.

Do not discount any kind of pen. Try different pens in a variety of circumstances, with several kinds of paper, to see what the possibilities might be. Fountain and ballpoint pens work best on bristol board, charcoal and bond papers, coquille, illustration and railroad boards, and hard-surfaced drawing papers. However, do not count out any paper until you have tried it. Like the tools themselves, papers are very versatile.

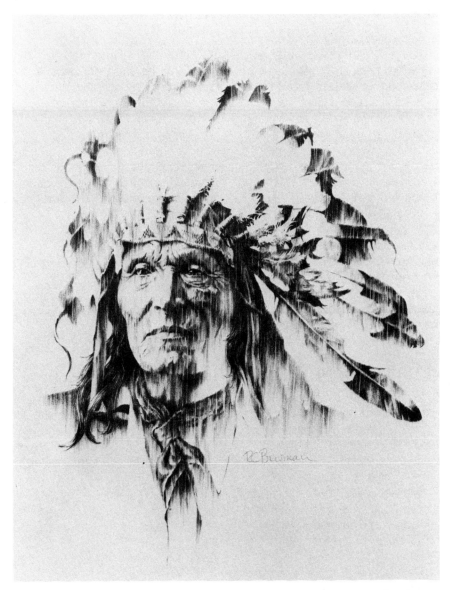

Valerie Love massed thousands of delicate squiggles to produce a soft pen drawing. Squint your eyes to see the facial features. *Figures,* 1977. Ballpoint pen, 16 × 10″ (40.5 × 25.5 cm).

Randolph Bowman used vertical directional lines to render this Indian Chief. He found that a change in the pressure of pen on paper allows a change in the value of the mark. A single pen can make both light and dark marks. *He Dog — Sioux Sub-chief,* 1972. Ballpoint on toned paper, 24 × 18″ (61 × 46 cm).

Activities

ART HISTORY

1. The Chinese and Japanese developed a long tradition of drawing with ink—a style and method called *sumi.* Research in art encyclopedias, books on Oriental art or in books on Sumi painting. Write a one-page report on *one* of the following topics:

• A Short History of Sumi Art
• How Sumi Ink is Made
• Basic Sumi Techniques.

2. Research and write a short paper on the history of drawing ink. Where was it first used? What materials were used to make it? How has it developed? Include the names of some great artists who made excellent ink drawings.

CRITICISM/ANALYSIS

3. Write a one- or two-sentence description of the typical marks made by each of the following wet media. Illustrate the assignment with your own marks, then describe them. 1) steel point and India ink; 2) twig and ink; 3) bristle brush and black ink; 4) watercolor brush and ink *wash;* 5) blue marker with a chisel point; 6) ballpoint pen.

4. Compare and contrast two of the wash drawings shown in this chapter. Discuss color, value, line, etc., and also the purpose of each work.

5. Compare and contrast two of Charles White's drawings: *Figure* (this chapter) and *Seed of Love* (Chapter 1). Discuss media, technique, subject, form, elements of art, etc.

AESTHETICS/PERSONAL SENSITIVITY

6. Study the colored marker drawings and the wash drawings illustrated in this chapter. Write a *general,* short description of each kind of media (wash and marker drawings). Compare and contrast the two media in regard to: subtleness, strength, painterly quality, value development, line, visual impact, and use in art. Which do you like better? Why?

PRODUCTION/STUDIO EXPERIENCES

7. Study the chart of marks on pages 102–103. Then make a chart with *similar* (but not the same) marks, using: 1) ballpoint pen; 2) stick and ink; 3) brush and ink; 4) steel pen and ink; 5) fine-point marker.

8. Using a ballpoint pen, make a chart of your own design, showing as many kinds of marks, hatchings, values, etc., as you can develop.

8 MIXED MEDIA

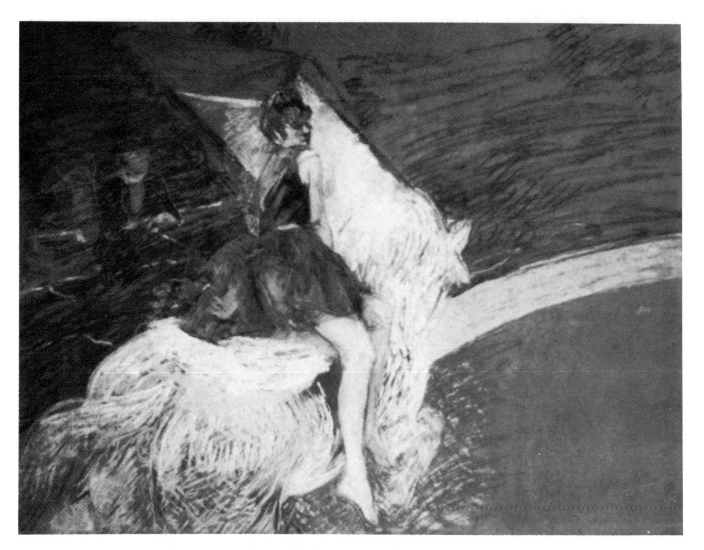

Henri de Toulouse-Lautrec often combined media in his work. In this drawing, he combined wet and dry media to visually describe the colorful circus rider. *The Circus Fernando*, 1888. Pastel and gouache (opaque watercolor) on cardboard, 23⅝ × 31¼″ (60 × 79 cm). Norton Simon, Inc. Museum of Art, Pasadena.

Powdery charcoal and waxy crayon were combined by a student in this large, spontaneous drawing from life, 34 × 22″ (80 × 56 cm).

It might seem that combining several media in one drawing is only a recent direction in art, but this is not so. Since Renaissance times, artists have combined materials to obtain desired effects. "Brush, pen and ink over black chalk, heightened with opaque white tempera, with a little gray wash and touches of pink and yellow pigment." Is it a contemporary drawing? Not at all! The artist, Bernardino Gatti, lived in Italy from 1490 to 1576. Artists have continued to mix drawing media throughout history, in order to better present their ideas, and/or to envision subjects for painting.

Swiss artist Paul Klee (1879–1940) and his contemporaries experimented freely with mixed media. A catalog of his work reveals some of the following: watercolor and oil on paper, chalk and ink on blotter, watercolor and wax on linen, watercolor over chalk on paper set on gauze backed with cardboard. He experimented as freely with his grounds as with his media.

Some artists prefer to work in a single medium, using it in all circumstances. Others prefer to use a variety of media in various combinations. Since exploration is a key word in art, combining materials seems attractive to many. Artists and students experiment and mix many drawing materials to get exciting results.

Mixing media generally produces rich surfaces and complex drawings. But remember that drawings are essentially linear in structure. Adding various washes, brushwork or textures should only increase the drawing's impact and/or enrich its surface. Mixed media should not produce painted surfaces or obliterate the graphic features of the drawing. Your goal should be to present a richer image, to show a contrast of materials or to express your drawing concept more completely.

Try mixing dry materials together, wet media together or wet and dry materials together. Work soft materials against hard, dry against fluid, dark against light. Experiment on various grounds: paper, cardboard, cloth, blotters, collages. Work large, small, loose, tight. Try all sorts of mixes to see what best fits your working habits or subjects. You cannot possibly work all the available combinations, but a bit of experimentation can add greatly to your drawing experiences.

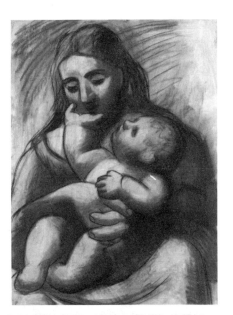

Pablo Picasso used several dry media to outline and shade these figures. Careful attention to light and shadow produce powerful forms. *Maternite,* 1921. Charcoal and red chalk, 41⅜ × 29¼″ (105 × 74 cm). Collection, Frederick Weisman Company.

Richard Wiegmann combines several media and draws on Mylar surfaces, often overlapping them to create dynamic surfaces. In this drawing, he used graphite sticks, Prismacolor pencils, Art Stix and some oil pastel, which he combined with solvents in places. The combination of materials and the Mylar support allow for a textural treatment not obtainable in any other way. *Eastertide,* 22 × 26″ (56 × 66 cm).

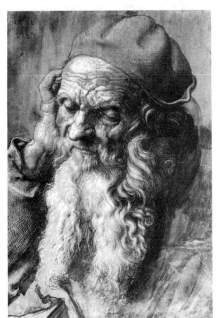

Albrecht Dürer, a German Renaissance artist, needed several media and tools to express how he felt about this old man. *Ninety-four-year-old Man,* about 1510. Pen, brush, India ink and white color on grayish-violet paper, 16⅜ × 11⅛″ (41.5 × 28 cm). Albertine Museum, Vienna.

Mixing Dry Media

There are too many combinations of media for you to take the time to try them all. You can get as many as twenty-four combinations from only five dry media. Each time you add one different media or ground to each combination, you will double the number. The most sensible approach to combining media is to begin by selecting only two.

The results of mixing media are more exciting if there are contrasts in the physical properties of the materials themselves. Try working a powdery material with a waxy one. Use soft charcoal with a hard pencil. Use the sepia color of a conté crayon with the rich black of a charcoal stick. Or try mixing colored pencils with white chalk. Within the dry media alone, a vast range of combinations and effects can be experienced, as you can see from the illustrations.

Try each combination on different papers. Charcoal and black crayon will give dramatically different results if drawn on bond paper than on oatmeal paper, or on a toned paper. Try drawing with various white media on black paper, or use colored media on toned paper.

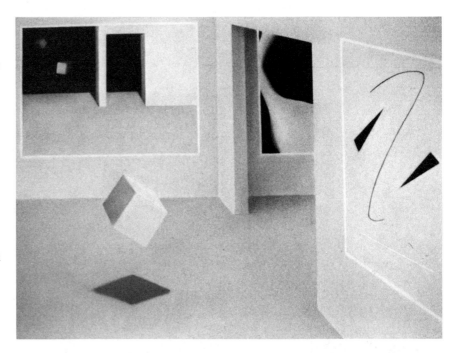

Richard Parker combined three dry media in this large surrealistic work. His drawing of an imaginary gallery includes drawings of his own drawings! *June 1986 Number III,* 1986. Charcoal, chalk and pastel, 30 × 44″ (76 × 112 cm).

Crayon (a waxy medium) and charcoal (a chalky medium) are combined in this attractive student drawing, done from a seated model. The drawing is 24 × 18″ (61 × 46 cm).

Richard Wiegmann's finished drawing almost has the quality of a painting. He combined several dry media in a single colorful work. *The Lost Sheep,* 1985. Oil pastel and colored pencils, 20 × 16″ (51 × 40.5 cm).

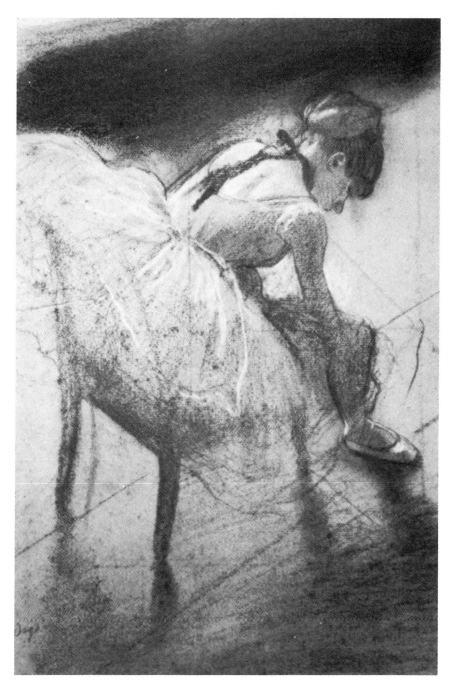

Edgar Degas was a leading exponent of the pastel medium, but here he combined it with charcoal. He often used ballet dancers as subjects and he was always concerned with light sources in his work. *Dancer Fixing Her Shoe,* 1885. Charcoal and pastel on paper, 12 × 8″ (30 × 20 cm). Norton Simon, Inc. Museum of Art, Pasadena.

Mixing Wet Media

The possible combinations of wet media are also too numerous to fully explore, but it can be very rewarding to try several of them. In order to add color to drawings, some artists use transparent or opaque watercolor as fluid washes to be played against sharp ink lines made with sticks, pens or markers. If the paper remains wet, the resulting lines will be soft and fuzzy.

A mixed media drawing can become very complex in its surface development. For example, begin with a pale India ink wash on drawing paper. Add darker passages with more intense washes. Run a stick and ink line through the damp areas and draw crisply in the dry sections. Lighten some parts with white tempera. Add more washes, line, tempera and some sepia ink in certain areas. Dry-brush some textured sections. Take a marker and add some rapid action strokes. Follow with more washes and stick and ink. Add some spatter with a toothbrush dipped in wash. Add a few final lines to finish. You might have to let the surface dry between some of the applications. Such a drawing will be rich in texture because of the overlapping of various media.

Gerald Brommer used reed pens, sticks, brushes and pens to draw India ink lines into and over layers of watercolor washes and gesso. Fluid washes, opaque passages of gesso and many kinds of lines are combined in a single work. *Texas Still Life,* **1977. 22 × 30″ (56 × 76 cm).**

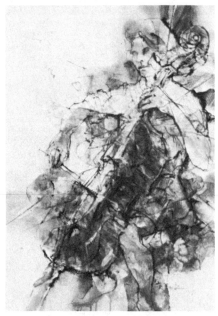

Lawrence Brullo brushed down watercolor washes of various hues for color and texture and ran sensitive ink lines over the washes when they had dried. More watercolor was used for line and wash until the drawing was finished. *Cello Player,* **1978. Watercolor and ink, 30 × 22″ (76 × 56 cm).**

Gray washes and several felt markers were combined in this student's drawing of his friend. Both dark and white backgrounds eat into the face, which reveals careful observation. Sketchbook page, 11 × 8½″ (28 × 21.5 cm).

Jock Macdonald combined watercolor washes and ink in his fanciful composition. Some objects can be recognized, but the overall feeling is of abstract joy and happiness. *Russian Fantasy*, 1946. Watercolor and ink, 9½ × 13½″ (24 × 34 cm). Art Gallery of Ontario, Canada.

Work on canvas, paper or gessoed boards or panels. If the support (ground) is enriched itself by collaging white papers to a white ground, the drawing will also be enriched. Use paper towels or various rice papers as collage. Gesso a masonite or chipboard panel and texture the surface, and use ink washes or watercolor over the heavy textures.

The accompanying illustrations may give you some more ideas. Fill a page or two with abstract explorations into mixing two or more wet media before you start on a still life or other subject.

George James used a brush and pen with ink to contrast broadly brushed flat shapes with delicate lines — used alone and clustered. Sketchbook page, 11 × 8½″ (28 × 21.5 cm).

This complex surface was begun with a
pencil outline of the three figures. A
bead of white glue was laid down over
the drawing and, when dry, pale water-
color washes were brushed over the
paper. When that was dry, pen and ink
were used to fill the sheet with pattern
and texture. Student drawing is
16 × 22″ (40.5 × 56 cm).

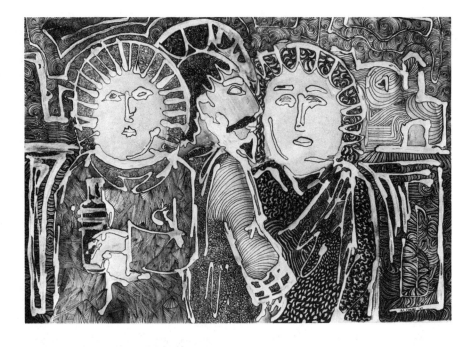

Rubber cement lines stopped the water-
color and ink washes from staining the
paper in this student work. When the
resist material was removed, the white
lines remained. Some color was brushed
over them in places to integrate them
into the surface of the 18 × 24″
(46 × 61 cm) drawing.

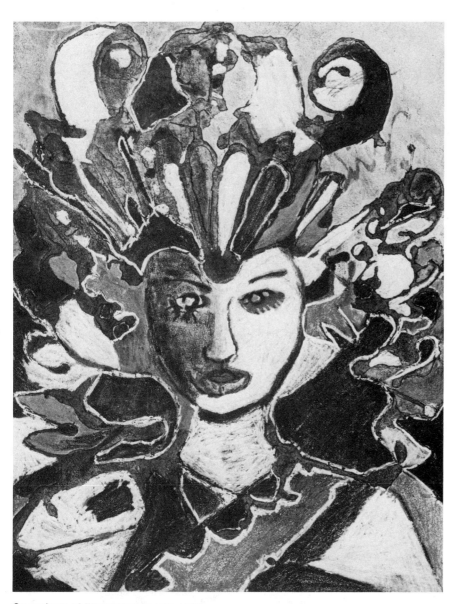

On a sheet of illustration board, white
glue was randomly applied, and pieces
of soft gray paper were pressed down.
When dry, the loose parts of the papers
were torn away, leaving a textured sur-
face. Over this background, a pencil line
was drawn to outline the face, and a
bead of glue was put over that. Pencil,
watercolor, tempera and charcoal were
used to shade and finish the student
work, 24 × 18″ (61 × 46 cm).

Using Blockouts

When working with combinations of
wet media, fascinating surfaces can
be developed by using blockouts
or stopouts, and drawing into them.
Apply rubber cement in patterns or
lines and, when dry, lay loaded
washes over the surface. When the
washes dry, remove the rubber ce-
ment by rubbing with your fingers,
and patterned white spaces will ap-
pear. Outline these with a pen;
draw in them with a marker; let
your imagination devise patterns,
lines and texture marks to fill the
spaces.

Apply white glue over pencil
outlines. It cannot be removed, and
will leave a slight ridge. Run water-
color or ink washes over the sur-
face and, when dry, outline, pat-
tern, cross-hatch and draw into the
various areas. Allow the developing
drawing to suggest further inking,
drawing or coloring.

The illustrations provide sugges-
tions for mixing wet media on a
variety of grounds. Experimentation
can produce endless surfaces on
which to draw with other media; or
the experimentation can be an end
in itself.

Mixing Wet and Dry Media

Mixing media encourages experimentation and decision making and provides a wide range of textural effects. Since Renaissance times, artists have been mixing wet and dry media to obtain desired effects. Combinations of materials were common among Baroque artists (seventeenth century) but were frowned on by the academic purists of the nineteenth century. The twentieth century has seen a tremendous expansion of media and materials, and mixing media is again popular. Exploration is a prime motivation for creative expression. However, take care not to rely on special effects as the heart of your work. It is fun to experiment and explore combintions of materials, but you must also understand the elements and principles of design. Learn to combine all of these things together with observation, sensitivity, emotion and drawing skills to produce art that is solid and exciting in both form and content.

If you list all the dry media and all the wet media, you will soon see that the number of possible combinations of the two is almost limitless. This is especially true if you also include grounds and other tools and materials—plastics, Mylar, cellophane, aluminum sheets, collaged surfaces, photographs, metallic paints and the like. No attempt will be made to list them all, but the illustrations will give you a small idea of what contemporary artists and students are doing with wet and dry mixed media.

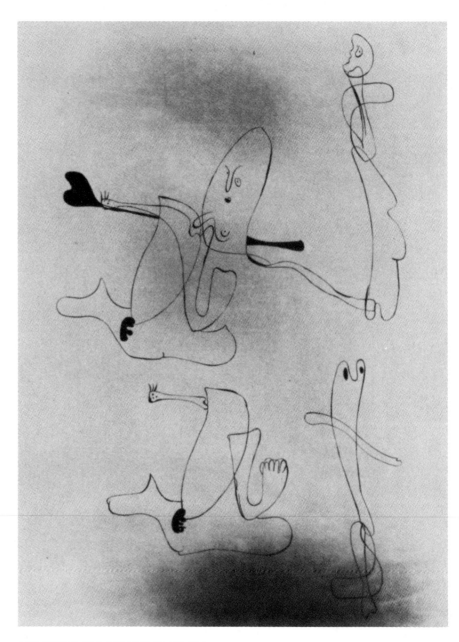

Joan Miro used a crisp ink line to contrast with the soft background of smudged pastel. His lines seem to float above the edgeless colored areas. *Untitled,* 1934. Pastel, brush and ink on paper, 24⅞ × 18⅜" (63 × 46.5 cm). **Collection, Frederick Weisman Company.**

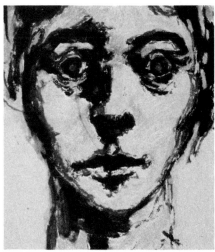

This face, done in wet and dry media, is from a student sketchbook, and shows an excellent understanding of form. Pastel, crayon and ink, 10 × 8″ (25.5 × 20 cm).

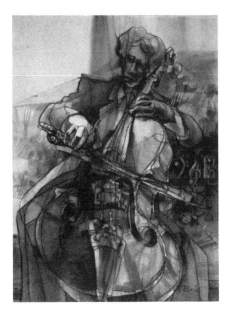

Spatter and drawing were combined in this student work, which explores media while developing a subject theme. Lead pencil, crayon, ink and colored pencil, 15 × 18″ (38 × 46 cm).

Lawrence Brullo's knowledge of music and instruments is evident in this fine drawing, which combines wet and dry media. *Cello Impromptu,* 1986. Charcoal, pencil and watercolor washes, 30 × 22″ (76 × 56 cm).

Arshile Gorky used several media to explore directions for a possible painting involving biomorphic shapes. The drawing is a complete work in itself. *Untitled (study),* about 1942. Colored crayons, graphite and watercolor on paper, 17 × 21½″ (43 × 54.5 cm). Collection, Frederick Weisman Company.

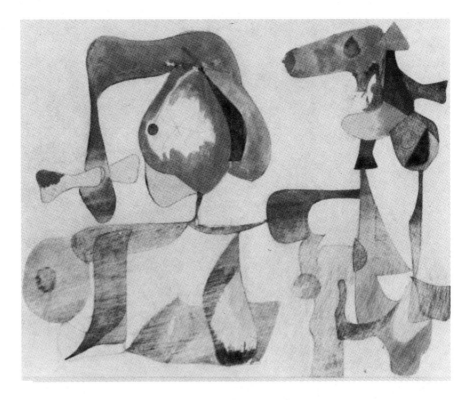

Valerie Love contrasted a crisp pen and ink line with a soft pencil drawing in a sensitive mixed media work. *Observation,* 1975. Pencil, pen and ink, 14 × 20″ (35.5 × 51 cm).

A student model was drawn on brown kraft paper with pencil. Wet and dry media and collage were added to build a textured surface. Pencil, ink, white tempera and newspaper collage, 24 × 15″ (61 × 38 cm).

This student drawing not only combines a variety of media (pencil, ink, markers and pastel), but also a variety of techniques and concepts (realism, contour line, and cubistic design). Mixed media, 18 × 12″ (46 × 30 cm).

Corrine Hartley combined wet and dry media in one drawing, but kept them separated. Look for the circle that encloses color. *Center of My Life,* 1978. Pencil and watercolor washes, 18 × 14″ (46 × 35.5 cm).

Invention and discovery can also lead to delightful, surprising and expressive ways of using traditional materials. Using traditional ink and washes, you can print with sponges, make marks with a palette knife or putty knife, or print and draw with a rag or crumpled rice paper dipped in ink. Draw with sticks, twigs, match sticks, pieces of metal or plastic, fingers or brush handles. Make soft textures by spattering with a toothbrush, atomizer, airbrush or painting brushes.

If you have available a range of contrasting materials, you will be encouraged to mix them while your drawing is in process. You will soon be able to decide to use wash where it works well and charcoal and chalk where they are needed. Work powdery charcoal or chalk against smooth washes and the crispness of a twig and ink line. Or work black wax crayon over gray tempera to heighten texture. Draw with a heavy pencil over smooth washes or use markers over liquid-like areas. Spatter and stipple, scratch and scrub. Use media fully and in combinations that produce exciting surfaces.

Spend some time filling pages with experimental combinations, and then apply what you have learned to drawing a still life or other subject.

Crayon (using points and sides) was first applied on white paper, and ink and watercolor washes were brushed over the surface. Notice the variety of textures and resists in the 24 × 18″ (61 × 46 cm) student work.

Sepia inks were used over wax crayon in this student resist drawing. Ink lines were added to complete the details on the textured surface. Crayon and ink washes, 18 × 24″ (46 × 61 cm).

Water + Wax = Resist

Perhaps some of the most interesting textural surfaces in drawing result because of the antipathy of water and wax. Since they do not combine, they *resist*. When wax is applied to paper, washes put over it tend to run off and settle in the unwaxed areas. The process is called **wax resist**. Draw vigorously with a white candle or white wax crayon on a sheet of white drawing paper. Apply a light wash over it and observe the patterns that form. When dry, draw with more wax over the washes and apply darker washes. The surface becomes richer and richer the more the process is repeated—up to a point. This design can be drawn into and over with pen and ink or pencil. Try a variety of approaches, abstract or representational.

Candle wax was put down first to make pattern, then dark wash, repeating until the desired richness of texture was achieved in this student work. Stick and ink were added in places. Wax and ink, 14 × 20″ (35.5 × 51 cm).

Gerald Brommer set his imaginary haunted house at the edge of a swamp, using resists and tempera on the black and white surface. *Homage to Poe,* **1975. Wax, black and white crayon, ink, ink washes and white tempera, 18 × 24″ (46 × 61 cm).**

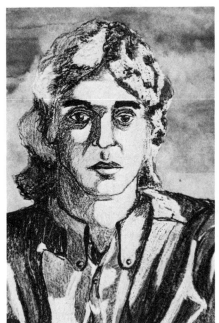

Black and white crayons were used by a student to draw a self-portrait. He then added watercolor washes that resisted and became the middle values in the 18 × 12″ (46 × 30 cm).

Crayon resist is very similar. Draw and apply colored crayons *heavily* to a paper, and flow watercolor or ink washes over the surface. Work back into the dried surface with more crayon and more and darker washes until the results are satisfactory. Work on large sheets of brown kraft paper or white drawing paper with crayons, pencils and white candle wax. Brush areas with India ink or watercolor washes. Work more with crayon and wax and wash. Scrub and scratch and manipulate the surface for varied results. Fill a few practice sheets before starting on a full-scale drawing.

Marisol has drawn her figures on many kinds of surfaces. In this assemblage, the faces are carefully drawn on flat and curved wood surfaces, while other parts are painted. *The Family,* 1962. Wood with pencil, charcoal, plaster and paint, 82 × 65 × 15″ (208 × 165 × 38 cm). Museum of Modern Art, New York, Advisory Committee Fund.

Lawrence Brullo combined watercolor and crayon to create wonderful textures, patterns and color combinations. He kept them all under careful control in *Cilla Cello,* 1986. Watercolor and crayon, 40 × 25″ (101.5 × 63.5 cm).

The student who made this "embossed" drawing, drew on the reverse side of a sheet of foil to make the raised lines. Markers were used to color the front of the 9 × 12″ (23 × 30 cm) work.

Experiments with Media and Tools

One of the basic characteristics of contemporary art is the desire to break from conventional ways and explore new materials and techniques. Drawing is not immune to this exciting attitude. New materials, pens, markers, inks, paints and grounds are available. But using conventional materials in unconventional ways probably is the most challenging situation.

For example: pour India ink on a sheet of hot pressed illustration board or other resistant paper. Manipulate the ink with a palette knife, draw in it with a toothpick, scratch it with a bristle brush or fork, blot it with crumpled paper or facial tissue—and observe the results.

John White painted wood 4 × 4's with white enamel and drew on the three-dimensional surfaces with felt markers. *Sculpture Drawings,* 1972. Colored markers on enameled wood, 4 × 4 × 16″ (10 × 10 × 40.5 cm). Orlando Gallery, Woodland Hills, California.

Richard Wiegmann played an organic line against broadly brushed ink shapes. He printed the number "5" over itself to texture the upper right and used collaged magazine type in the foreground. An active surface is the result. *Untitled,* 1972. Ink, printing type and collage, 18 × 24″ (46 × 61 cm).

Don Lagerberg used plywood and collaged papers as a ground for this delightful drawing. *English Lemons,* 1972. Pencil, ink and collage on plywood, 21 × 14″ (53 × 35.5 cm). Orlando Gallery, Woodland Hills, California.

Fill a squeeze bottle with white glue colored with India ink and trail the material in a contour-like line drawing. Or mix white tempera with white glue and trail on a sheet of black railroad board. Ad lib from there on.

Draw on 4 × 8′ sheets of plywood with ink and wash. Or take a small cube of wood and draw on it. Make a papier-maché face and draw in the features with pencil. Brush gesso on any three-dimensional surface (found or built) and begin to work with your pencils.

Draw with markers on clear Plexiglas or mylar and view the drawing from both sides. Or draw on the six sides of a plastic cube, and turn the "drawing" around in your hands to observe the overlapping and combining images.

Contemporary artists and students are experimenting with the oldest and newest materials in some unusual combinations . . . and they continue to draw.

Activities

ART HISTORY

1. It is mentioned in the text that the attitude of the French Academy (art school in Paris) of the nineteenth century put a stop to experimental mixing of media, and turned artists back to "purist" techniques. Research in art encyclopedias or art history books about this academic movement (it was associated with the Neo-Classic style). Write a paper on *why* they wished to return to purist drawing techniques. What were their goals? Who were the leaders of this movement? What kind of art did they like? What art of the past did they admire? Why?

2. Research the life and work of Paul Klee. Write a short paper explaining his desire to make mixed media drawings and paintings. What were his goals in art? Why did he use so many techniques? To which groups of artists did he belong? Why was he not a purist? Why was he so experimental?

CRITICISM/ANALYSIS

3. Compare and contrast the drawings *Maternite* by Picasso and *Ninety-four-year-old Man* by Dürer shown in this chapter. Write a short paper, covering such things as media, technique, emphasis, style, light, value, emotional content, balance, appropriateness of the medium for each work, and so on. If you have slides of the two works, you might lead a class discussion instead.

AESTHETICS/PERSONAL SENSITIVITY

4. There are three examples of the drawings of Lawrence Brullo in this chapter: *Cello Player, Cello Impromptu,* and *Cilla Cello.* The artist is very familiar with musical instruments because he makes violins for symphony players and plays several stringed instruments. How does this love of music show in his drawings? Which drawing has the most emotional feeling? Which has the sharpest design? Which is a kind of carricature? Which of his *techniques* do you like the best? Why? Which of the three drawings do you prefer? Why?

PRODUCTION/ STUDIO EXPERIENCES

5. On each of six sheets of 8 × 10″ (20 × 25.5 cm) paper, outline a single object (slice of orange, slice of watermelon, soccer ball, etc.) and use six different *mixed media* techniques to finish the drawings.

6. Gather two wet and two dry media together. Draw the outline of an imaginary fish or bird and use *all four* media in texturing the surface of the drawing. Realism is not a goal. Simply explore the possible media combinations.

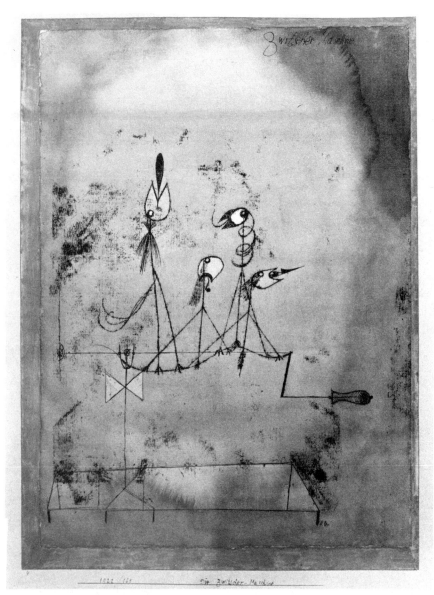

**Paul Klee's imagination created delightful
images for us to smile at and enjoy.**
Twittering Machine, **1922. Pen, ink and
watercolor, 16 × 12″ (40.5 × 50 cm).
Museum of Modern Art, New York.**

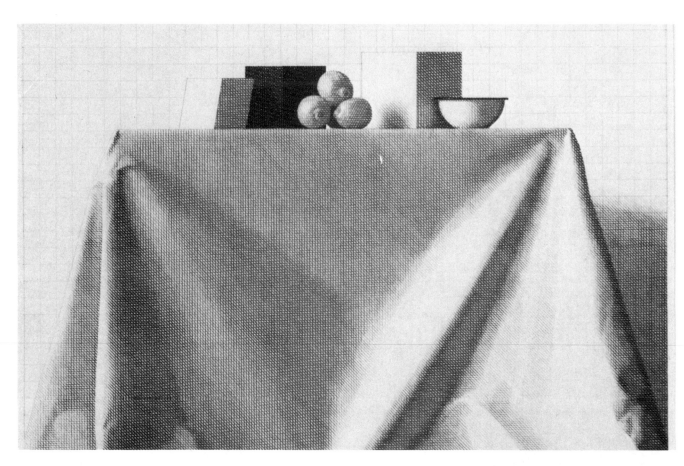

William A. Berry. *Still Life: Homage to Zurbaran,* **1985. Colored pencil, 30 × 40″ (76 × 101.5 cm). (Photo: Howard Wilson)**

P
A
R
T
III

LOOKING AND SEEING: SUBJECTS FOR DRAWING

Chapters 6, 7 and 8 dealt with drawing media—dry, wet and mixed. These media are the tools and materials with which we draw and make marks—lines, shapes, textures, colors and tones. The remainder of the book covers subject matter—the things that artists draw.

Some artists draw subjects that they feel most comfortable with: flowers, people, action, sports, animals or cities. Some exercise their imaginations, while others draw exactly what they see.

At various times in history (and for various reasons), certain subjects were considered to be most important and were drawn most often. For example, Renaissance artists drew figures; Impressionist artists drew landscapes; and social satirists depicted the plight of the human condition.

When you ask the question, "What can I draw?" the answer is **subject material.** Someone has said, "All things are drawable," and that might well be true. Subject matter is all around you. The following chapters will help you become aware of many kinds of subjects for drawing.

9

DRAWING FROM STILL LIFES

Throughout history, young artists have drawn still lifes as a way of learning to see objects in front of them. Today, artrooms all over the world continue to contain still lifes as basic subjects for drawing.

The term **still life** is used to describe an arrangement of objects that does not move—that sits patiently waiting to be drawn. Still lifes are valuable subjects because they can be used for any length of time, the lighting can be controlled and constant, color and texture can be arranged at will, themes can be developed, and many approaches can be tried on the same subject. Drawing still lifes is a good way to learn to see objects.

Several values of gray chalk were used by a student to draw this still life. Careful attention was paid to light and darks, and also to the relationship of values in different objects. 18 × 24″ (46 × 61 cm).

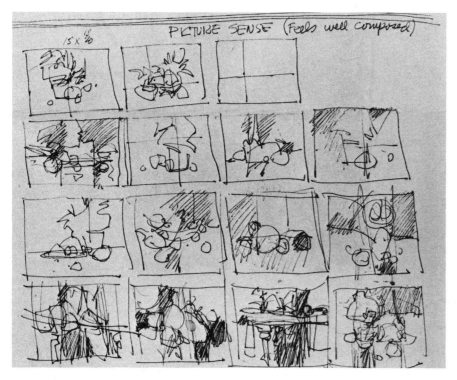

These thumbnail still life drawings from a sketchbook page represent visual thinking. They explore clustering, overlapping, center of interest location, close-ups, distant views and some value studies.

When setting up a still life, three things should be considered: 1) selection of objects, 2) arrangement of objects and 3) lighting the arrangement. A still life may contain only one or two items, or dozens of things. Living or artificial plants, auto parts, sculpture, toys, bits of cloth, pottery, musical instruments, chairs, books, and shoes are only a few things that could be used. The arrangement will be most interesting if you choose objects of different sizes and shapes. The objects should be *clustered*—not strung out or in a line. Group the items to make an interesting overall shape. Lighting often comes from above or from a nearby window. One strong light source will provide excellent shadows and help to define forms.

Before beginning to draw a still life, walk around it to find a view you like. It is helpful to make several thumbnail sketches to get the "feel" of the clustering and overall arrangement of the objects. Always consider the proportions of one object compared to another and the relationship of each part to the whole setup.

Still lifes can be drawn in line, value, color, texture; in perspective or flat; patterned or realistically; in one medium or mixed media; selectively, completely, directionally or partially. Every approach you choose definitely should involve *looking, seeing* and *recording*.

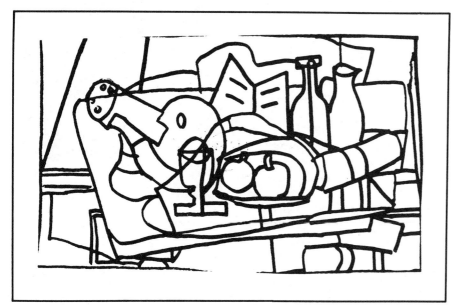

A line drawing of a still life painting by Georges Braque illustrates the concept of clustering objects. Notice how parts are related to the whole, and how the objects are related to each other.

Individual objects were drawn in contour and the paper was turned after each was finished. Objects were overlapped to create a large cluster, and a heavy line was added to contain the entire shape. Pen and ink, 24 × 18″ (61 × 46 cm).

After much contour drawing experience, a complicated still life was outlined by a student who observed objects and relationships carefully. Some texture is indicated but contours are emphasized.

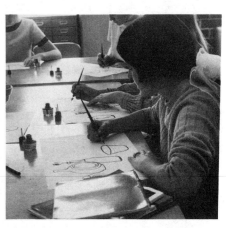

A wide Speedball nib is being used to explore individual still life objects in pen and ink contour line.

Exploring with Contour Line

The best way to explore still life subjects is with contour line. Direct observation is essential to contour drawing, and the ability to see is strengthened with each contour drawing experience.

Making contour lines is a convenient way to show edges and limit shapes. Move your eye over the edge of a bottle and move your pencil or pen accordingly, at a comfortable pace. Concentrate on edges of objects and do not allow yourself to be sidetracked by values or textures. Make solid, sure

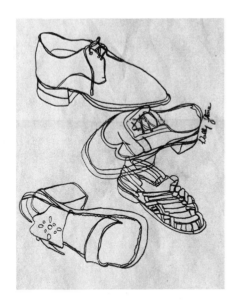

"Take off your shoes and put them on the table." These directions provide excellent subjects for contour drawing. Allow the drawings to overlap at times. Pencil, 24 × 18″ (61 × 46 cm).

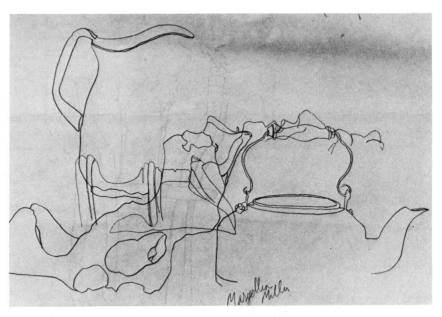

Careful and selective contour drawing eliminates generalization and emphasizes perception. Four objects were drawn singly and allowed to overlap, with six minutes spent on each. Pencil, 18 × 24″ (46 × 61 cm).

continuous lines. Avoid backing up, retracing or erasing. Keep your wrist a bit stiff to help prevent distortion. Do not worry about inaccuracies or distortion, however. Some is healthy and indicates a real searching and discovery of edges. Do not generalize your lines—make them specific.

After you become somewhat adept at defining outside edges, let your eye travel over significant interior edges and define them also. Do not allow the contours to get too complicated at first. Learn to see selectively and carefully.

Use a heavy, dark pencil, pen or marker. Do not be tentative or timid with your marks. Try a variety of papers. Start with single objects. Then, overlap a few selected objects. Begin with simple forms and then try more complicated things.

Make setups of three or four objects. Then arrange more complicated combinations. Or work selectively, choosing only a few objects from a complex setup.

Change media, surfaces and objects to encourage continuing exploration and discovery—and growing visual awareness.

A student wash drawing shows an awareness of the light source, strong value contrasts and form. Light washes were brushed down first, stick and ink lines were added and darker washes were applied.

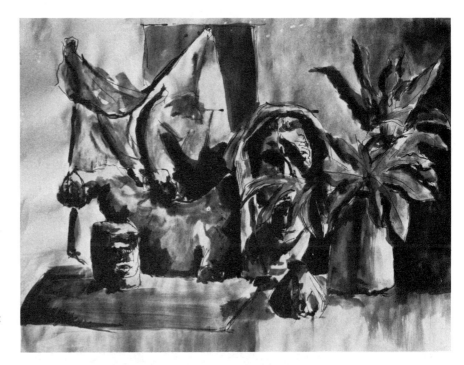

Light-value washes were brushed down to identify generalized shapes. A student then used stick and ink to draw specific contours and edges. Wash and ink, 16 × 24″ (40.5 × 61 cm).

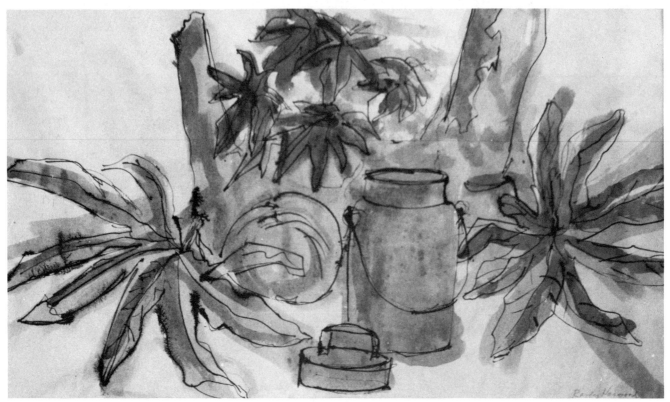

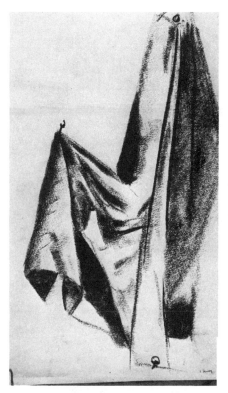

This student paid attention to a range of values in a single object—a draped cloth. Charcoal, 24 × 16″ (61 × 40.5 cm).

Contour lines were drawn with marker on a sheet of colored construction paper. White chalk lines were used to elaborate on the contour and pattern the background. 18 × 12″ (46 × 30 cm).

A large dark pencil was used by a student to define *only* the middle and dark values in a complicated still life. Squinting helps to isolate darker vaues for drawing. Pencil, 24 × 18″ (61 × 46 cm).

Exploring with Value

Value refers to the use of dark, light and intermediate grays in a drawing. It is easy to see the difference between the value drawings shown here and the line drawings on the previous pages. Initial exploration with value should involve using dark and light as contrast, not necessarily to define form accurately. As soon as value is introduced in a drawing, however, there is at least the suggestion of three-dimensional form.

Charcoal and pencil are excellent dry media for working with dark and light, because each medium has a range of value depending on the pressure used to make the marks. Ink washes (several values) can be combined with stick or pen line, if wet media is desired. Colored papers can provide a middle value, and black and white crayon or chalk can be used for line or for extreme value contrasts. Gray markers of different values also can be used to explore value drawing of still life objects.

Combine media. Try different papers. Try using shapes without lines. Work with single objects, small clusters or complex arrangements. If a single object gives you problems, isolate it and draw it in several techniques. Combine one of the line activities with a value technique. Continue to explore still life drawing in as many ways as possible.

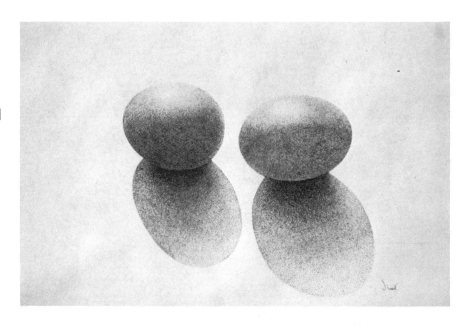

Only dots were used in this student drawing, but careful observation of light and shadow enabled him to create a feeling of form. Pen and ink, 12 × 16″ (30 × 40.5 cm).

Chiaroscuro: Using Light and Shade to Draw Form

Occasionally, you may wish to make finished drawings that fully express form, light and shadow. The drawing of rounded forms requires concentrated observation to be aware of the subtle value changes that indicate form. Representation of form by shading is called **chiaroscuro,** a system (dating from Renaissance times) that involves light, shadow, reflected light and cast shadow. Rounded forms are indicated by gradual changes in value, and sharp edges and corners are shown by abrupt value changes. The light from one object also can be reflected in its neighbor. The key to working with this kind of *realism* is disciplined observation and patience in drawing.

Paul Taylor used pen and ink in defining the form of this jug. He used pen lines in many ways to indicate values, and spattered ink to show the subtle roundness of the object. The jug is 11″ (28 cm) high.

Careful observation and equally careful shading can produce accurate reflections, forms, shadows and refractions. Such student renderings consume many hours of looking and drawing. Pencil, 9 × 12″ (23 × 30 cm).

Analyze shapes, proportions, shadows, reflections, reflected light, transparency, softness, hard surfaces, glass, paper, wood and the many small but important differences that characterize each material and object. Start simply, with one or a few objects. Place a single spotlight, if possible, to cast direct and permanent shadows. Control of shadows is essential, especially if it will take several days to finish the drawing.

Beware of overworking these drawings and having them become tired. The dry media work best in such detailed drawing, but do not eliminate pen and ink completely from consideration.

If the light on your setup is controlled, it will remain constant for many days. A single source will dramatize shadows and emphasize form.

Excellent clustering and arrangement of objects are evident in this student still life. Some objects are completely finished, others are not, a treatment that gives the drawing a unique quality. The value range is complete (white to black) and carefully controlled. Charcoal, 18 × 24″ (46 × 61 cm).

Negative space is highly patterned while positive shapes show only a hint of their labels. Edges are not drawn, but are hinted at by the pattern. The unpatterned spaces relieve textural overload and allow our eyes to rest. Pen and ink, 18 × 20″ (46 × 51 cm).

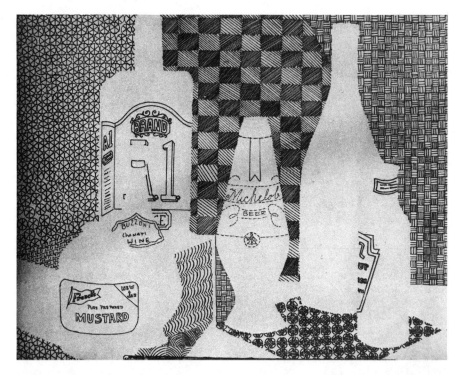

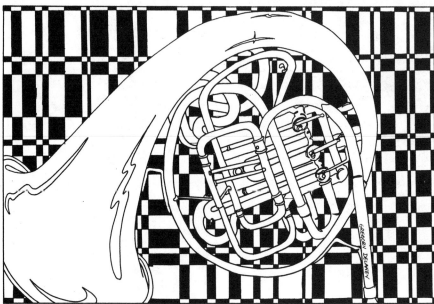

After the horn was drawn in contour, the negative space was patterned in black and white. Pattern transforms uninteresting areas into visually exciting space. Markers, pen and ink, 12 × 18″ (30 × 46 cm).

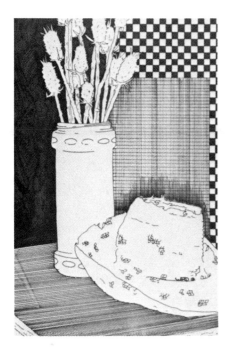

A simple setup, drawn in contour with a marker, is greatly enhanced with the addition of pattern in the background areas. Markers, 18 × 12″ (46 × 30 cm).

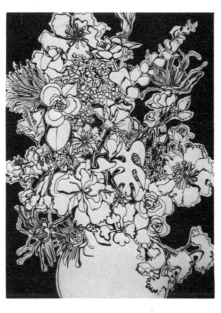

Random patterns occurred when a student simplified the flowers in a classroom bouquet. Linear pattern is emphasized by flat, black negative space. Pen and ink, 23 × 17″ (58.5 × 43 cm).

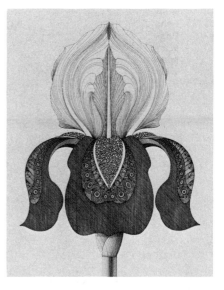

Paul Taylor drew a single iris blossom, but instead of shading in a natural way, patterned the entire flower with delightful linear motifs. The drawing is meticulous and in keeping with the symmetrical design. Pen and ink, 24 × 18″ (61 × 46 cm).

Using Pattern

Wherever you look, you can notice some kind of pattern. **Pattern** is formed by repeated units or motifs, such as lines or shapes. Pattern has two main functions in a work of art: it unifies and organizes specific areas, and it enriches the work visually, making it more complex and interesting. Pattern can be carefully designed or it can be accidental or random. Some patterns are measurable and consistent. Others are less regular, more difficult to identify.

Artists use pattern to enrich the surface of drawings, and apply it in both positive and negative space. After you make a contour drawing of still life objects, you may wish to develop and emphasize pattern instead of value. Your objects will not appear to be real, but their decorative quality can be fascinating and inventive and can please your eye.

You can look for pattern in nature or in manufactured surfaces, in magazines or in your environment. Draw some rough ideas in your sketchbook or on scratch paper. Make up patterns by "doodling" your own ideas or by combining ideas from several pattern sources. If you want your patterns to look controlled and regular, it is best to use markers, pen and ink or sharp pencils when you work.

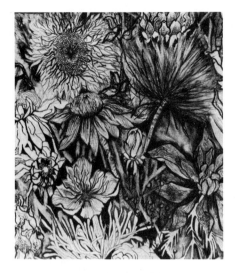

A student held each artifical flower in-
dividually, drew and shaded it, and
placed another alongside until the page
was full. The dark background was
added to unify the surface. Pencil, detail
about 15 × 15″ (38 × 38 cm).

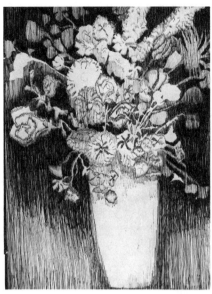

After the outline of this bouquet was
done in pencil, vertical ink lines were
drawn to indicate values. The overall ef-
fect is of texture and pattern. Pen and
ink, 24 × 18″ (61 × 46 cm).

A sensitive and searching line was used
by a student to explore several chrysan-
themum blossoms, 18 × 12″
(46 × 30 cm).

Paul Taylor experimented with dry media
to draw this rose in color. Prismacolor
and pastel, 16 × 12″ (40.5 × 30 cm).

Drawing Flowers and Plants

We usually think of flowers in terms
of color and scent, not as
something to be drawn in black
and white. But the shapes and
forms of blossoms and leaves pro-
vide wonderful subject matter for
drawing, and their organic qualities
are welcome additions to the art
room. Flowers can be drawn singly,
as individual plants, in floral
arrangements or combined with
other still life materials.

Artists traditionally have drawn
and painted flowers as a way of
working from nature while being
confined to their studios for one
reason or another. Flowers have
long been a favorite motif for
designers, fabric makers and dec-
orators. They have become the
subjects for many artists who draw
and paint them because of their
wonderful variety of forms and
because of the way light affects
their surfaces.

Flowers and plants can be drawn
realistically or can be stylized. They
can be drawn in every media—wet,
dry or mixed. Blossoms, leaves and
stems can be enlarged or handled
in ways to make interesting
designs. All kinds of plants, from
tropical blossoms and foliage to
desert cacti, are used as subjects.
The accompanying illustrations pro-
vide a small idea of possible sub-
jects, styles, treatments and direc-
tions that you may wish to explore.

A marker was used by a student to draw this classroom rubber plant in contour, 18 × 12″ (46 × 30 cm).

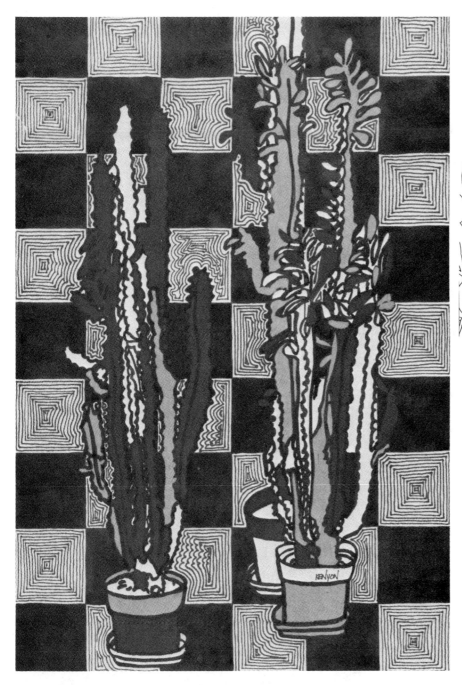

After drawing the cactus with a marker, the student patterned the background and added washes to the forms, 18 × 12″ (46 × 30 cm).

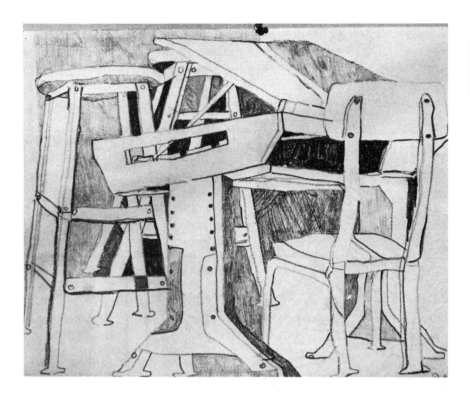

The student who made this drawing started with a red crayon in one hand and a blue one in the other, and drew contours of the chairs and desks with both hands. Shading was added later. Crayon, 20 × 24″ (51 × 61 cm).

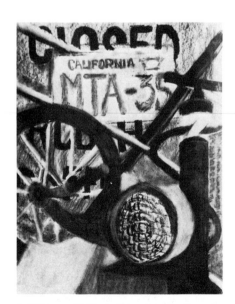

A rather realistic drawing is actually only part of a much larger still life of mechanical objects. Charcoal, 24 × 18″ (61 × 46 cm).

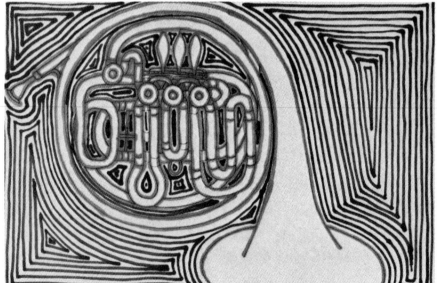

The contour drawing of a French horn was the start of this colorful drawing, which seems to reverberate with sound. Colored markers, 12 × 18″ (30 × 46 cm).

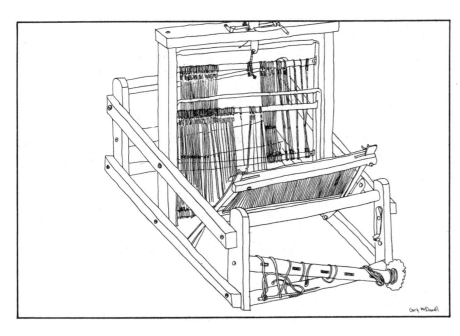

One of the school's looms is an excellent subject for a student contour drawing. Marker, 12 × 18″ (30 × 46 cm).

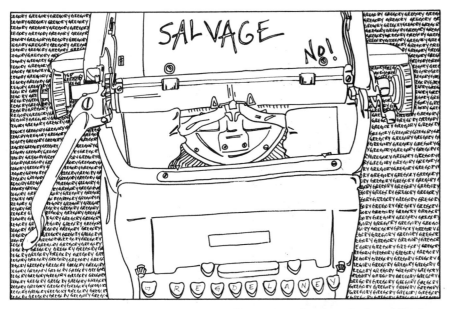

The contour drawing of a typewriter is backed by inked texture—repetitions of the student's name. Black marker, 12 × 18″ (30 × 46 cm).

Drawing Mechanical Objects

Manufactured forms can be grouped together to make fascinating still life subjects or can be studied and drawn separately. Parts of cars, tools, bicycles, typewriters, musical instruments, furniture and a host of assembly line products can present new and different drawing challenges. Their edges are hard, their surfaces are often reflective, and their feel and essence are mechanical.

Depending on the medium used, such objects can be rendered realistically, given a soft organic quality, decorated with patterns or turned into flat designs. They can be drawn in contour, shaded completely or flattened into shapes. They can be drawn individually, in clusters or in formal still life arrangements. Large subjects (like motorcycles) can be drawn in their entirety or details can be selected. An automobile engine or complete motorcycle would make a fascinating permanent model in the art room.

Study mechanical objects carefully. Let your eye run over, into and around them. Decide how you would like them to look in your drawing, and then select the medium that would best meet your goals. Begin with a generalized sketch and work toward your specific conclusion.

Experimental Approaches

Experimentation with still life drawing can take several directions. You can experiment with the media—mix, combine overlay, use different tools. You can experiment with the subject—look at it from above, below, close up, fragment it. You can combine several still lifes, add people to the drawing or place it in unnatural light.

You can take one object and draw it four or five times, overlapping to create a cluster of forms. You can pattern surfaces that are not usually patterned; dot surfaces that are usually smooth; smooth surfaces that are usually textured. You can reverse values—draw all light-valued objects dark, and vice versa. You can make gigantic drawings of small objects or tiny drawings of huge objects.

Experimentation provides alternate views of your subjects and can often lead to fuller understanding and, therefore, better seeing and drawing experiences.

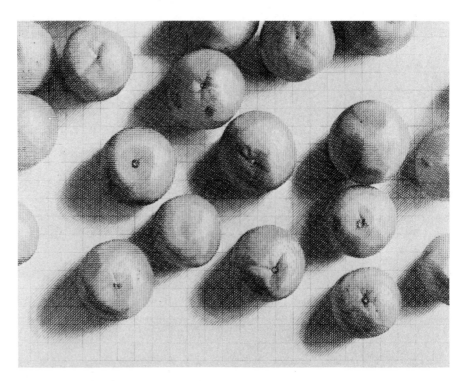

William A. Berry looked straight down on his subject instead of facing it. *Still Life:18,* **1983. Colored Pencil, 30 × 40″ (76 × 101.5 cm). (Photo: Howard Wilson)**

A single doll was overlapped and drawn several times, but the concept also includes the student artist's hand and some shading. Pencil, 24 × 18″ (61 × 46 cm).

The ink bottle (which held the ink for the drawing) is given a dot pattern (pointillism) instead of a smooth surface. Stick and ink, 24 × 15″ (61 × 38 cm).

A portrait of Abraham Lincoln was inserted into a still life drawing to create an experimental feeling. The student chose to complete the portrait and leave the still life unfinished. Pencil, 24 × 18″ (61 × 46 cm).

Activities

Art History

1. Still lifes have been drawn and painted by artists in many styles for many years. Look in art history books to find examples of such paintings. Make a list of ten artists who painted still lifes and include the dates when they lived. The paintings may be in realistic, abstract or Pop Art styles. List the title of one of each artist's still life paintings.

2. In art history books or encyclopedias, find five still life paintings that you like. On pieces of thin typing paper, acetate or tracing paper, trace the linear outline of each painting and label it. The result should look similar to the Georges Braque painting outlined in this chapter, which was traced from *Still Life: The Table,* 1928. Be aware of clustering, overlapping, positive and negative space, balance, and so on.

Criticism/Analysis

3. Study this small still life sketch. Write a few paragraphs, describing ways in which spatial depth is indicated.

4. Study the still life drawing by William A. Berry on the opening pages of Part Three. Write a complete description of what you see. Analyze the drawing and write about how the artist developed or used line, shape, form, value, space, texture, balance, visual movement, emphasis, contrast, pattern and unity.

Aesthetics/Personal Sensitivity

5. Write a one-page essay on one of the following subjects:

- How drawing from still life heightens your awareness of structure and space
- How still life objects can be chosen and set up to express a specific theme
- Modern artists (Cézanne, Van Gogh, Chagall, Picasso) and their use of still life

Production/Studio Experiences

6. Choose a single object and repeatedly overlap it to create a contour line drawing of clustered objects.

7. Select one or more mechanical objects as your subject matter and emphasize pattern in drawing the arrangement.

8. Make a still life arrangement and draw the objects upside-down.

10 DRAWING THE HUMAN FIGURE

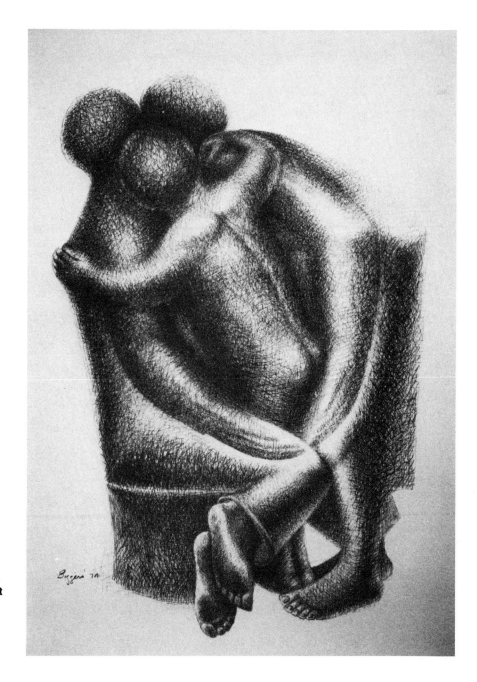

John Biggers, a contemporary American artist, used figures to form a closely knit grouping—to express a sense of family. Faces are not important here; the interlocking, monumental figural forms tell the story. *Family*, 1974. Lithographic crayon, 24 × 18″ (61 × 46 cm).

Albrecht Dürer used many kinds of pen lines to produce the variety of values seen in this drawing. He drew figures extensively, often in exotic costume. The lines are sketchy but the overall impression is of great detail. *An Oriental Ruler on a Throne,* **1494–95. Pen and black ink, 12 × 7¾″ (30 × 19.5 cm). National Gallery of Art, Washington, DC, Ailsa Mellon Bruce Fund.**

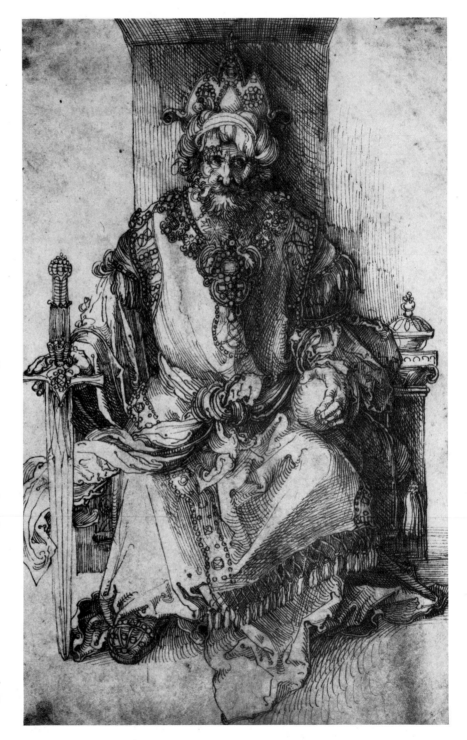

Throughout history, young artists have learned to draw by working from the human form. A model can be positioned in unlimited poses and provide drawing experiences in line, form, perspective and every phase of the drawing process. Looking and seeing experiences can be controlled, and growth in drawing can be measured by how well we record the figure.

The very first artists drew human forms in caves. Egyptian, Sumerian, Greek, and Roman artists drew people. Realistic human forms were not drawn in Europe during the Middle Ages because of religious prohibitions, but the Renaissance saw a new interest in the realistic depiction of the human body. Artists have continued to use people as prime drawing subjects—more than any other—no matter what school or style has been dominant. Artists draw people to learn about seeing, to use in paintings, to make portrait studies, to learn animation, to draw newspaper advertisements and to express themselves graphically.

If you learn to look carefully and record what you see, your ability to create a likeness of the model will improve as time passes. This chapter will help in developing this ability. Each section deals with a different approach. Select some ideas that seem to fit you best, then draw as large as possible, on large sheets of paper. Try different tools and media. Never stop exploring.

If you wish to study anatomical, proportional or structural approaches, look in some of the books listed in the Bibliography at the end of the book. Artists (past and present) who are beneficial to research include: Mary Cassatt, Edgar Degas, George Grosz, Burne Hogarth, Honore Daumier, Rico Lebrun, Kathe Kollwitz, Amedeo Modigliani, August Renoir, Larry Rivers, Charles White, Paul Calle, Anthony Ravielli and others.

The Pose

Models can be posed above, at a level with, or below you. The model's hands can hold something (a book, purse, musical instrument), or be closed, open or reaching. The model can be in any position, (sitting, standing, reclining, bending over) and can be doing something (reading, writing, walking). Models can be posed alone, in pairs or in groups. Surround the model with plants or chairs or still life material. Use costumes and props.

Before beginning any drawing, look carefully at the model and the surroundings for a minute or so. Absorb the lines, textures and feeling—and then begin to draw.

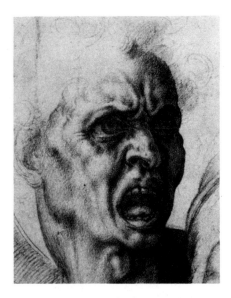

Michelangelo drew this head study for a figure to be painted in his gigantic *Last Judgment* in the Sistine Chapel. The tortured expression is of a soul glimpsing the sights of hell. *Head of a Lost Soul,* about 1538. Black chalk, 10½ × 8⁵⁄₁₆″ (26.5 × 21 cm). Royal Library, Windsor, England.

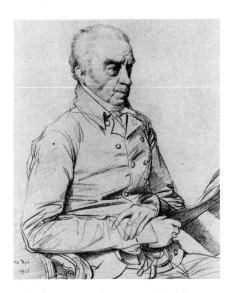

Jean Auguste Dominique Ingres, the great Neo-Classic artist, took great care with facial features of his portrait studies, but his pencil flew quickly over the rest of the figure. *Portrait of Thomas Church,* 1816. Pencil, 7½ × 6¼″ (19 × 16 cm). Los Angeles County Museum of Art, Loula D. Lasker Fund.

Contour Line as Exploration

Contour drawing is probably the most rewarding way to begin drawing. It takes concentration and application, but will produce positive results and learning experiences. Before working on contours, however, spend time making **outline drawings** from a posed model. Draw a line *around* the figure, setting it off from its background.

A lot is missing in an outline, however, since it produces a flat shape. A **contour drawing** will suggest three dimensions, because it involves overlapping forms, curved interior lines, and a feeling of the form. It is good to start by making **blind contour drawings** in which you do not look at the paper while drawing. Do not worry about making perfect drawings. You are trying to learn to see and feel the figure. Begin at a point and let your eye move slowly over a form— draw it without looking. Move your eye; move your pencil. Continue until you have explored much of the figure. Do not lift your pencil from the paper for long periods of time. You may peek once in a while to see how you are doing (and perhaps relocate your pencil) but try not to look at all. It is normal not to end up where you think you should. Keep your wrist rather stiff to help eliminate distortion. However, distortion is usually a positive aspect of careful looking and seeing. Your line should have the feeling of searching and recording, not of a finished and polished study.

Practice all kinds of details, as these students did, in drawing hands, feet and combinations. Fill pages in your sketchbook with such studies.

Make blind contours of a figure, your hand, some shoes, your feet, your own face, your neighbor's face. Concentrate. Draw detail by detail, area by area, contour by contour. Look carefully and record line by line what you see. Use heavy pencils or markers and do not be timid. Do not erase. Do not draw generalizations—only what you see! Draw lines that *contribute* to the whole subject. If you draw every wrinkle in your hand, it might look a hundred years old. Work *slowly* and try to understand what you are drawing.

Donna Berryhill shows us that some professional artists continue to use contour drawing in their work. Her sensitive line beautifully describes her model, and she shaded a few spaces to punctuate the drawing with value. She added contour-drawn flowers and lines to achieve a sense of environment. Pen and ink, 18 × 24″ (46 × 61 cm).

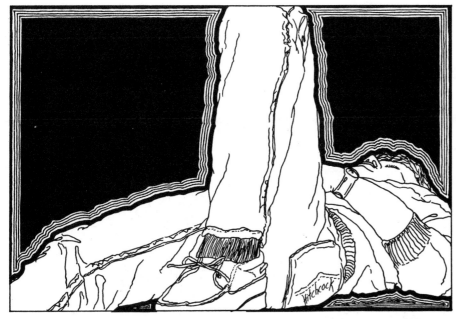

After completing a contour drawing, this student drew a heavy line around the outside shape, added four thin lines to echo the heavy one, and filled the remaining negative space with India ink, 12 × 18″ (30 × 46 cm).

When making an outline drawing, pose the figure so arms and legs are somewhat visible. The searching lines of a blind contour drawing (below) should not be perfect, but should indicate seeing and feeling the surface configuration. 7″ (18 cm) high.

Practice contour drawings for a week or more. For variations, switch hands to draw; begin at the bottom of the figure and draw up; use 18 × 24″ newsprint or bond paper and draw with heavy pencils, markers, conté crayon, stick and ink or brush and ink. Vary your materials, but concentrate on line and form. Keep lines free of repetition, making them clean and not fuzzy. And enjoy your explorations.

After some practice, contour drawings can be very complete linear statements that indicate form. The saxophone-playing model was seated atop a ladder (note the distortion), 18 × 24″ (46 × 61 cm).

Using Positive and Negative Space

Contour drawing uses line to separate the figure from the space around it. The drawings on these pages use changes in value to show the same thing. The figures stand out from the background because of a contrast in values, dark and light.

You may use flat shapes, cutouts or textures, washes or lines, but the results are similar—concern for positive and negative shapes rather than the contour line. The values are up to you. You may work dark positive areas against light negative shapes, light positive shapes against dark negative space or various combinations. You may use one or several values, textures or patterns to do the job.

Drawings can be made with flat sides of charcoal (or crayon, markers, etc.) directly from the model with no sketch lines put down first. This forces a careful look at *shapes* and edges and the relationships between positive and negative spaces. Or you may wish to outline first before applying value or pattern. Careful observation will help you see interlocking shapes, enclosed shapes, related shapes, elongated shapes, value relationships and contrasts.

The big shapes are important when working with such simplified forms. The addition of detail or contour lines with such bold shapes can result in interesting combination drawings. Try some of the ideas on these pages or work out some of your own ways of using positive and negative shapes to make figures.

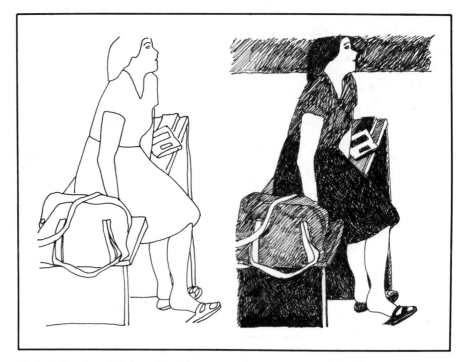

Linda Doll makes drawings like this before she paints her figures with flat shapes of color. At left, she reduces the figure to a few simplified outlines. She then uses two values (these are made with a marker) to provide substance to the drawing. She purposely wants the shapes and figures to remain flat.

Use a crayon or marker and "feel out" the positive shape. Do not outline, but start shading in the middle and work out to the edges. Then, use the same technique to define negative space. Shade up to the edge and let the figure remain. Keep the drawing tools moving and do several of each technique from short, two-minute poses.

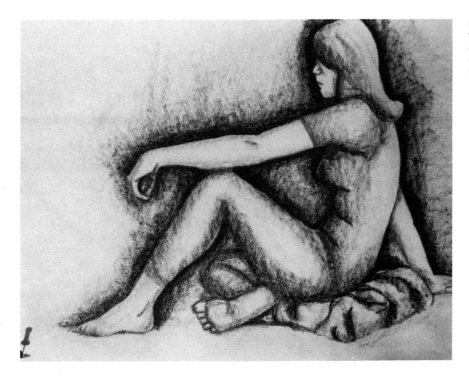

Black and brown wax crayons were used to indicate negative space and provide an edge for the student model. Some shading in the figure suggests form. Crayon, 16 × 20″ (40.5 × 51 cm).

After lightly outlining his subject with pencil, the student artist used carefully patterned negative spaces to allow the figure to emerge. Pen and ink, 24 × 18″ (61 × 46 cm).

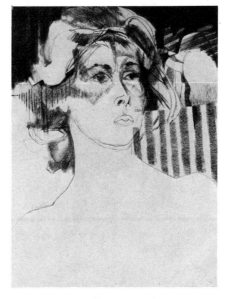

Diane LaCom combined a sketchy outline with delicately patterned negative space to set off her portrait. She shaded in parts of the face to suggest form. Charcoal, 24 × 18″ (61 × 46 cm).

The Search for Form (Modeling)

The search for form involves finding ways to represent the dimensions of the human form—roundness and flatness, indentations and projections, forward and back. Many techniques are used by artists who wish to have their drawn figures occupy visual space.

You can use line to indicate forward, back, up, down and around. Drawing parts of the human form in perspective is called **foreshortening.** It is a difficult aspect of figure drawing to master, and much practice in your sketchbook is needed to become proficient. If an arm or leg is projecting toward you, draw it in contour (with one eye closed), just the way it appears to you. Often, it is best to begin drawing the part that is nearest you, and work back into space as you draw. A **weighted line** (heavy and light) can also suggest form since it has its own feeling of dimension.

Value change is probably the easiest way to indicate form, just as it is in drawing still lifes. To give a feeling of modeled roundness to the arm, a graded shadow defines the form. To draw an angular face, sharp value contrasts delineate the areas. These value changes (or shading) rely on a source of light, real or contrived, to help in recognizing the form. Study again the sections on chiaroscuro.

Searching for ways to indicate form can make use of line and

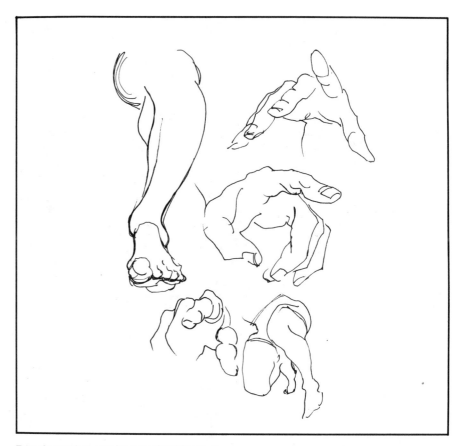

Foreshortening can be practiced in your sketchbook. Start with the part closest to you and work back into space.

value singly or in combinations. Your individual discovery is what is truly exciting. This is the main reason that formulas are not recommended for producing dimensional effects. Notice how each artist in the book, not only on these pages, indicates form. A variety of methods should be tried in your search for a way to show form.

The student who drew this portrait in her sketchbook used line and shadow. Her drawing is sensitive and effective. Pencil, 11 × 8½″ (28 × 21.5 cm).

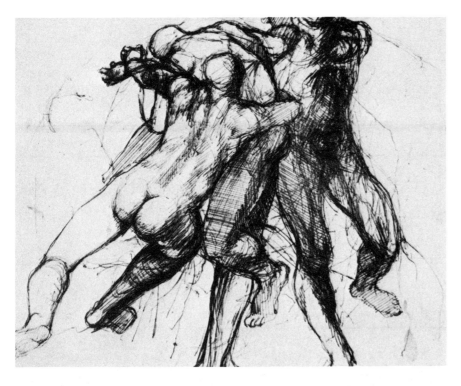

Sketchbooks are excellent places to work on a personal style to represent form. Notice that line itself, if weighted, can depict form, as in the leg at the lower left. Ballpoint pen, 8 × 10″ (20 × 25.5 cm).

Jean Charlot drew this powerful work with a lithographic crayon on a stone block and made a print of it. Light and shadow have created dramatic, powerful forms. *First Steps,* 1936. Lithograph, 13¾ × 9″ (35 × 23 cm). Philadelphia Museum of Art, gift of Sam Golden.

The student who made this drawing of a classmate used both foreshortening and shading to indicate form. Charcoal, 24 × 18″ (61 × 46 cm).

Charles White used cross-hatching and parallel lines to depict form. The large folds and smooth contours help portray the bulk of the figure. Pen and ink, 10 × 8″ (25.5 × 20 cm), 1978.

Drawing Faces

Faces can be drawn in contour line or fully shaded, placed in light or shadow, flattened or rounded, complete or fragmented. Use crayon, charcoal, pencil or any other medium. Draw from plaster casts, photographs, models, friends or yourself. Regardless of the situation or medium, the drawing of faces is based on *observation.* It is necessary to look carefully at faces, noticing curves, relationship of the parts, shadows and details.

Draw the person opposite you. Draw the teacher or have a student model pose. Draw a family member or look in a mirror and sketch a self-portrait. Look carefully, see and record. Look at black and white photographs and other artists' drawings and paintings of faces. Note the ways a face can be shaded, broken into parts, or sketched. Look at faces in other parts of this book. Find out how the Cubists fractured the planes of faces. Feel your own face to notice the bones and ridges, hollows and fleshy places.

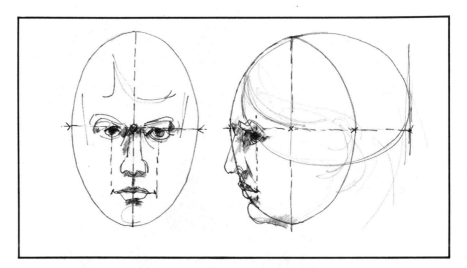

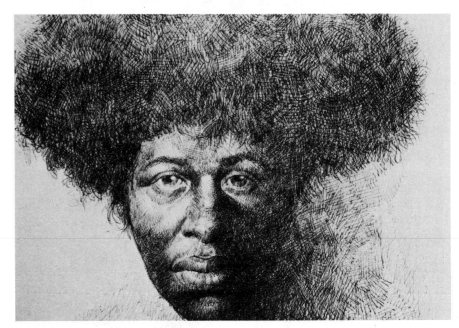

Charles White used a pen to develop effectively a feeling of form through soft, subtle value changes. The drawing is based on careful observation and many years of figure drawing experience. Pen and ink, 18 × 12″ (46 × 30 cm).

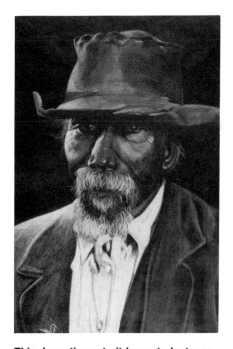

This dramatic portrait by a student was drawn with white pencil on black paper, a technique that allows you to build lights instead of shadows, 24 × 18″ (61 × 46 cm).

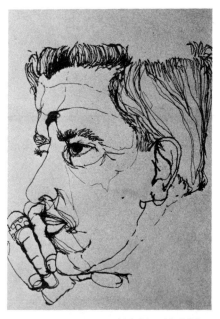

Starting an ink line on wet paper, a student drew his teacher with careful concern for characteristic details. The lines got harder as the paper dried. Stick and ink, 24 × 18″ (61 × 46 cm).

A few basic proportions might help you get started. You may begin with generalities but do not *rely* on formulas. Observe and notice specific characteristics. Notice what happens when heads are tilted forward or back. If parts of faces are difficult, enlarge those sections from a photograph. Look in a mirror and draw the problem part from your own face several times. Work on details.

Place a hand by the face, put a funny hat or shawl on the head or turn the face sideways. Do anything to develop interest. Make quick sketches and produce finished drawings. Each experience adds to your ability to see—and to your concept of drawing faces.

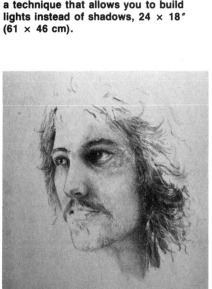

David Mesplé drew this portrait as part of his preparation for a painting. Note the concentration on some details and lack of detail in other areas. Pencil, 10 × 9″ (25.5 × 23 cm).

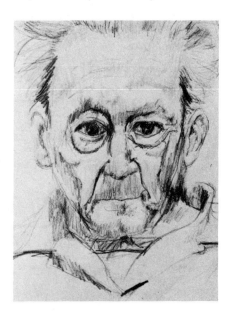

Working from a model, a student drew from observation, sensitively recording what was seen: texture, shadow, light, and—most importantly—individual characteristics and feelings. Pencil in sketchbook, 12 × 9″ (30 × 23 cm).

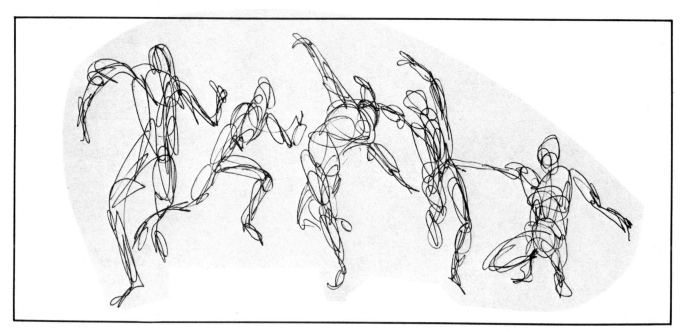

Fill pages in your sketchbook with gesture drawings of figures in action. Base them on observation, memory or imagination. Study halls and terminals are excellent places to practice such sketches.

Working from a photograph of a school football game, this student made a large gesture drawing on kraft paper. It emphasizes *action!* Ebony pencil, 24 × 36″ (61 × 91.5 cm).

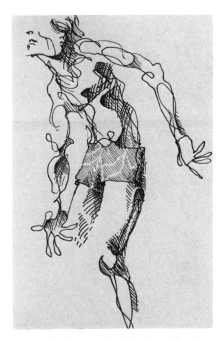

A continually moving line describes the action, and other lines add value but retain the active characteristics. The student was selective in choosing parts to draw to express action. Marker, 12 × 9″ (30 × 23 cm).

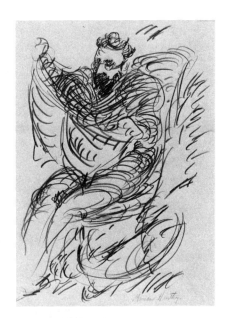

Marsden Hartley drew this man in a rocking chair so we can sense and feel the continuous movement. How did he accomplish this? *Man in a Chair,* 1930. Pencil, 12 × 9″ (30 × 23 cm). Los Angeles Country Museum of Art, gift of Frank Perls.

A student gesture study is one figure in ten sequential poses. You can see the figure turning around and sitting down on the floor. Charcoal, 24 × 18″ (61 × 46 cm).

Gesture Drawing/ Figures in Action

Dynamic action studies seem to generate interest and enthusiasm in drawing classes. Models may be posed in active positions, but the drawing will have to move rapidly because such poses are difficult to maintain. Action can be studied in photographs and drawings made of movements not possible to pose: off-balance, falling down, mass football-like action, or reaching and leaping basketball players.

Sketchy lines suggest action and make the drawing itself an active element. Edges and contours are constantly changing when the subject is moving, so clean, precise lines do not indicate action.

Gesture drawing—a scribbling active line that emphasizes movement—is an excellent way to develop an awareness of dynamics. Many one- or two-minute gesture drawings provide excellent experience in observing and recording motion. Watch a dance or physical education class in practice and sketch movement. Get the big motions down first, with correspondingly large drawing movements. Then refine if you wish. Try to draw the action rather than the person.

Make some drawings that show a rapid progression of movements—the figure in various positions—all superimposed like a stop-action photograph or strobe light sequence. Have the model move slowly through a sequence of motions (turning around, sitting down, etc.) again and again to establish a pattern, and draw the model at several places in the pattern. A confident and a natural gesture drawing can only be done through much observation and practice.

Costumes and Props

A change in the model's wardrobe will generate new energy in your figure drawing. Throw a towel over the model's head, add a jacket, discard the shoes. Have several interesting clothing items around. Perhaps complete costumes could be rented for a week at a time. Have classmates pose in uniforms or dance leotards. Every change stimulates more careful looking.

Props also have a tendency to promote closer observation. Have the model hold or play a musical instrument, sit in an ornate chair, carry shoes, sit in a still life setup. If possible, pose the model in some sort of action and use some props. Masks placed on the model will eliminate the problem of drawing a recognizable face. The sometimes bizarre impression of a mask together with a costume can encourage you to *interpret* the subject, along with observing and recording.

It seems to follow that the more carefully these added items are observed, the more searching are the lines that are recording the face and hands of the model. Some models seem to generate better drawings than others, but costumes and props can make almost any model more interesting and stimulating to draw.

The doorknob, door, wall and paintbrush are important props and set a wonderful mood for this student mixed media drawing. Pencil, brush and ink wash, 12 × 16″ (30 × 40.5 cm).

If the costumed model is in the center of the room, you may get a chance to draw from a different angle, as this student discovered. Charcoal pencil, 24 × 14″ (61 × 35.5 cm).

School dress-up days provide an excellent opportunity to draw from costumed models. These student drawings were done from such models. Above: stick and ink and wash, 24 × 13″ (61 × 33 cm); below: charcoal, 24 × 18″ (61 × 46 cm).

Vincent van Gogh used the same short, jabbing strokes with his pen as he used in his oil paintings. He posed his uniformed mailman as a model and used a chair and table as props. *The Postman Roulin,* 1888. Reed pen, ink and black crayon. Los Angeles County Museum of Art, Mr. and Mrs. George Gard de Sylva Collection.

David Mesplé makes mural-sized drawings that often have powerful emotional overtones. This drawing of Vincent van Gogh shows the artist in a period of great anguish. *Van Gogh's Garden,* 1985. Pencil on gesseod canvas, 83 × 126" (211 × 320 cm).

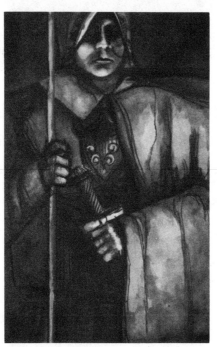

The large figure seems to burst out of the frame. The student model is placed slightly off-center, but movement of dark and light tend to afford balance. Wash drawing, 36 × 24" (91.5 × 61 cm).

An insignificant hug was enough to motivate a student to record the emotion in pen and ink, 12 × 9" (30 × 23 cm).

The strong value contrast and placement of the face in this student drawing is critical to its visual impact. Ebony pencil, 24 × 14″ (61 × 35.5 cm).

Composition, Design and the Figure

Where the figure is placed on the paper or what its relationship is to the rest of the drawing is a matter of **composition**. In a finished drawing, all the principles of design should be considered, but in sketching they might be overlooked. In fact, when sketching, it is often the disregard for these principles that gives the drawing its spontaneity.

When no backgrounds are used, figures can be placed off-center, usually moving or looking *into* the larger open space. If placed alone

A simple happening can be the cause for a sensitive illustration. Do not ignore your family as subject matter. Stick and ink, 24 × 18″ (61 × 46 cm).

in the center of the sheet, the elements in the environment should provide balance.

Single figures can be shown in their entirety or partially. They can be slanted, stretched or turned sideways. They can be self-contained or may need environmental assistance. They can be placed on the page for dramatic effect or can become part of the overall design.

The figure itself might become the basic shape for problems in design: pattern, texture, line, tone, movement. Try applying some of the normal still life design problems to the figure. Work with selected parts rather than the entire figure. The greater the variety of searching that goes on, the more familiar the various aspects of composition and the figure will become to you.

Illustration and the Figure

Motivation for figure drawing might include illustration, or telling a story with the drawing. Figures may suggest the story (Rembrandt worked in this way), or the story may suggest the drawing. Most illustrators today draw figures to accompany stories.

Ideas for illustration can be found in poetry, songs, books, film or the Bible. A costume worn by the model might suggest a story, and the feeling could be transferred to the figure. The dress, facial appearance or physical makeup of the model can recall a story or inspire an emotion that can be projected in the drawing. The pose of the model might recall an idea or action that can be illustrated.

For example, several students may pose, sitting around a table. From the sketches of interacting figures, several illustrations might be suggested: Vikings plotting war movements, colonists watchfully eating dinner, a coaching staff diagramming strategies, students questioning a teacher, and so on.

Similarly, the design elements and compositional techniques of master painters can be analyzed and redrawn in various styles and media. Reworking such compositions provides a fine insight into spatial arrangements as well as an opportunity to experiment further with the figure.

Experimental Figure Drawing

Some experimental figure drawing methods rely on different styles or new materials; others depend on the figure itself. Those stressing techniques might include collage, stencil or combinations of media to produce exciting results. Experimental styles might make use of the figure as texture, pattern or design. Tracings and rubbings can become points of departure for further exploration. Using techniques usually associated with other drawing problems (Pop Art, still lifes, surrealism or landscape) might trigger stimulating project ideas.

The figure itself can be used in several ways. Put the model in an elastic sack and draw the sculptural forms. Drape the model completely in sheets and work on the folds of the material. Figures can further be explored by drawing huge close-ups, by looking down on them, using extreme simplification, developing patterns, and so on. Remember, there is no "best" way to draw figures. The greater the variety of approaches, the more apt you are to find your individual style. It is impossible to exhaust the possibilities. Select one or several, adapt and add, and always be open to new or better ideas—especially those you may discover yourself.

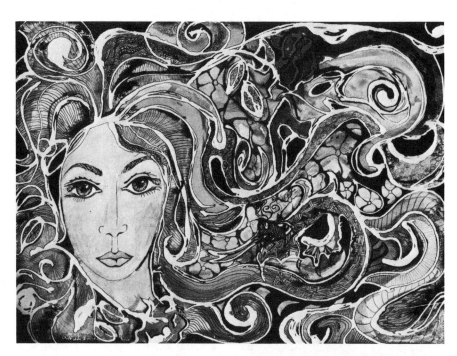

After a pencil sketch, this student "drew" with a bead of white glue and, when dry, used wash, ink, watercolor and colored pencils to develop patterns that fill most of the spaces. Mixed media, 18 × 24″ (46 × 61 cm).

Using a hugh piece of brown kraft paper, this student drew part of her instructor's face in gigantic proportions. Purple crayon on wrinkled kraft paper, 36 × 24″ (91.5 × 61 cm).

Louis Dow experimented with pen and ink technique in this drawing, and used thousands of short lines, each about ¼″ (.5 cm) long, to develop his figure subject. *Michelle at the Mirror,* 1986. Pen and ink, 14 × 9″ (35.5 × 23 cm).

Use a different medium, as this student did, to spark new interest in drawing figures. This subject was scratched and drawn from a photograph taken in photography class. Scratchboard, 12 ″ (30 cm) high.

Attempts at caricature are excellent ways to discover aspects of figure drawing. Student drawing in ink and colored markers, 12″ (30 cm) high.

Activities

ART HISTORY

1. Portraits and figures have been drawn and painted for centuries. Look in art history books and find some examples. Make a list of ten artists whose figures and/or portrait paintings you like. Include the dates of their lives and the title of one of their figure paintings that you like.

2. Compare and contrast *Head of a Lost Soul* by Michelangelo and *Portrait of Thomas Church* Jean Auguste Dominique Ingres, which are illustrated in this chapter. Discuss purpose, emotional content, model, three-dimensionality (form), use of medium, size and other aspects of your choosing. Why is each artist's drawing appropriate for his time in history?

CRITICISM/ANALYSIS

3. Write a short paper defending or denying one of the following statements. Illustrate your paper with your own drawings.

- It is possible to use *line* to show spatial *depth.*
- Dark values *must* be used to draw *form* convincingly.
- *Value* can only be made with soft, broad strokes of charcoal or crayon.
- Soft blurry edges are helpful in establishing a sense of action in a drawing.
- Contour and gesture drawing both make use of *line.*

AESTHETICS/PERSONAL SENSITIVITY

4. Study the drawing by Donna Berryhill in this chapter. Write a description of what you see. Then answer the following questions: How did the artist establish a mood in the simple drawing? How does the drawing make you feel? Is the artist's statement complete, or should she have added more? Why or why not? Do you like the drawing? Why or why not? If it were your drawing, would you add or delete anything? What? Why?

PRODUCTION/STUDIO EXPERIENCES

5. Draw blind contours of your feet. Use at least three different poses.

6. Draw an entire figure or just a selected part, using value change only to represent form.

7. Draw an illustration inspired by your favorite song.

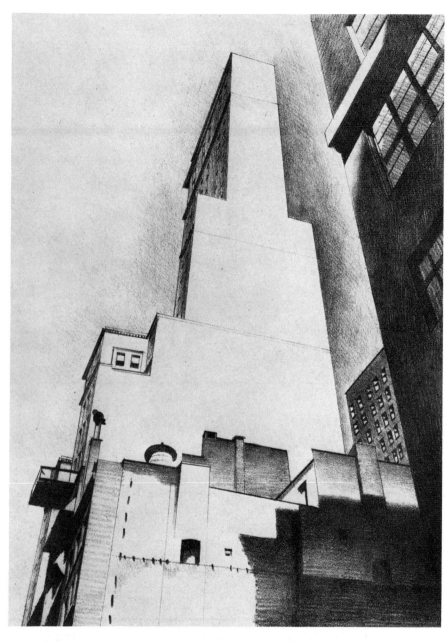

Charles Sheeler loved to draw American cities, and here chose an "ant's-eye view" with vertical perspective added. He drew with lithographic crayon on a stone, which was printed to make multiple images. *Delmonico Building*, 1926. Lithograph, 10½ × 8½" (26.5 × 21.5 cm). Fogg Museum, Harvard University.

Throughout art history, some artists have been more interested in drawing and painting buildings than others. A list might include Giovanni Piranesi, Antonio Canaletto, Charles Meryon, Paul Cezanne, Claude Monet, Fernand Leger, Lyonel Feininger, Joseph Stella, Charles Sheeler, George Bellows and Edward Hopper. Many other artists included buildings and interiors in their paintings as environments for figures.

Develop your own individual drawing style in working with structures. Your personal style will grow and emerge only out of constant drawing. It can be valuable to check out the drawing styles and techniques of Paul Hogarth, Richard Downer, Ernest Watson, Robert Cottingham, Richard Estes and others, just to see how they handle various problems. Carefully study the drawings in this chapter to learn how other artists approach architectural subjects.

Architects and architectural delineators (see Chapter 5) make their livings by drawing buildings and their details. They and all other artists who draw buildings must have working knowledge of perspective.

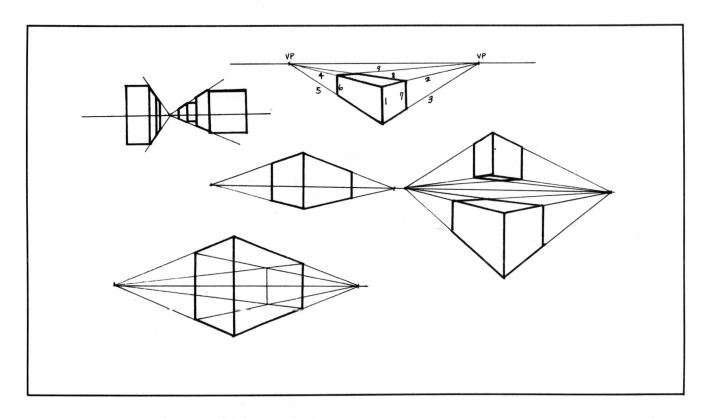

Perspective—Drawing in Three Dimensions

Perspective is the technique of drawing objects the way they appear to the eye. We know from observation that things look smaller in the distance and drawing them that way gives the illusion of depth of space. A feeling of depth is also achieved by overlapping shapes: a tree in front of a house visually indicates a space between the two. **Aerial perspective** refers to the technique of making distant objects less distinct and often lighter in value in order to show spatial relationships.

Linear perspective is a mechanical process in which lines recede to vanishing points to create a three-dimensional feeling. A **vanishing point** is a point at which the horizontal lines in a structure would converge if extended. Lines on a building (roof, window or foundation lines) that run away from the viewer *all* begin to converge toward the horizon or **eye level**—an imaginary line across the picture at the level of the observer's eye. All horizontal lines in a building that are above the eye level will slant

This drawing shows a basic interest in linear perspective, but not an accurate measuring. A fundamental knowledge of perspective drawing enables artists to capture the *sense* or *feeling* of depth in space, and to show it effectively.

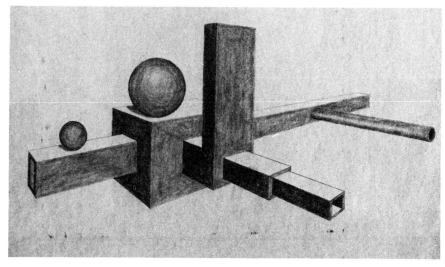

A student artist used accurately drawn perspective lines to create this imaginary setup. Pencil shading emphasizes the dimensional feeling.

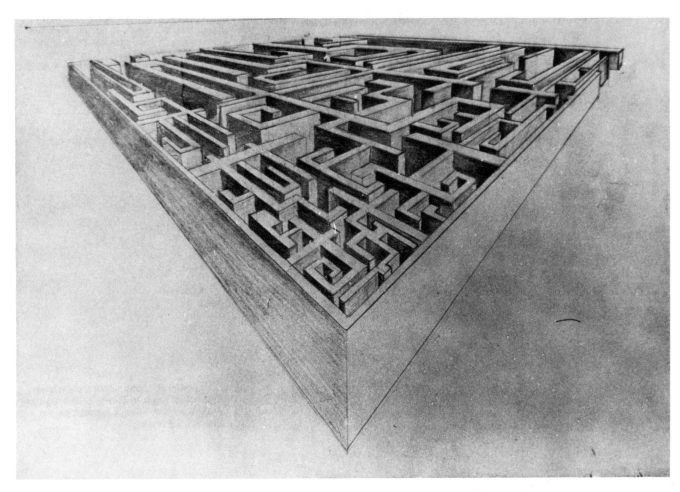

A student used both linear perspective and shading while drawing this imaginary maze in pencil. All horizontal lines lead to one of two vanishing points; all vertical lines are perpendicular to the base of the paper.

When George James drew two old houses in his sketchbook, he was not concerned with *mechanical accuracy* in perspective. He wanted to create a *feeling* of three-dimensionality. How did he accomplish this?

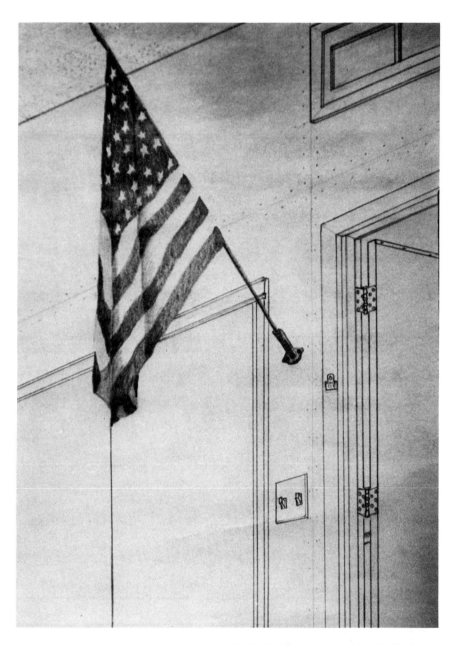

downward to a vanishing point and all lines below the eye level will slant *upward* to meet at a vanishing point. When looking at a building head-on, or when looking down a street, only one vanishing point is needed. Drawing buildings from an angle can cause technical problems, however. When looking at a building from an angle, two vanishing points are required. See the sketches for examples.

Drawing buildings on hills or in valleys can be difficult. Apply what you have learned about linear perspective—the solution can be figured out in the same way. Try several perspective problems as you begin to draw architecture to familiarize yourself with the functions and uses of perspective.

Once you understand the principles of linear perspective, you need not be a slave to it. Consider it a tool that can help you draw architecture, landscapes, figures and still lifes more convincingly.

A shaded flag was combined with linear perspective in this student project that involved the art room walls.

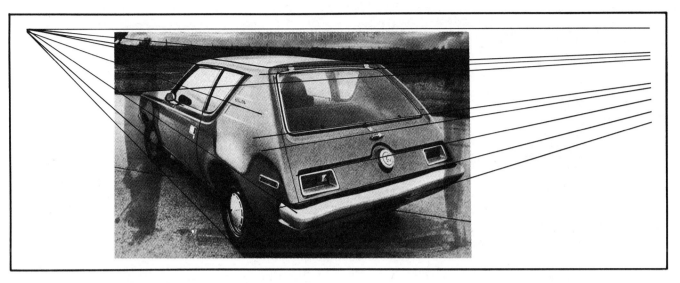

Photographs can be drawn over, illustrating the principle of two-point perspective. But look out for distortion caused by wide-angle camera lenses. Lines can be drawn on photos of cars to vanishing points so that automotive perspective can be studied. Photos can help a great deal in teaching perspective.

Putting Perspective to Work

A study of photographs of buildings is an excellent way to clinch your understanding of perspective principles. Lines drawn over magazine illustrations will strengthen newly learned ideas. A feeling of depth in a drawing can be emphasized by varying the weight of the lines. Objects nearer the viewer can be drawn with heavier lines than distant trees and buildings. Washes or pencil shading should be darker up close, lighter farther away. This aerial perspective produces a feeling of solidity in structures.

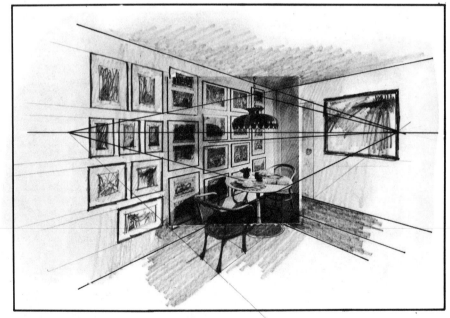

Using the lines in the photo, find the vanishing points and continue the lines of the room or house, exploding the photo with pencil and extending the textures and furniture from the photo outward. Two-point perspective in a room (same as inside a box) can be drawn over many photos, and also extended to clinch your understanding of perspective concepts.

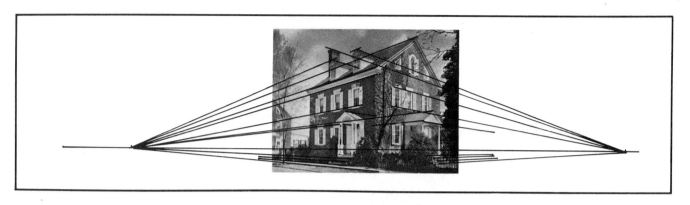

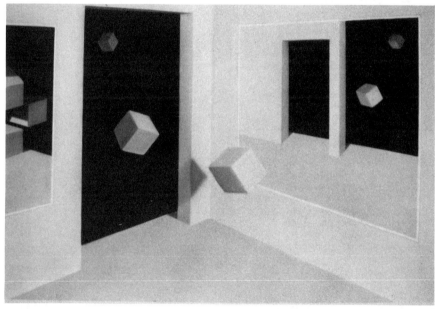

In drawing cities and structures, the feeling of depth is enhanced by framing the foreground with close-ups of building corners, windows or trees, and perhaps by keeping it simple. This forces the eye into the middle ground where the main subject is often found.

The overlapping of buildings also pushes others back into the picture, and shading from a single light source strengthens the feeling of solidity. To emphasize bright sunlight, put detail in the shadows and leave sunlight areas void of detail. This produces a feeling of glare, as if the brightness of the sun had eliminated detail. Each perspective device can be effective; using them all together can be extremely dramatic.

As you walk or drive through town, notice how these ideas really work. You do not have to sketch a building, just look and see that the principles of perspective drawing are always sound.

Richard Parker uses perspective to create astonishing results. A normal room is turned into a surrealistic fantasy when cubes are made to float weightlessly in space. Notice how shading and shadows strengthen the sense of space. *March 1986, Number VI,* **charcoal and chalk, 30 × 44″ (76 × 112 cm).**

By overlapping shapes (buildings), depth and space can be shown. The bases of the shapes (dark lines) also appear farther away the closer they are moved to the horizon line.

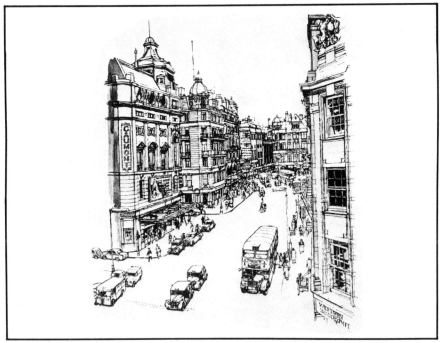

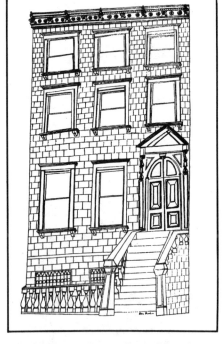

Interpreting the Urban Scene

Buildings as well as people exist in the city. Obviously, the buildings are there because of the people. Although some artists are fascinated by structures themselves and their history, other artists' hands are set in motion by the presence of people.

In interpreting a city or town, always be sensitive to the presence or lack of people. Human figures can be placed in the drawing to show scale or comparative size, or they may become central to the feeling of the drawing. Does the presence of people suggest dense crowding or bustling energy? Does the lack of people suggest serenity or loneliness?' You may wish to show construction details in your

Richard Downer used his characteristic detailed style to show his hometown, London, in one-point perspective. People and vehicles bring the city to life. The large white space of the street is a restful area in a complex subject. *Haymarket, London* **is from his book,** *Drawing Buildings,* **courtesy of Studio Vista Limited.**

architectural drawings or only emphasize major shapes—or you may make a caricature of specific buildings. Be observant and look for certain styles of architecture, decoration, street lights, parks, statues or mailboxes that are characteristic of one particular locality. Study such features with care, and project your feelings about them in your drawings.

Cities can be shown in daylight or at night, from a distance or close up, in individual parts or

Ben Shahn used a mechanical line for *Brownstone Front,* **1950, but did not concern himself with accurate perspective. Slight distortions tend to present a caricature-like image. Pen and ink, 37¾ × 25¼″ (96 × 64 cm). Hood Museum of Art, Dartmouth College, New Hampshire.**

massed together in order to project certain moods or feelings. How you draw urban subjects depends on how you feel about them. If you think cities are exciting or fear-provoking, then project that feeling in your drawing. Be sensitive to the contrasts in a city: old vs. new, restoration vs. decay, crowding vs. open space. Your feelings about these factors will color your interpretation of the urban scene and develop into your personal style.

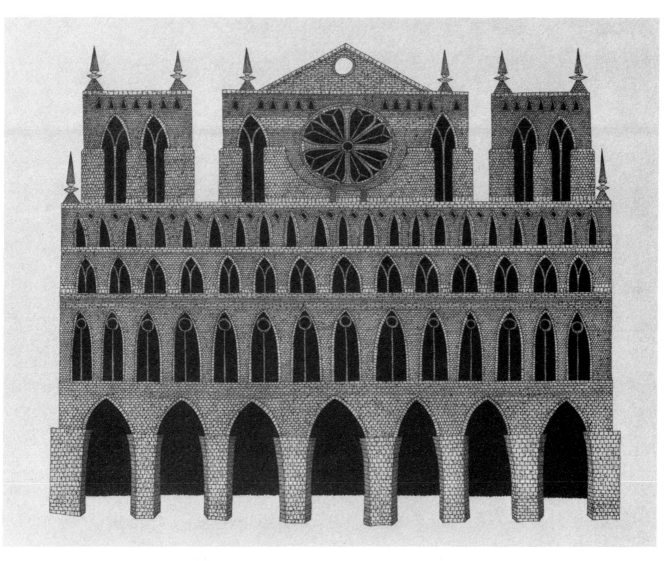

Paul Taylor emphasized the arches and stonework with characterize this building. All environmental material is deleted and only the structure remains in a portrait-like presentation. Pen and ink, 18 × 24″ (46 × 61 cm).

An oriental pagoda was first outlined with a thin black marker. Then parallel lines were added with large colored markers; 12 × 9″ (30 × 23 cm).

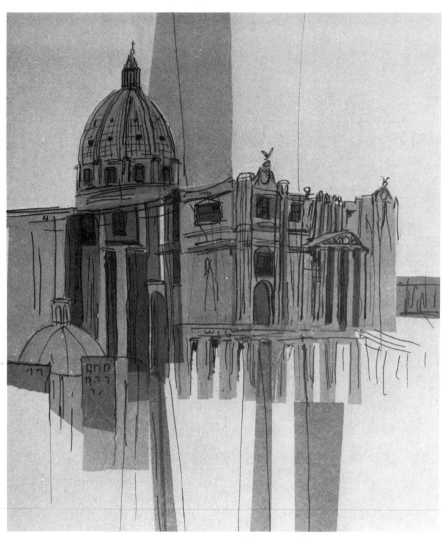

Experimental Approaches to Drawing Architecture

Experimental architectural drawing is not done too often, but some techniques can be fascinating. Media can be explored experimentally while the artist is using urban subjects. Collage and drawing can be combined effectively and crayon etchings and resists and mixed media combinations can provide colorful and exciting results.

After the building was drawn with stick and ink, tissue paper was cut into large chunks and adhered with clear lacquer. Mixed media, 24 × 20″ (61 × 51 cm).

This crayon etching was made using white tempera (instead of the usual black paint) over wax colors. The city design was scratched on a 14 × 24″ (35.5 × 61 cm) piece of tagboard.

Experimentation in working techniques themselves can provide different directions. Draw on unconventional backgrounds or handle different aspects of the city with different media. Make the buildings organic rather than static blocks. Combine indoors and outdoors in a single drawing (through a window) or bring the country into the city.

Exploratory handling of subject matter can provide startling effects. Distort perspective or even try reversing it. Break up the parts of a city and either leave it fragmented or put it together in a bizarre fashion. Put the city under water, or underground. Try to apply some cubist, pop, or art deco techniques to city drawing. Flatten out a city, with no perspective at all—just pattern and shape. Simplify a city street into black and white shapes with no middle values. Each experiment should help you see architecture more clearly and with more perspective eyes. Since awareness is one of the goals in drawing, any problem that stimulates seeing in a new way is valuable.

Contour drawing is often used for figures and still lifes, but here a student used it to draw part of her art room—with open door and a glimpse outside. Marker, 18 × 24″ (46 × 61 cm).

Activities

ART HISTORY

1. The principles of perspective were established by Euclid about 300 B.C. They were not made practical, however, until the Italian Renaissance, when Brunelleschi (1377–1445) developed a system of linear perspective. Research this artist and his contribution to perspective drawing. Write a paper or give a report on how he discovered and developed his ideas.

2. Canaletto (1697–1768), the great artist of city subjects, specialized in scenes of Venice, Italy. His use of linear perspective and his attention to structural details is astonishing. Research Canaletto and prepare a short report on his style, subject matter, travels and use of perspective. Why did he draw buildings? What media did he use? Xerox some examples and illustrate your report.

CRITICISM/ANALYSIS

3. Write a short essay on the two major kinds of perspective: linear and aerial (atmospheric). Define the terms and tell how they are alike and how they differ. How can both be used in *drawing*? Illustrate your essay with historic examples or your own drawings.

4. Study the three architectural drawings by Charles Meryon, Charles Sheeler and Paul Taylor at the beginning of the chapter. How are they alike? How are they different? Make a chart with three columns, one for each artist. Under the name of each, analyze his work according to these criteria: use of line, use of shape, use of texture, use of aerial perspective, use of shading, use of value contrast, use of drama.

AESTHETICS/PERSONAL SENSITIVITY

5. A variety of successful architectural drawing styles are shown in this chapter. Look at the work of Charles Meryon, Charles Sheeler, Paul Taylor (two drawings), Richard Parker, Richard Downer and Ben Shahn. Select the one drawing that you like best and describe the media, subject and artist's style. Why do you like it? How does it make you feel? How do you think the artist felt about architecture?

6. Oriental perspective is based on different principles than either linear or aerial perspective. Research oriental perspective and write a paper or prepare a short video program on the subject. Explain how space is used and how depth is shown. Which system is more mechanical; more sensitive; more subtle; more exact? Which involves your visual sensitivity?

PRODUCTION/STUDIO EXPERIENCES

7. The drawing of Charles Sheeler early in the chapter makes use of three-point perspective—an ant's-eye view looking up into the sky. Make a drawing of your house, a school structure or an imaginary building using this technique.

8. Draw your own house or a house in your neighborhood. Practice the principles of perspective, but do not worry about mechanical exactness. How might extreme weather be used to create drama in your drawing?

12 DRAWING FROM NATURE

Rembrandt recorded many of his nature interpretations with a pen and wash drawing technique. Buildings often are part of his landscapes. *Cottages and Barn Beside a Road,* **1650. Pen and gray-brown bistre wash, 4⅛ × 7″ (10.5 × 18 cm). National Gallery of Art, Washington DC, Rosenwald Collection.**

Drawing from nature is generally called **landscape drawing.** It encompasses all the major elements of our natural environment: land, water, sky and vegetation. Landscapes have probably been drawn, painted and photographed more than any other subject. The variety of style and interpretation is endless.

Chinese artists drew landscapes for centuries. The natural environment first became important in Western art during the Renaissance, when artists used observed nature as backgrounds for their figures. In the sixteenth century, Albrecht Dürer and Pieter Brueghel made masterful landscapes, both real and imagined. Rembrandt, Claude Lorraine and Nicholas Poussin created certain moods and feelings with their interpretations of real and idealized landscapes during the seventeenth century. Realism emerged as an important factor in drawing in seventeenth century Netherlands, and landscape drawing flourished in the eighteenth century under John Constable and J. M. W. Turner.

Gustave Courbet, Winslow Homer and Thomas Eakins were a few of many nineteenth century Realists who added impetus to landscape work as they sketched profusely to fully understand their painting subjects. But the boon for landscape artists came with the Impressionists who tirelessly worked outdoors to interpret their favorite scenes. Claude Monet, Camille Pissarro and Post-Impressionists Paul Cezanne, Vincent van Gogh and Paul Gauguin spent countless hours under a blazing sun and in

Leonardo da Vinci observed this tree closely, recording it in his sketch book. He was among the first Renaissance artists to draw directly from nature. *Study of a Tree.* **Pen and ink. The Royal Library, Windsor, England.**

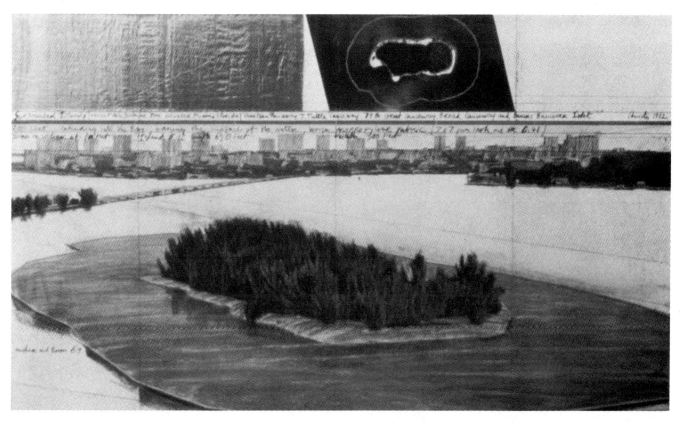

drenching rain, drawing the land-
scape of France.

Many twentieth century artists
have continued this fascination with
nature, each adding his or her own
style to the continuum of landscape
drawing. Contemporary artists still
draw landscapes—actual or
imagined—using any and all
media. Styles range from the pencil
interpretations of Paul Calle to the
exploratory mixed media work of
Christo.

**Christo uses large, mixed-media draw-
ings such as this to build interest and
cooperation when he conceptualizes one
of his immense wrapping projects. *Sur-
rounded Islands—Project for Biscayne
Bay,* 1982. Two drawings, mixed media,
15 × 96″ (38 × 244 cm) and 42 × 96″
(106.5 × 244 cm). Frederick R. Weisman
Collection, Los Angeles.**

Landscape Drawing Style

Landscapes can be drawn in huge panoramas or intimate close-ups done in extreme detail. They can be gestural line sketches or finished, shaded renderings. All landscape drawing is based on careful observation of nature. Always be aware of textures, colors, shadows and lines that give each thing its specific character.

Keep in mind that you are not to imitate or reproduce nature. You are to interpret it—give it your own personal sense of substance and place. Respond to your natural environment in your own way as you see and feel it. Fill your sketchbook with your observations and perceptions.

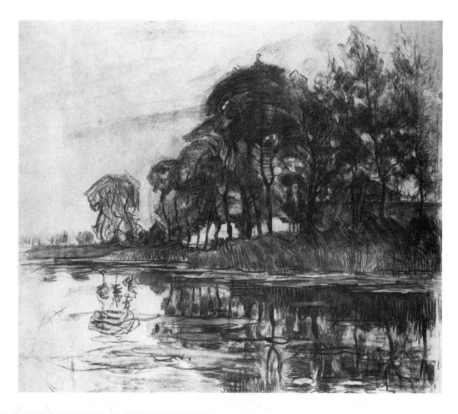

Piet Mondrian. *Trees at the Edge of a River,* ca. 1908. Charcoal and estompe on buff laid paper, 28⁵⁄₁₆× 33½ ″ (72 × 85 cm). The Baltimore Museum of Art.

Selective seeing creates selective drawing. Use only the parts of your natural environment that will contribute positively to your drawing. Compare this marker sketch with the poor composition.

Paul Edwards added figures to his pencil drawing to provide a sense of scale and proportion. The tree is large by such comparison. Analyze this drawing, using the design criteria in the text.

The vitality of a drawing depends on your spontaneous reaction to what you see. Your interest and feelings provide life and meaning to your work. Your emerging style should be evident in your drawings. Remember, however, that most artists make thousands of drawings over many years before a definite personal style is established.

Look at artists whose work you might recognize, and study what it is about their work that allows you to identify the styles as theirs. Consider, for example, the work of Rembrandt, van Gogh, Dürer, Leonardo, Charles Sheeler, Charles White, Chuck Close and Pablo Picasso. The artists represented in this chapter also have their styles; and you can probably recognize the work of some of your classmates.

Many things affect personal style: experience, use of media, purpose of the work and previous visual experiences. Do not try to *force* style on yourself. If you respond naturally and easily to your subject, you will be taking a giant step toward establishing a style of your own.

Paul Klee used ingenious line techniques and his own wonderful imagination to interpret nature. Here he used pencil to capture the feeling of moving water. *Play on Water*, 1935. Pencil, 7 × 10⁹⁄₁₆″ (18 × 27 cm). Paul Klee Foundation, Museum of Fine Arts, Bern, Switzerland.

Composing Landscapes

Composition refers to how you organize the elements of your landscape in relation to the paper. It is also important, however, to consider mood, atmosphere and emphasis. Every part of your paper is filled with some sort of space that is important. **Positive shapes** are the objects in the landscape; **negative shapes** are the spaces between the positive shapes. Composition refers to how these two are interwoven and related.

The drawing above is an example of poor composition. The shapes are too regular and sizes too similar; there are distracting corners; the horizon is too central. By making thumbnail sketches, as below, these compositional errors can be eliminated before the drawing is started.

A three-value wash drawing, done on location, emphasizes the hardness of rocks and the softness (liquid quality) of water. Note the soft edges of the water and the variety of sizes and shapes in the rocks.

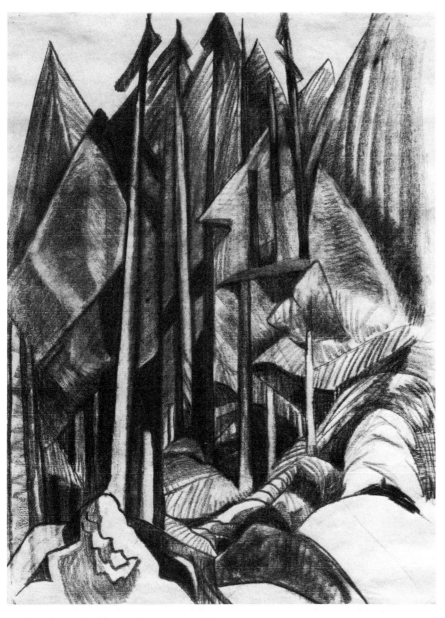

Emily Carr, one of Canada's easily recognized artists, created stylized landscapes in solid geometric forms. *Nootka.* Charcoal, 24 × 19″ (61 × 48 cm). Vancouver Art Gallery, British Columbia.

Your composition can help you emphasize what you consider the most imporant part of your drawing. There are several danger areas in landscape drawing. For example, *corners* are natural arrows leading out of the drawing; do not make them too active. *Edges* are already emphasized by the frame; putting too much emphasis at the edges will detract from the center of interest. The *center* is an automatic point of emphasis; placing the major element there will not permit easy visual movement around the drawing. Also, be careful of equal proportions, same-sized shapes, and lack of scale. Often, artists are so concerned with details, with making an object look "just right," that they forget these things that can weaken the drawing's composition.

Contrasts are important: light and dark, large and small, rough and smooth, etc. Balance is needed to make the drawing feel comfortable. Movement, even in a sketch, creates a visual flow toward the major area of emphasis.

The huge cluster of crisp-edged desert rocks is described with a slightly dry, fiber-tipped marker. Note that the value range is as wide as that in the previous wash drawing. Can you tell where the light source is? How do you know?

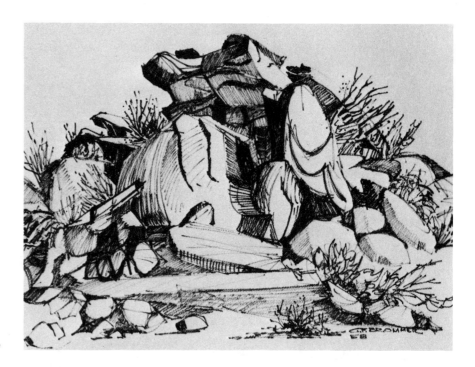

Paul Edwards used a broad pencil to sketch this landscape, which includes the elements of land, water, sky, foliage and an added building. Analyze the drawing in terms of balance, values, aerial perspective, texture, movement, contrast, emphasis, variety, unity, rhythm and pattern.

Elements of the Landscape

Landscapes are usually made up of four major elements: land, water, sky and vegetation. They can also include buildings and people. As you walk in nature, you can easily identify these features, and can separate them for drawing study. Isolate a rock, tree, flower or cloud and draw it by itself. Make its portrait. Sketch it quickly or draw it carefully. A mountain, hill, cascade, reflection, cactus, root or leaf can be drawn to study its design, detail, or characteristic textures, forms or shapes. Such elements can be combined to make more complex drawings.

All the landscape elements (land, water, sky and vegetation) are indicated in this simple line drawing. Such studies need not be detailed, but should reflect the artist's immediate response to the landscape.

Effective rocks can be drawn with a few simple brush strokes, as in this wash study. Crisp edges describe sharp breaks in the planes of the rocks. How could rounded rock forms be drawn?

LAND, WATER AND SKY

Landscape features begin with the *land* itself: valleys, cliffs, rocks, mountains, mesas, plains, etc. These make up the foundation in your environment and in your drawings. Land features are usually heavy, strong and static.

Water is liquid and is often in motion. It can tumble, crash, swirl, splash and lie motionless. It is seen in oceans, lakes, ponds, rivers, swamps, streams, cascades and brooks. Water can be immensely powerful (Niagara Falls or thunderous surf) and delicately subtle (ponds, reflections and small brooks). Moving water can be drawn with soft edges—out of focus and agitated. Still water can be hard-edged and reflect its surroundings.

The *sky* can be calm or dramatic, active or still, empty or full of life. A high horizon will squash the sky into a narrow band. With a low horizon, your drawing can be dominated by sky. Clouds of all types, fog, storms, stars, sunlight, clarity, drama and sunsets are all part of the sky. Since it is so variable, you can use the sky as an effective backdrop for your landscape drawings.

In your sketchbook, record the contours of trees to help you understand their shapes, masses, branch strucure and characteristic appearance.

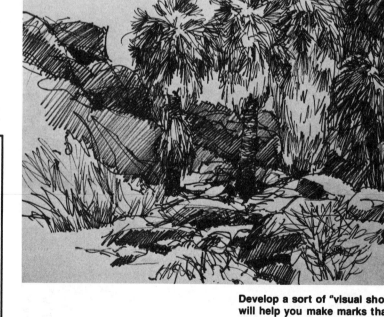

Develop a sort of "visual shorthand" that will help you make marks that typify different types of foliage. Here a fiber-tipped pen was used to develop a system of marks that "say" palm trees. Marker, 12 × 16″ (30 × 40.5 cm).

These rocks seem to have exquisite detail, but were made by a simple process. A *dark* ink wash was applied to smooth paper in the shape of the rock, and then a crumpled piece of absorbant tissue was used to blot the lightest parts.

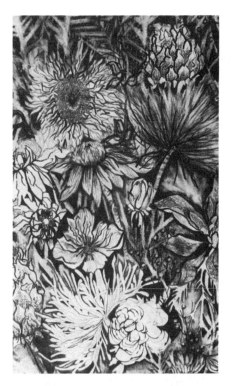

You can bring fragments of vegetation indoors to draw them, as this student did with flowers. She held individual flowers in one hand and drew with the other, clustering them together to make a complete bouquet on paper. Pencil, 24 × 18″ (61 × 46 cm).

Small fragments of vegetation make excellent drawing studies. This student chose to draw a few cut bamboo shoots in a local park because they made an interesting pattern. Marker, 12 × 18″ (30 × 46 cm).

ADDING BUILDINGS AND PEOPLE

Landscapes often include buildings, people or animals. Such elements can indicate scale, add visual interest or be essential parts of the environment and your composition. If you include them, they must look like they belong to the drawing and are an integral part of it.

AERIAL PERSPECTIVE

To show depth in landscape drawings, artists primarily use aerial perspective. Distant elements are smaller, less detailed, have softer edges and are lighter in value. Try to use these features to show space in your next drawing.

VEGETATION

Vegetation and foliage in a landscape drawing usually must be generalized. You cannot draw every leaf or twig because the result would be chaotic. Instead, look for generalized *shapes* and characteristic (typical) *textures* and *shading*. A few descriptive details will provide the visual identification that distinguishes individual plants and trees.

Make contour drawings of trees, plants, leaves and flowers to study their shapes. Experiment with squiggles, doodles and various marks that can help you describe different types of foliage: needles, broad leaves, massed foliage, individual leaves, palms, ferns, bark, trunks, twigs, seeds and so on. Once you can generalize trees and plants with characteristic shapes and textures, you will draw landscapes with greater confidence. Study the way other artists (in this book and in other sources) draw plants and trees.

It is often helpful to use a small cardboard frame (finder) to limit the extent of subjects in nature. Always be selective in your seeing and in your drawing. If you do not want to draw entire scenes, just draw small sections or studies: a group of three trees, a single plant or flower, part of a tree. Twigs and branches brought into the artroom provide excellent sources for studies of vegetation. Hold them in one hand and draw with the other.

It is not essential or even desirable to see everything in nature and include it in your drawing. Your responsibility as an artist is to make effective and interesting drawings that characterize and interpret the natural environment, not imitate it.

After sketching a simple landscape outline in pencil, this student used a ruler and ballpoint pen to make parallel horizontal lines that create the necessary value contrasts.

Experimental Approaches

Experimentation in landscape drawing may involve mixing media for exciting textures or surfaces. For example, collage rice paper on illustration board for fascinating surfaces for wash drawings. Draw on wet paper or experiment with various resists. Produce imaginary landscapes (another planet?) in exotic media combinations that can be surrealistic in feeling.

Subject matter also can be the source of experimentation. Draw small items (a peach pit) in mammoth blowup. Condense a huge landscape into a small pen and ink drawing. Discover the textures on a branch or tree trunk and make designs from them. Abstract the essentials of flowers or leaves and produce patterns and designs from them.

Experimental approaches help you to develop a more acute awareness of nature. In exploring nature's arrangements and your own rearrangements, you become increasingly familiar with the forms and features of your natural environment.

Paul Taylor has simplified plant forms into large shapes and filled the resulting positive areas with contrived patterns. Such an extremely decorative approach can help develop an awareness of design in nature. Pen and ink, detail of an 18 × 24″ (46 × 61 cm) drawing.

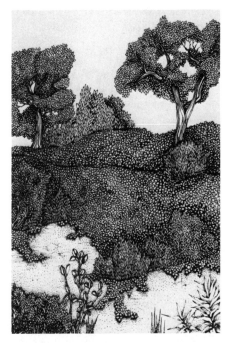

Douglas Robinson selects single elements from nature and draws delicately detailed renderings in colored pencil. He arranges them to look like a group of small drawings, but they are actually drawn on a single piece of illustration board, 18 × 12″ (46 × 30 cm).

A student arranged and outlined trees, bushes, ivy ground cover and plants, and then filled the simplified shapes with noodled patterns. This decorative drawing approach produces work that appears complex in detail. Pen and ink, 18 × 12″ (46 × 30 cm).

Activities

ART HISTORY

1. Research in books on Chinese paintings or encyclopedias and study the landscape drawings by Sung Dynasty Chinese artists. Write a short paper, describing the general differences between Oriental and Western landscape drawings. How do Chinese artists show space; use people; define details? Why? Why were they so interested in drawing landscapes?

2. The French Impressionist artists sketched outdoors, and often used their sketches to start their paintings. Read about some of the Impressionists (Monet, Pissarro or Renoir) or several Post-Impressionists (Cezanne, van Gogh, Gauguin or Seurat) and describe why they wished to draw directly in nature. Why was this a new way of drawing?

3. How did Impressionist and Post-Impressionist drawing differ in concept, attitude, techniques, purposes and design? Cite examples to illustrate your points.

CRITICISM/ANALYSIS

4. There is a sketch in this chapter that illustrates poor composition. Analyze it and then make *two* similar line drawings, using the same elements, but correcting the compositional weaknesses.

5. Study the drawing by Vincent van Gogh on the title page. Write a short paper and describe what you see—the subject of the drawing. Analyze how van Gogh used perspective and how he developed value with line. How did he use people? How did he show the *form* of the tree trunks? How are the top and bottom of the drawing alike and different?

AESTHETICS/PERSONAL SENSITIVITY

6. Look at the *stylized drawings* in this chapter. Write descriptions and compare and contrast the styles of Paul Taylor, and Emily Carr. They all drew trees, but used different techniques. Describe their techniques. Which do you like best? Why?

7. Study carefully the drawing by Vincent van Gogh (see Activity 5). Describe what is happening in the drawing. How does the drawing make you feel? What time of year is it? How do you know? Does the artist make you *feel* something about the French countryside? What kind of mood do you sense? How does van Gogh convince us of his own feelings? Do you like the drawing or not? Why?

PRODUCTION/STUDIO EXPERIENCES

8. Choose one subject (for example, a cluster of seed pods) and make three separate drawings using different media.

9. Outline natural forms such as trees or branches, then fill the spaces with noodled patterns.

10. Create a drawing in which you illustrate the *movement* of trees or grass.

13 USING YOUR IMAGINATION

Celeste Rehm uses traditional drawing techniques, but her combination of subject matter is unreal. Here, a young man, apparently kneeling on the top edge of the drawing, pulls a tree out of the ground. The tree brings the lawn (carpet?) along with it. The rest of the drawing seems normal, but the total situation is fascinatingly bizarre. *Uprooted Tree,* 1985. Pen and ink, 32 × 22″ (81 × 56 cm).

Almost every work of art involves imagination, even art that repesents observed subject matter. A great deal of drawing, however, does not rely on observation. Much art is based solely on imagination and is a record of purely mental invention.

Imagination is the precious ingredient that distinguishes the creative person. It accounts for originality— the ability to think and respond in unique ways. It enables you to fantasize and dream, and to put imagined thoughts on paper.

Imagination can be exercised by manipulating either subject or media. Subjects can range from pure imagination and nonobjectivity (no relation to reality at all) to the visual manipulation (distortion, abstraction, transformation, fragmentation, simultaneity, etc.) of recognizable subjects. Media also can be handled in imaginative ways: combine and mix, incorporate collage and/or actual objects, flatten, draw sculptural surfaces, use computers, combine photography and drawing, etc.

Saul Steinberg's imaginative approach to drawing involves caricature and a deftly brushed line. *The Violinist,* **1952, is appropriately, drawn on music paper. Pen, brush and ink, 21 × 13″ (53 × 33 cm). Fogg Art Museum, Harvard University, bequest of Meta and Paul J. Sachs.**

Piet Mondrian's *Pier and Ocean,* **1914, was drawn during his "plus and minus" period. Although remotely associated with an actual subject, the drawing is highly imaginative. Charcoal, brush and** **ink, heightened with white wash, 30 × 40″ (76 × 101.5 cm). Museum of Modern Art, New York, Mrs. Simon Guggenheim Fund.**

Many artists have consistently emphasized pure imagination in their work. Visual representation of gods and spirits have been imagined since the beginning of time. Artists of the Middle Ages created images of saints, hell and paradise. Pieter Bruegel and Hieronymus Bosch (sixteenth century) imagined and recorded incredible sights and happenings. In the eighteenth century, Giovanni Battista Piranesi drew the interiors of fantastic buildings that did not exist, and William Blake astounded viewers with his wondrously imaginative "visions."

Artists in the nineteenth and twentieth centuries have expressed their imaginations in Surrealism (Salvadore Dali, Yves Tanguy, Joan Miro), in abstraction (Pablo Picasso, Georges Braque, Piet Mondrian), in fantasy art (Marc Chagall, Jean Dubuffet, Paul Klee), in distortion (Umberto Boccioni, Marcel Duchamp, Saul Steinberg), and in nonobjective drawing (Wassily Kandinsky Arshile Gorky, Jasper Johns).

By trying some of the suggestions in this chapter, you will be able to exercise your own imagination—to stretch your own abilities to think creatively.

Georges Braque started this abstract drawing with bits of collaged papers. Can you find playing cards, guitar, vases, table top and wall suggested by the added lines? *Still Life with Playing Card,* 1912. Charcoal and collage, 11⅝ × 18⅛″ (29.5 × 46 cm). Los Angeles County Museum of Art, Mr. and Mrs. William Preston Harrison Collection.

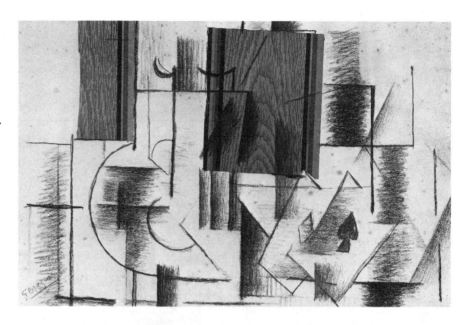

Abstract Drawing

Abstract drawing, which is more a study of form than a pictorial representation, can be approached from two directions. For example, it can be developed from recognizable subject matter. The subject can be simplified in form and abstracted until a distillation—the "purified" subject—is left. Or abstract drawing can be based on imagination. Start with shapes, lines, patterns or textures and build up from them. Both approaches are valid. The Cubists called the first method of abstraction *analytical* and the second *synthetic.* Can you explain why?

Imagination and exploration are key words in abstract drawing. Study the work of Cubist artists, such as Pablo Picasso, Georges Braque and Juan Gris, to see how their work was constructed.

Fracture shapes (break into smaller shapes) and divide them into other shapes that can be re-arranged at will. Extend edges of shapes (contours) to the borders of your paper. Displace broken

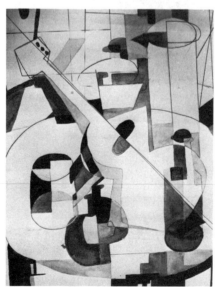

Breaking up shapes and displacing them is a Cubist technique; so is the transparency and reshaping of still life objects. This student drawing (pencil and watercolor washes) is 24 × 18″ (61 × 46 cm).

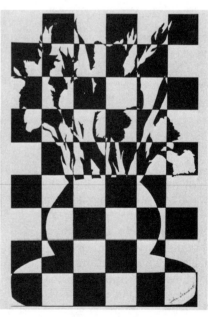

A simple contour line study was transformed into a more interesting drawing by placing a large grid over it. What other shading technique could this student have used? Pen, brush and ink, 18 × 12″ (46 × 30 cm).

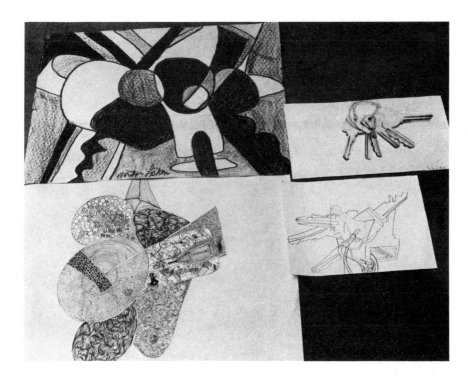

A four-step student problem in abstracting: 1) a realistically shaded drawing of a bunch of keys; 2) a contour drawing of the same keys; 3) contour and value drawing of selected detail, greatly enlarged, done with crayon (18 × 24″—46 × 61 cm) and based on second drawing; 4) an imaginative pen and ink drawing, based on the shapes in the third drawing, but not relying on the others except for shapes or suggestion.

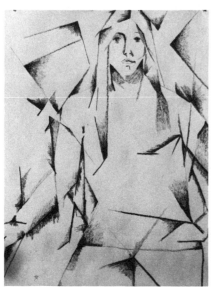

A student model was drawn and then fractured, with lines and edges made straight where possible and continuing to the edge of the paper at times. Tone was kept to a minimum. Black crayon, 24 × 18″ (61 × 46 cm).

shapes (move parts up or down) or make them appear transparent. Divide an entire drawing into checkerboard squares, and shade the squares in various ways. Simplify complex forms into flat geometric shapes or into a few simplified lines. The examples on these pages can help you get started, but do not be restricted by them. Try some ideas of your own.

Nonobjective Drawing

Nonobjective art is nonrepresenta-
tional—it does not represent natural
or actual objects in any way. It
should not even suggest actual ob-
jects. Nonobjective drawing might
simply express the glory of line, the
power of shapes or the complexity
of texture. It could be based on the
concept of softness, the structure of
geometry or the quality of a mood.
It is purely imaginative, originating
and developing in the mind and
hand of the artist.

Nonobjective drawings often
begin with a single mark—and a
concept. This concept might be
conceived ahead of time, or you
can develop it as the drawing
grows. Some effective concepts in-
clude movement, pattern, texture,
mood, decoration, contrast, line,
floating, geometry, structure, soft-
ness and transparency. The ex-
amples on these pages are only a
few of many hundreds of ideas that
could be developed as nonobjec-
tive drawings.

A nonobjective mixed media drawing ex-
presses the pure joy of line, value and
pattern. The student started with a
single shape and let the drawing develop
and grow from that. Pen, ink, pencil and
white conté crayon on gray paper,
18 × 24″ (46 × 61 cm).

This nonobjective drawing was started
when a student dropped ink on paper
and blew on it through a straw. When
the black shape was dry, pen lines were
used to outline it again and again until
the 6 × 12″ (15 × 30 cm) sheet was
full.

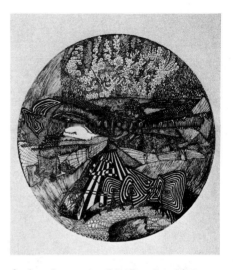

Michael Sulphor did not outline the floating shapes, but created them by drawing ruled ink lines on the rest of the ground. *Grandeurs et Lumiers* is one of sixteen panels (each 25¾ × 20″—63 × 51 cm) that make a drawing 55 × 167″ (139.5 × 424 cm) in size. Los Angeles County Museum of Art, gift of Esther and Robert Robles.

Channa Davies Hortwitz based this drawing on the concept of progression. Can you follow it from beginning to end? What is happening? *And Then There Were None #3*, 1978. Ink on graph paper. Orlando Gallery, Sherman Oaks, California.

An imaginary, nonobjective drawing extols the beauty of lines made with pen and ink. A student used a variety of patterns, lines, dots and values to create an intriguing surface. Pen and ink, 16″ (40.5 cm) in diameter.

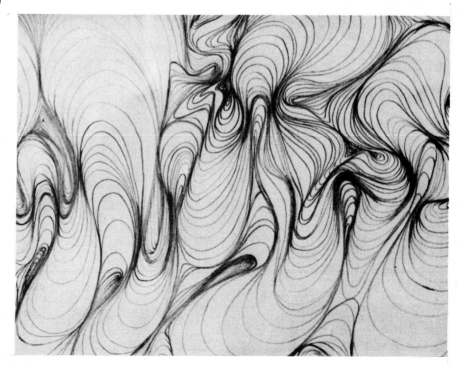

A rhythmic, nonobjective drawing simply explores the kinds of lines a pencil can make. How did the student use variety and still establish unity?

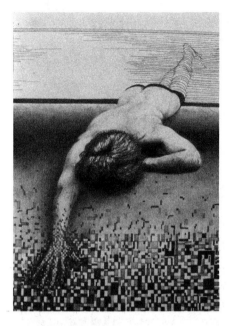

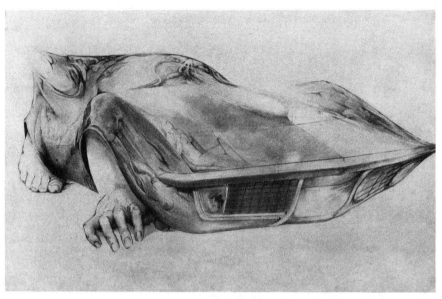

A simple drawing of a human figure was given a surrealistic interpretation as the student artist treated it with a fascinating series of drawing techniques. Can you use this concept with other subjects? Pencil, 18 × 12″ (46 × 30 cm).

Roger Kutz took a slick auto body and gave it hands and feet! Such imaginative work combines perspective drawing, anatomy and careful shading in a mysterious way. Pencil and charcoal, 24 × 39″ (61 × 99 cm).

Surrealistic Drawing

Surrealism, an art movement started in Paris in the 1920s, was an outgrowth of an interest in psychoanalysis. It was concerned with dreams, personal symbolism and spontaneous visual expression. Some artists used traditional drawing and painting techiques (Salvadore Dali); others used naive forms of expression (Joan Miro). Some emphasized recognizable subject matter placed in improbable situations (Rene Magritte); others developed new and unique visual forms (Yves Tanguy).

Today, surrealistic drawing takes different directions, emphasizing dissociation, combinations of unlikely objects, dream sequences,

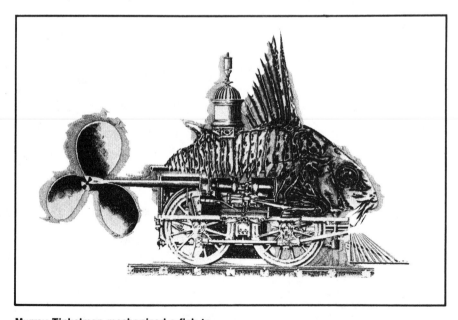

Murray Tinkelman mechanized a fish to run on rails—and perhaps underwater. The drawing is carefully done but the combination of parts is impossibly wonderful. Can you made up a name for this "mechanimal?"

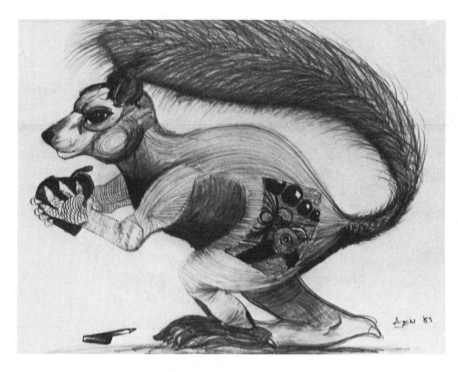

An opening in the side of this squirrel allows the student artist to reveal the springs and gears that enable the animal to jump so high—an unlikely situation drawn in a realistic way. Pencil, 12 × 14″ (30 × 35.5 cm).

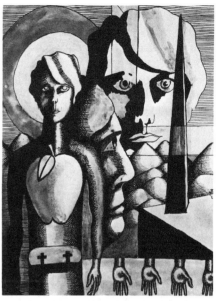

Personal symbolism is a characteristic of some surrealistic drawing, but the student artist had a reason for including each object in his drawing. Ink and wash, 24 × 18″ (61 × 46 cm).

Edward Ruscha drew a normal-looking book, but floated it in a large open space. What does this do to your perception? How did the artist make the book float? *Suspended Book,* 1970. Gunpowder and pastel, 11½ × 29″ (29 × 73.5 cm). Los Angeles County Museum of Art, gift of the Contemporary Art Council.

dream-like subjects and personal symbolism. Animals are combined with machines ("mechanimals"), and recognizable objects are placed in peculiar settings. Books float, fish walk, animals look like people, and illogical happenings occur on paper. Artists respond to questions that begin with, "What if"

The contemporary direction in surrealistic drawing tends to emphasize a lack of convention and the heightened sensitivity to express personal impulses. Collage is often combined with drawing, and media are easily mixed as part of surrealist expression. If imagination helps you think about things in new or different ways, surrealistic drawing is one way to open the door to creative expression.

Distortion

Artists can exercise their imaginations by distorting their subjects—overemphasizing certain aspects to heighten interest in them and make us more aware of them. Line, texture and shape; pattern, space and emphasis—all the principles and elements of art—can be overemphasized for desired effects. If proportions are stretched, linear perspective disregarded, sizes enlarged or reduced, space expanded or condensed, we see the subjects in new and visually stimulating situations.

Artists who draw caricatures emphasize (distort) certain physical characteristics. Fashion illustrators lengthen their models to enhance a sense of elegance or place emphasis on the clothing. Surrealist artists often distort space, mood or natural proportions. Chuck Close draws faces that are six feet high. Some artists miniaturize their subjects. Masks are often distorted human faces. Any attribute (obesity, thinness, squareness, tallness, angularity, furriness, etc.) can be emphasized by distortion.

Almost any subject (figure, animal, still life, landscape, machinery, etc.) can be distorted to satisfy the need and desire of the artist. Perhaps the examples on these pages will help you develop a drawing that features distortion in some way.

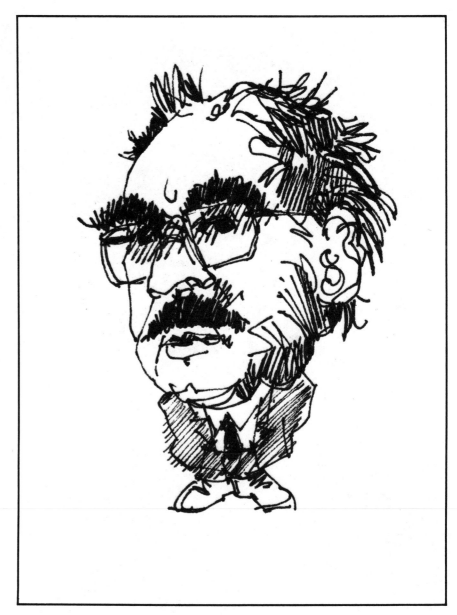

Caricatures exaggerate selected features that are characteristic of the subject. Editorial cartoonists are expert at this type of distortion.

Thomas Hart Benton distorted the train to emphasize speed and determination. How else did he stress this point? He drew on a lithographic stone and this image was printed on paper. *Going West,* 1929. Lithograph, 12⁵⁄₁₆ × 23³⁄₈″ (31 × 59.5 cm). The Philadelphia Museum of Art.

Fashion figures are usually drawn nine or ten heads high, a distortiion of reality (most people are generally about eight heads high). The clothes are emphasized in these student fashion sketches. Ink and wash, 12 × 18″ (30 × 46 cm).

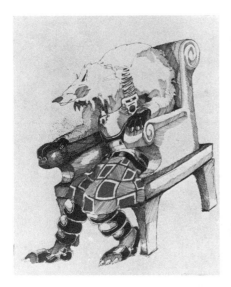

This drawing from a student sketchbook illustrates a fantasy method of placing animals in human-like situations. Markers, 10 × 10″ (25.5 × 25.5 cm).

Fantasy Art and Imaginary Illustration

Did you ever try to draw what you may have seen in your dreams or daydreams? Fantasy art often depicts subjects that can only be imagined—things, events and scenes that do not actually exist except in the imagination of artists.

Fantasy art is closely associated with Surrealism because both deal with imaginary subjects. Many Surrealist artists (Dali, Miro, Tanguy, etc.) deal in fantasy and personal imagery. Marc Chagall, Paul Klee and Max Ernst were fantasy artists as well.

Some artists use fantasy to illustrate imaginative stories or situations. Can you imagine illustrating such literature as Dante's *Inferno*, Richard Adam's *Watership Down*, Milne's *Winnie the Pooh*, Tolkien's *Lord of the Rings*, or Ray Bradbury's *Martian Chronicles?*

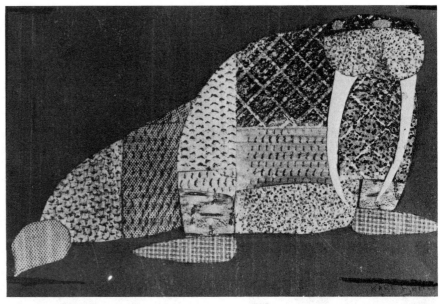

Rubbings were made with crayon and paper over various textures, and a collage was made of a walrus-like animal (above). Can you imagine making a more exotic creature?

Some subjects for imaginary illustration include scenes on other planets, space travel, future times on earth, underwater or underground cities, and so on. You might draw incredible creatures (the Loch Ness Monster?) or put regular creatures in impossible situations. Combine the head of a lion with the body of a shark—or make other illogical combinations. How would the house of a mermaid look? Or the studio of a Martian artist? Use your imagination!

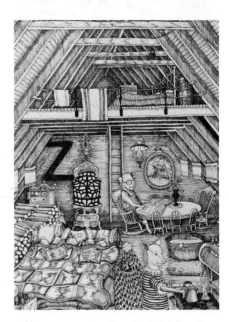

Arthur Geisert made this drawing in preparation for an etching that illustrates the letter *Z* in his book *Pigs from A to Z.* In the book, pigs are seen planning and building their dream house, and here at the end they are enjoying their new home. Much imagination was needed to conceive the ideas for each letter of the alphabet. Pen and ink, 14¼ × 10⅜″ (36 × 26.5 cm).

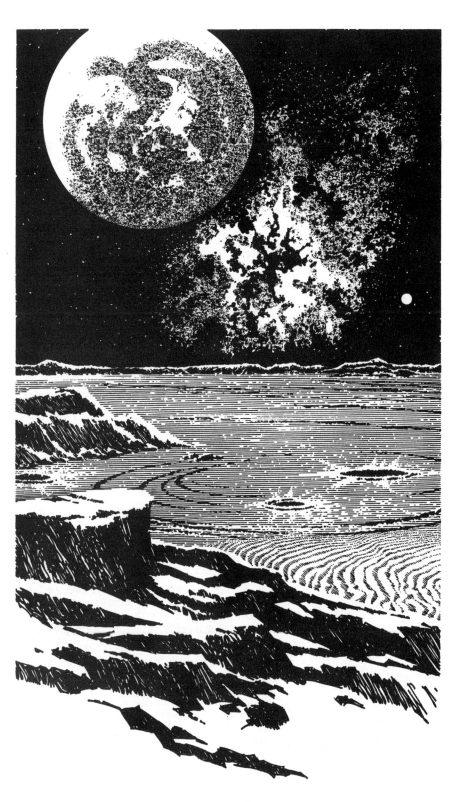

Paul Taylor imagined a scene from outer space. What might earth look like from another planet? Pen and ink, 12 × 7″ (30 × 18 cm).

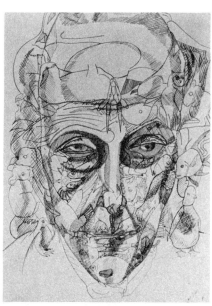

This face was drawn by a student in the style and manner of fantasy artist Giuseppe Archimboldo. It is filled with drawings of small animals. Pen and ink, 24 × 18″ (61 × 46 cm).

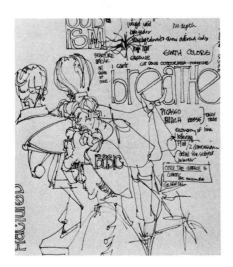

The notes and doodles on this sketch-book page are part of a student's art history notes. Words, ideas, Duchamp-Villon's cubist horse sculpture, four classmates, half a Christmas tree and some other linear doodles are combined on a single page. Such creative doodling is the result of allowing an imagination to have free rein. Rapidograph pen, 14 × 12″ (35.5 × 30 cm).

Sketchbook Doodling

Sketchbooks can serve many functions for artists and students, and one of the most important is to give us a place for imaginative doodling. Doodling is creative visual wandering—allowing our minds and hands to go where they will, almost automatically—without preconceived plans. Put down a mark or a shape and then start drawing. Build on previous marks, extend and distort shapes, shade and cross-hatch if you wish. Sometimes recognizable things will emerge, but most of the time doodling will be nonrepresentational (nonobjective). Often, words become part of the doodling process. Lines might turn into shapes, or they can wander aimlessly around the paper.

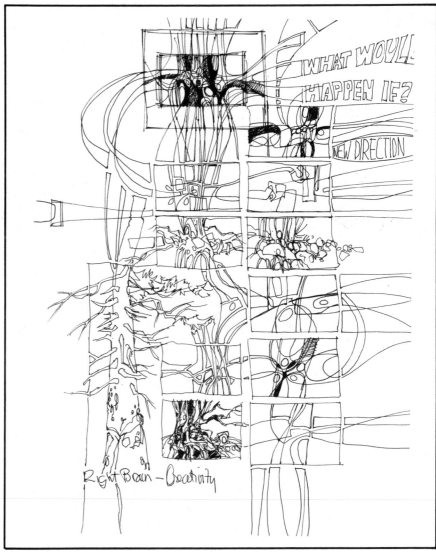

Doodling on scratch paper or in sketchbooks is an excellent way to exercise your imagination. You can doodle while doing anything that leaves your hands free. There are no assignments or projects; no plans or goals. Sometimes an idea or something you've heard will get you started, but just let your pen or pencil wander aimlessly. Give your imagination free rein and see where it will take you.

This sketchbook page was doodled during a roundtable discussion on the creative linking of ideas—a subject that is actually visualized on the page. The doodling began with the tree (the session was held at a mountain retreat) and grew in many directions, with each mini-doodle linked to the next one. Marker, 8½ × 11″ (21.5 × 28 cm).

Two student sketchbook pages show two types of imaginative doodling. One takes a single motif (imaginary creature) and repeats it in various forms and positions. The other is a free-flowing and random doodle that eventually forms a rather impressive shape. Both are in pen and ink.

Activities

ART HISTORY

1. Several art styles have been based on the imaginative capacity of the human mind. Write a brief paper on the background and development of one of the following: Surrealism, Dadaism, Futurism, Abstract Expressionism. Name several major artists associated with the style.

2. Write a short essay on one of the following topics:
- How Paul Klee has combined imaginary with real images in *Twittering Machine.*
- Hieronymus Bosch and Creative Imagination
- Marc Chagall and Fantasy Art
- Jasper Johns and Creative Imagery

CRITICISM/ANALYSIS

3. Study the work of Arshile Gorky's *The Plow and the Song* (p. 239) and Piet Mondrian's *Pier and Ocean* at the beginning of the chapter. Then write a brief paper or prepare a video tape in which you compare and contrast the two works. You may wish to expand the project to include other works by the two artists.

4. Study the drawing in this chapter of the pigs in their dream house by Arthur Geisert. Describe the drawing and explain how the artist effectively combines imaginative subject matter with traditional design concepts, media techniques and perspective.

AESTHETICS/PERSONAL SENSITIVITY

5. Why is it sometimes difficult to understand, interpret and/or react to the work of Surrealist artists—or other work based mostly on imagination? Write a short paper.

6. Write a script for a short television documentary, titled *When You Look at Nonobjective Drawing.* Tell the viewers what to look for and what causes their reactions to drawings. Research the topic and use the work of several artists to explain.

7. Study the Arthur Geisert drawing of pigs in this chapter. What is your initial reaction to it? Does your feeling change after studying it? Why or why not? Discuss the concept of placing animals in human context. What books, authors or comic strip characters might be included in this discussion?

PRODUCTION/STUDIO EXPERIENCES

8. There are many studio experiences explained in the text. Use at least two of them to explore the use of your own imagination in drawing.

9. Simplify some complex forms into flat geometrical shapes. You may choose to abstract the forms into a few simplified lines.

10. Choose any subject for a drawing. Study the subject and choose one characteristic or attribute that you would like to emphasize. Use distortion to create the emphasis.

11. There are several examples in this chapter of animals in impossible situations. Draw a human being in an equally improbable setting.

14 OTHER SUBJECTS TO DRAW

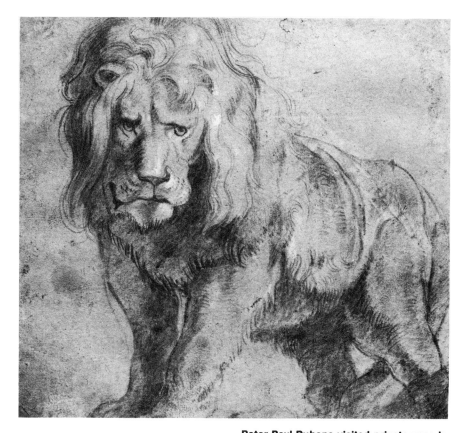

Peter Paul Rubens visited private zoos in seventeenth century Flanders to sketch animals that were later included in some of his paintings. *A Lion,* **1615. Black and yellow chalk, heightened with white, 10 × 11⅛″ (25.5 × 28 cm). National Gallery of Art, Washington DC, Ailsa Mellon Bruce Fund.**

A gestural drawing captures the action of a screeching bird. The active line was made at a zoo, with black crayon on 18 × 24″ (46 × 61 cm) drawing paper.

Pets have to be observed carefully over a period of time, because they do not often hold a single position long enough to finish a drawing. After study and sketching, the process will become easier. Ballpoint pen, 12 × 9″ (30 × 23 cm).

A trip to a natural history museum will give you a chance to draw all kinds of animals that will not run away and hide. Many quick contour drawings can be done in a single visit. Carpenter's pencil on newsprint, 24 × 18″ (61 × 46 cm).

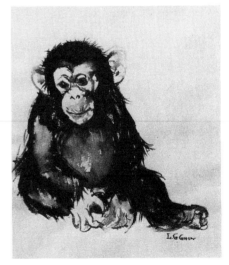

Lois Green Cohen draws animals at zoos, directly from observation. Her drawings are sketchy and sensitive and capture the feeling and attitude of the animals. *Baby Chimp,* 1978. Brush, ink and wash, 19 × 13″ (48 × 33 cm).

Hundreds of new drawing problems are devised by artists, teachers and students around the world every day, and a drawing book can only contain a small fraction of them. In addition to the previously illustrated examples, there are many other subjects to draw and ways to handle them. You can take off in many directions. Some drawings are sheer fun and excitement, some are visual records and reporting, and some are probings into the subconscious mind.

Work on subjects that are of special interest to you, but also be sure you continue to explore new and challenging subjects, approaches, styles and media. In such stretching are the ingredients for growth. The following pages summarize a few other drawing areas, but there are other possible directions for you to explore as well.

Drawing Animals and Birds

Drawing animals offers the opportunity to expand your experience of drawing from models. Careful observation is very important—just as it is in figure drawing. Accurate animal drawings can only be done after extensive sketching. But in drawing classes it is the experience that is important, not the end product. Three sources are available as models for drawing animals: live animals, mounted specimens and flat reproductions.

Obviously, live animals cannot easily be brought into the classroom. It is much more convenient to go to the zoo. Since it is impossible to get wild animals (and even pets) to pose, you should watch the movement of the animals for a bit and then begin to sketch. Gestural drawings will familiarize you with the major shapes and movements, and then more careful

observations can be recorded. Pets can be drawn at home, at times when they are quiet. Zoo animals are most relaxed and quiet right after feeding.

Mounted animals make excellent models. They can be found in natural history museums and sometimes in local museums that often rent them to schools. Your school's biology department might have some mounted animals and birds that can be borrowed, or some classmates might be able to bring some from home. Insects can also be borrowed from biology departments or student collections, and observed under a magnifying glass if necessary.

The student who made this fine gestural sketch of a horse started with brush lines of a very light ink wash. When the lines seemed to express the desired action, darker wash lines were brushed down on the 18 × 24″ (46 × 61 cm) bond paper.

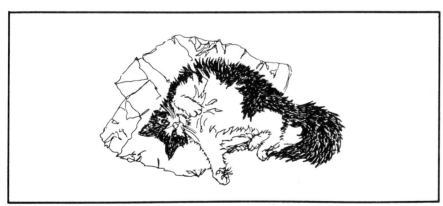

Meg Huntington Cajero draws her cats in wonderfully relaxed poses. This one has just torn open a large paper sack. Her direct pen and ink drawings are clean and fresh and happy. Pen and ink. 6″ (13 cm) across.

A single mounted bird was drawn in contour from several angles and overlapped in places. Some of the resulting shapes were filled with ink, others left white. Pen, brush and ink, 18 × 24″ (46 × 61 cm).

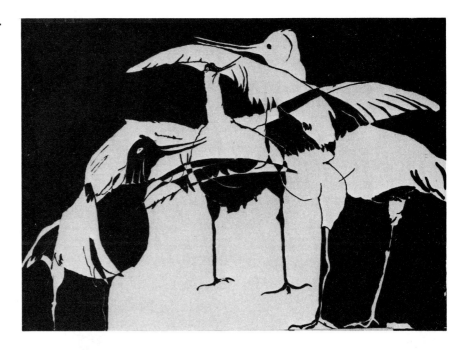

This drawing of a zebra was done in brush and ink by a high school student. The drawing was done after the student interpreted several sources, including photographs of zebras, to create a personal rendition of the subject. Brush, ink and wash, 18 × 24″ (46 × 61 cm).

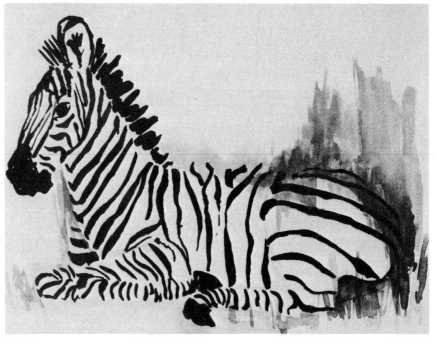

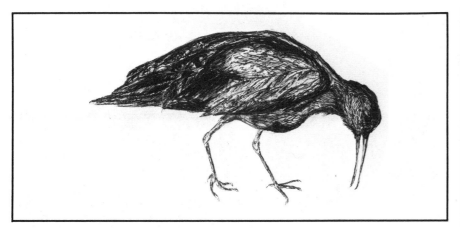

Mounted birds and animals are excellent subjects to sketch in the art room, and also to use as models for finished drawings. Marker, 15 × 24″ (38 × 61 cm).

George James used a nearly dry fiber-tipped pen to sketch goats at rest. Notice how lines are used to generalize shapes and also to create a feeling of form. Black ink was brushed in places to add drama and strength.

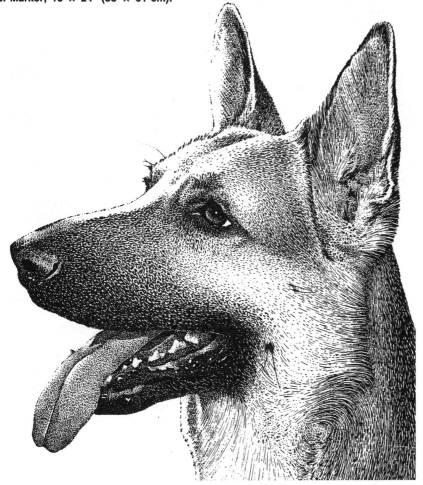

Paul Taylor sketches his animals lightly with pencil, then invents pen and ink marks that express the feeling of hair of various lengths, textures and values. *German Shepherd,* 1986. Pen and ink, 11″ (28 cm) high.

Drawing Machinery, Automobiles, etc.

We live in an age of machines, computers, electronics and constantly changing technology. Since these components are important parts of your life, you should take time to study and draw them. Technical illustrators need to draw such items with incredible accuracy, but as a searching artist, you are free to be more creative in your approaches to drawing machines of all kinds.

Any medium can be used to draw the hard and often reflective surfaces of machinery, but the usual goal would be to make viewers "feel" the quality of the surface with their eyes. Of course, you may wish (for personal reasons) to make a steel surface appear soft and fuzzy. As you can see from the examples on these pages, many techniques can be used to interpret the shapes, forms and surfaces of machines. Look in newspapers, brochures and magazine advertisements to see how commercial artists draw various mechanized objects.

You can draw entire machines, sections of machines or individual parts. You can draw them realistically, as part of a design, symbolically, or as a caricature. Machines can be drawn from the side or top, as three-quarter or cutaway views. They can be linear, shaded or treated as part of a flat design. After studying the many approaches to drawing in the text, you can probably use several other

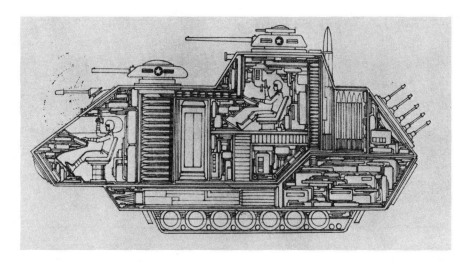

Cutaway drawings reveal what is inside of machinery, as this student's pen and ink drawing of an imaginary tank illustrates. Can you think of other applications for this technique?

methods to draw machinery of all types.

The same treatments and approaches could be made for furniture, toys, tools, utensils, games, sports equipment, and so on.

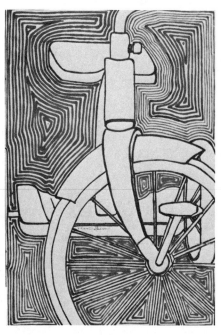

After a simple contour drawing was made with a black marker, colored markers were used to repeatedly outline the initial shape until the sheet was filled, 18 × 12″ (46 × 30 cm).

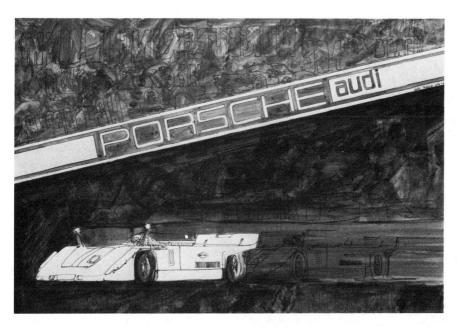

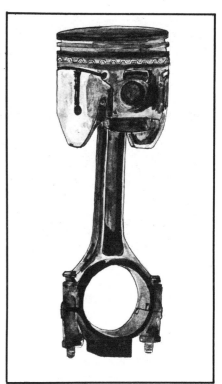

Three student approaches to drawing automobiles are shown: an isolated view of a favorite car (pencil, 12 × 18″—30 × 46 cm); a dramatic composition with commercial implications (marker, pen and ink, and acrylics, 24 × 36″—61 × 91.5 cm); and a detail of an automobile part (pen, ink and wash, 12″—30 cm—high).

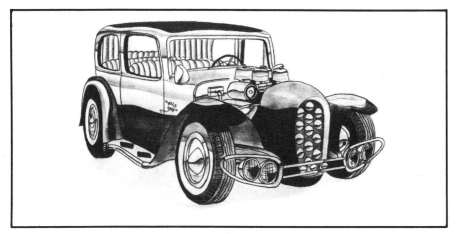

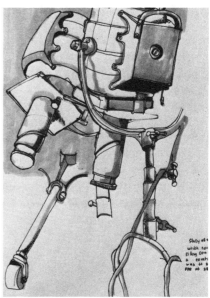

A student sketchbook contains this study of a spotlight, drawn in ink and wash. Shading provides a feeling of form and dimension, 11 × 8″ (28 × 20 cm).

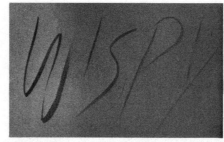

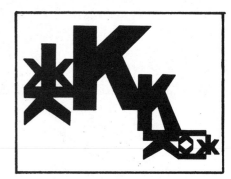

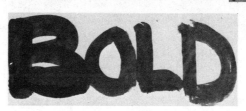

Try to express a feeling in the way you draw a word. Make the style express the same thing as the word. Pencil, brush and markers, each about 12″ (30 cm) long.

Calligraphy, Letters and Numbers

Our senses are bombarded with words and numbers in an unbelievable variety of ways, but seldom do we experiment with these visual symbols in our drawings. Although lettering in the traditional sense can become tedious after a while, some fresh ideas can spark new approaches to using letters and printed words.

Pictures can be made from words. Designs using letters can be worked out. Calligraphy can provide textures, or a calligraphic line of words can be worked into a drawing. An abstract pattern can be developed with words or numbers. Notice the rhythm developed by repetition of letters and the texture produced by overall patterning.

Observe how the advertising industry makes use of words and letters. Study logos and symbols that make use of letters and words. Expand these ideas into drawing activities.

Choose the medium to suit the purpose of your drawing. Markers are extremely useful for working with lettering, but so are pen and ink, pencils and brushes. Even charcoal and crayon can be used effectively, depending on the quality of your design.

Choose any letter (or your initials) and work out an interesting design that creates a fascinating shape. Vary the sizes of letters for maximum interest. Pen and ink, 10 × 14″ (25.5 × 35.5 cm).

This complex design is made up of letters and words filled with various patterns in selected places. Use your name, or the name of a street, town, friend or school to develop such a project. Pen and ink, 14 × 20″ (35.5 × 51 cm).

Take a lettered advertisement (or do your own lettering), crumple the paper and partially open it. Place the resulting form under a strong light and draw it, shading for wrinkles, values and words. This drawing is in pen and ink, 22 × 18″ (56 × 46 cm), but markers, pencils or charcoal will work as well.

Lettering and words are used (upper left) to texture the negative space behind some of the bottles. Does this give you ideas for further use of words as texture? Pen and ink, 24 × 18″ (61 × 46 cm).

Cartoons

Cartoon drawing is an outgrowth and extension of figure drawing. Cartoons are a regular part of our newspapers and many magazines, where we see them as editorial statements, comics, illustrations or forms of advertising. They are also found in children's books and as illustrations that help people understand concepts.

One characteristic of cartoons is exaggeration. Prominent facial features can be enlarged or reduced for special emphasis. Arm or leg movement can be exaggerated to express appropriate actions. Splashes are bigger, buildings lean, cliffs are immense; mouths can be gigantic, flowers huge, eyes tiny. Cars can be distorted, telephone poles can slant, and embarrassed faces can be bright red.

Some cartoonists draw their features without such evident exaggeration. They may emphasize other things, such as speed, technology, sports, animals, and even serious messages.

Think of a humorous incident in your life and devise a cartoon to illustrate it. Perhaps you can make a caricature of yourself as the main figure. Or you can use a made-up character to carry the action. Draw many practice sketches to develop the figures you will use, and to express the actions effectively. Cartoonists often use a light-table to help them trace drawings once they are effective. You may use a window or other device to help in this manner.

This sophisticated action cartoon sequence is part of a series designed by a student. It deals with a science fiction theme but also involves the student's hometown. Drawn with markers, the panel is about 18″ (46 cm) high.

This cartoon is of a cartoonist in action, drawing an action cartoon. Marker, actual size.

Roger Armstrong draws his nationally syndicated comic sequence every day, as he gives human traits and characteristics to his animal stars. Original art is about twice the size of this printed strip. Courtesy of Walt Disney Productions.

Op Art

Optical art relies on complete abstraction to be effective. Some drawings rely on pure scientific approaches, while others involve more feeling and emotion. Whatever the approach, all op art drawings have one thing in common—they are eye-teasers.

Straight lines seem to curve, moiré effects are achieved, lines wriggle and flat surfaces undulate. The eye often cannot focus and is stretched, flattened and tricked into seeing things that are just not so. And there is a scientific reason for all this to happen.

The drawings must be accurate and clean to be effective. Sometimes these restrictions are a welcomed change of attitude and purpose in drawing classes, where freedom generally reigns. If you enjoy working with such restrictions, you will like op art projects.

Only a few of hundreds of possibilities are shown here. Measurement is important, and changes in size and distance produce a variety of effects. Look carefully at these examples and figure out how the effects were obtained. Compasses, rulers and protractors are necessary equipment, and neatness and exactness are essential. Markers are excellent tools to use, but pen and ink and brush and ink can also be effective.

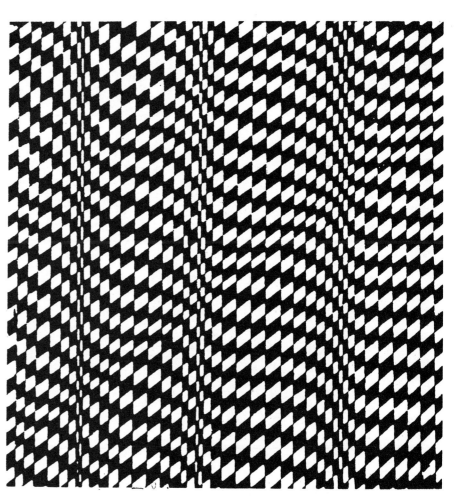

All the lines in these two op art drawings are straight, even though many of them seem to curve. Spacing is the secret. Look at the edges of the designs to see how the spaces are measured to get the desired effects. Markers, each 12″ (30 cm) square.

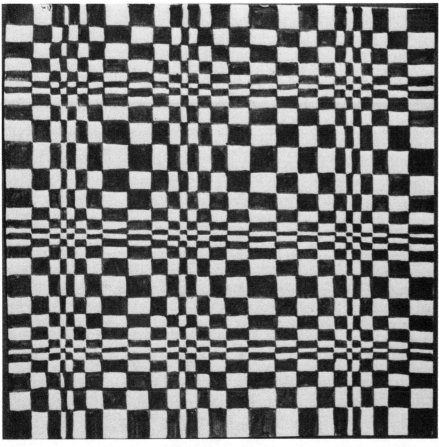

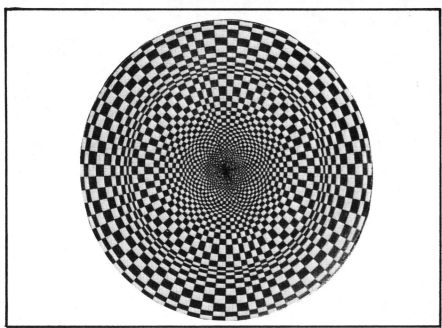

Concentric circles (varying in spacing) are combined with straight lines radiating from the center to provide the space divisions in this op art drawing. Marker, 12″ (30 cm) in diameter.

SOME FINAL
THOUGHTS

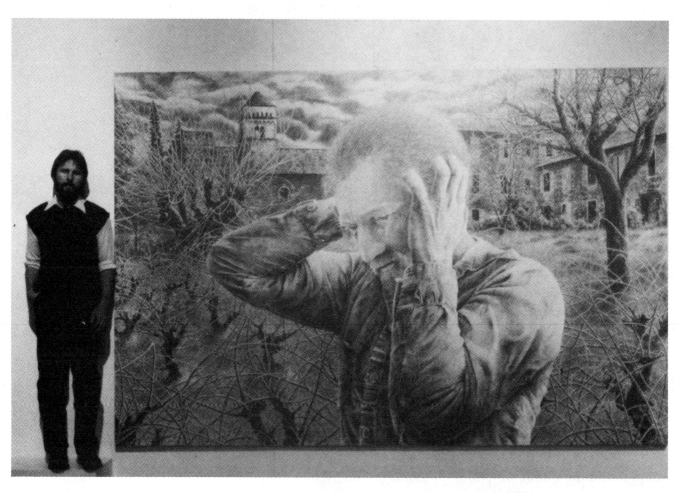

**David Mesplé worked with an old draw-
ing material (pencil) but used historic
dimensions (6.9 × 10.5′ −2.1 × 3.2 m)
to make a mural-sized drawing. The ar-
tist is standing by the work to provide a
sense of scale.** *Van Gogh's Garden,*
1985.

The hundreds of illustrations in this book are all valuable visual experiences, both for the artists and the viewers. Some of the world's most famous artists are represented, as well as contemporary professionals and student artists in search of methods of working and recording what they see. Continue the search for drawing excellence as artists before you have done.

Do not get discouraged over drawings that do not seem *just right* to you. The fact that you are looking carefully at things and recording what you see is of the utmost importance. Relax and allow yourself to respond to the subject. Do not worry if your drawings do not look like those of your neighbor or like some great masterpiece that you have seen. The important thing is that you are looking and seeing and drawing.

Draw frequently! Be on the lookout for new subjects! Develop an awareness of things around you. From this *looking and seeing,* unlimited subject matter for your own drawing and painting will continue to evolve.

Keep looking, experimenting, innovating and drawing, as you have been doing for the past months.

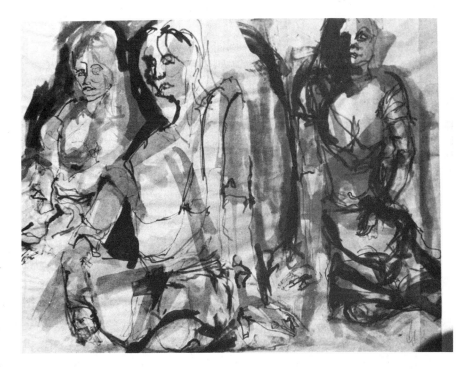

A student blocked out the general shapes with light washes, and then used brushes, sticks and quill pens to add linear detail. Deeper values were added with darker washes. The young artist was searching for ways to show form, and learned about value, form, line and style—simply by looking, seeing and reacting.

Drawing of a Student's Hands Drawing a Drawing. **Pencil, 12 × 18″ (30 × 46 cm).**

WHERE CAN YOU GO FROM HERE?

Throughout the text you have been reminded that drawing is the basis of most forms of art. Painters, sculptors and printmakers draw. So do commercial designers, layout artists, book designers and illustrators. Drawing is also basic to architects, fashion designers, cartoonists, industrial designers, film designers and space planners. If you plan for a career in some area related to art, then drawing or sketching will always be an essential part of your life, and you should continue to draw and take drawing classes as you prepare for your career. Even if you do not intend to make a living from art, you should keep looking and seeing (and hopefully keep drawing) the rest of your life.

There is more to learning about art than just making drawings. You have learned to look critically at drawings to see what they say and how the artists communicated their ideas and feelings to you. You have also learned to be sensitive to your own feelings about art, and you understand that all people see and interpret art in their own ways. These are important concepts to take with you the rest of your life. You have also studied something about art history and should realize the importance of knowing about our culture and how contemporary art has developed through dozens of centuries and thousands of artists. These historical artists and their work still communicate to us in the universal language of art, even though the people themselves are no longer living.

Computers and technology have made a tremendous impact on design and graphic art in recent years, but drawing is still a necessary skill for all kinds of designers. Cameras and video equipment become more sophisticated every year, but drawing is still the basic skill for the visual arts.

From the sixteenth century admonition of Michelangelo to his assistant, "Draw, Antonio! Draw, Antonio!" to your own art teacher's similar message, "Draw! Draw! Draw!" the need for drawing skills has not lessened. Your drawing abilities and confidence will continue to improve in direct proportion to the effort you put into practice, sketching, drawing, looking and seeing.

At times there will be problems that can stump you, and it is refreshing and inspiring to check out the work of other artists. Look in museums and galleries—and in books. There is an incredible variety of drawing books on the market, some of which are listed in the bibliography. There are many more that cannot be included in a limited list. If you are interested in books that offer ideas or techniques, some of these should help you solve problems and push you in new directions.

New materials might be costly and difficult to find, but the student who "drew" this friendly dog used old-fashioned ink pad and her own finger. Look for new ways to use old materials.

PART IV

USEFUL INFORMATION

The following pages contain some observations about what you have been studying in your drawing course and about the directions that your drawing interests might take. They also contain some helpful information to make your knowledge of art more complete.

The bibliography lists many excellent drawing books. These are helpful if you have areas of drawing that are especially interesting to you. Each author has a personal direction and approach to drawing that makes the book unique. You should find several (in book stores, art stores or libraries) and study them for specific help.

The glossary contains the definitions of many words associated with drawing. Use it regularly when you come across words or expressions in the text that are not familiar to you. Your art vocabulary should grow along with your drawing abilities and skills.

The index will help you find artists, techniques, materials and tools in the next. It will help you make the best and fullest use of the materials contained, discussed and illustrated in the book.

Bibliography

If you would like to learn more about specific areas of drawing, you should look in some of the following books.

Ashwin, Clive. *Encyclopedia of Drawing: Materials Technique and Style.* Cincinnati: North Light, 1983.

Berry, William A. *Drawing The Human Form: Methods/Sources/Concepts.* New York: Prentice Hall Press, 1977.

Blake, Wendon (drawings by Fredinand Petri). *Starting To Draw.* New York: Watson-Guptill Publications, 1981.

Blake, Wendon. *The Drawing Book.* New York: Watson-Guptill Publications, 1980.

Borgeson, Bet. *Color Drawing Workshop.* New York: Watson-Guptill Publications, 1984.

———. *The Colored Pencil.* New York: Watson-Guptill Publications, 1983.

Borgman, Harry. *Drawing in Ink.* New York: Watson-Guptill Publications, 1977.

———. *Drawing in Pencil.* New York: Watson-Guptill Publications, 1985.

———. *Landscape Painting with Markers.* New York: Watson-Guptill Publications, 1974.

———. *The Pen and Pencil Technique Book.* New York: Watson-Guptill Publications, 1984.

Brommer, Gerald F. *Drawing: Ideas, Materials, and Techniques* (revised). Worcester, Massachusetts: Davis Publications, Inc., 1978.

Calle, Paul. *The Pencil.* Westport, Connecticut: North Light Publishers, 1974.

de Fiore, Gaspare. *Composing and Shading Your Drawings.* New York: Watson-Guptill Publications, 1985.

———. *Drawing with Color and Imagination.* New York: Watson-Guptill Publications, 1985.

———. *Learning to See and Draw.* New York: Watson-Guptill Publications, 1984.

Edwards, Betty. *Drawing on the Artist Within.* New York: Simon and Schuster, 1986.

———. *Drawing on the Right Side of the Brain.* Los Angeles: J.P. Tarcher, Inc., 1979.

Gatto, Joseph. *Drawing Media and Techniques.* Worcester, Massachusetts: Davis Publications, 1987.

Goldstein, Nathan. *The Art of Responsive Drawing.* Englewood Cliffs, New Jersey: Prentice-Hall, Inc., 1973.

———. *Figure Drawing: The Structure, Anatomy, and Expressive Design of Human Form* (second edition). Englewood Cliffs, New Jersey: Prentice-Hall, Inc., 1981.

Graves, Douglas R. *Drawing Portraits.* New York: Watson-Guptill Publications, 1983.

Greene, Daniel E. *Pastel.* New York: Watson-Guptill Publications, 1974.

Gurney, James, and Kinkade, Thomas. *The Artist's Guide to Sketching.* New York: Watson-Guptill Publications, 1982.

Hanks, Kurt, and Belliston, Larry. *Draw! A Visual Approach to Thinking, Learning and Communicating.* Los Altos, California: William Kaufmann Inc., 1977.

———. *Rapid Viz: A New Method for the Rapid Visualization of Ideas.* Los Altos, California: William Kaufmann, Inc., 1980.

Hogarth, Burne. *Drawing Dynamic Hands.* New York: Watson-Guptill Publications, 1977.

———. *Drawing the Human Head.* New York: Watson-Guptill Publications, 1967.

———. *Dynamic Figure Drawing.* New York: Watson-Guptill Publications, 1970.

Hogarth, Paul. *Creative Ink Drawing.* New York: Watson-Guptill Publications, 1968.

———. *Drawing Architecture: A Creative Approach.* New York: Watson-Guptill Publications, 1973.

Horn, George. *Cartooning.* Worcester, Massachusetts: Davis Publications, Inc., 1976.

Kuhn, Bob. *The Animal Art of Bob Kuhn.* Cincinnati: North Light Publishers, 1973.

James, Jane H. *Perspective Drawing: A Directed Study.* Englewood Cliffs, New Jersey: Prentice-Hall, Inc., 1981.

Johnson, Peter D. (Editor). *Drawing for Pleasure.* Cincinnati: North Light, 1984.

Kaupelis, Robert. *Learning to Draw: A Creative Approach to Drawing.* New York: Watson-Guptill Publications, 1983.

Laidman, Hugh. *The Complete Book of Drawing and Painting.* New York: Crown Publishers, 1983.

Leslie, Clare Walker. *Nature Drawing: A Tool for Learning.* Englewood Cliffs, New Jersey: Prentice-Hall, Inc., 1980.

MacDonald, Norman. *Artist on the Spot.* New York: Van Nostrand Reinhold Company, 1972.

Malins, Frederick. *Drawing Ideas of the Masters.* Tucson: H.P. Books, 1981.

Marshall, Samuel. *How to Draw and Paint People.* Maidenhead, Berkshire: Intercontinental Book Productions, Ltd., 1981.

Mendelowitz, Daniel M. *Drawing.* New York: Holt Rinehart and Winston, Inc., 1967.

Mugnaini, Joseph. *The Hidden Elements of Drawing.* New York: Van Nostrand Reinhold Company, 1974.

Nicolaides, Kimon. *The Natural Way to Draw.* Boston: Houghton Mifflin Company, 1969.

Oliver, Robert S. *The Sketch.* New York: Van Nostrand Reinhold Company, 1979.

Parramon, J. M. *Perspective.* Tucson: H. P. Books, 1982.

Petri, Ferdinand. *Drawing Landscapes in Pencil.* New York: Watson-Guptill Publications, 1979.

Porter, Albert W. *The Art of Sketching.* Worcester, Massachusetts: Davis Publications, 1977.

Rines, Frank, M. *Landscape Drawing with Pencil.* New York: Van Nostrand Reinhold Company, 1984.

Roukes, Nicholas. *Art Synectics.* Calgary, Alberta: Juniro Arts Publications, and Worcester, Massachusetts: Davis Publications, Inc., 1982.

Savitt, Sam. *Draw Horses with Sam Savitt.* New York: The Viking Press, 1981.

Smith, Ray. *How to Draw and Paint What You See.* New York: Alfred A. Knopf, 1984.

Smith, Stan. *Drawing and Sketching.* Secaucus, New Jersey: Chartwell Books, Inc., 1982.

Steffins, Theodore E., Jr. *American Master Drawings and Watercolors.* Petersen, New York: Harper & Row, 1976.

Glossary

abstract art — a style of art that shows objects, people, and/or places in simplified arrangements of shape, line, texture and color, often geometrical. Sometimes abstract refers to *non-objective art*.

Abstract Expressionism — a twentieth-century painting style that tries to express feelings and emotions through slashing, active brush strokes. Often called *Action Painting*.

aerial perspective — a way of drawing that shows depth in space by such methods as overlapping objects, using lighter values for more distant objects, using less detail in distant objects and using warm colors for nearer items.

anatomy — the structure of the human body (can also mean the structure of animals or plants). Anatomical drawing often shows such details as muscle and bones.

architect — a person who develops plans for buildings, groups of buildings, communities, etc.

architecture — the design of buildings, such as homes, offices, schools, industrial structures.

asymmetrical balance — a type of visual balance in which one side of the composition appears different than the other side while remaining balanced with it. Visually equal without being identical.

Avant Garde Art — the style of contemporary art in any period of time. It is the newest form of visual expression, and farthest from the traditional ways of working.

balance — a principle of design that refers to the equalization of elements in a work of art. There are three kinds of balance: symmetrical (formal), asymmetrical (informal), and radial.

Baroque — a period of time and style of art (1600's) that stressed swirling action, large works of art and elaborate detail and richness, even in drawing.

Bauhaus — a German art school, begun in 1918, that stressed science and technology as major resources for art and architecture.

bister (or bistre) — a brownish pigment (color) made from the soot of burned wood, used as an ink and in wash drawings.

block out materials — materials such as rubber cement, Miskit, and Maskoid that block the application of pigments from certain areas of the background. Later, they are rubbed away, leaving an underneath layer or the background exposed in those areas.

broad strokes — using the sides of drawing materials (charcoal, graphite, crayons, pastels) to make wide markings on paper.

calligraphy — is really handwriting, but, in drawing, refers to lines that have the quality of beautiful handwriting (calligraphic lines) and/or brushed lines that are similar to Oriental writing.

caricature — a drawing (usually of a person) which exaggerates selected characteristics of the subject (such as a prominent chin, large eyes, etc.). Often the drawings are humorous.

cartoon — a full-sized drawing or pattern for another work of art, such as a mural, fresco, mosaic or tapestry.

cartoon — a drawing (often for publication) that symbolizes or caricaturizes a person or event. Animated cartoons are drawings that are placed on film to create the illusion of movement.

chamois — a soft leather (from a Eurasian antelope) that is used in charcoal and pastel drawing to smooth shaded areas.

cityscape — a painting or drawing that uses elements of the city (buildings, streets, shops, etc.) as subject matter.

collage — a technique in which the artist glues material such as paper, cloth or found materials to some type of background.

color — an element of design that identifies natural and manufactured things as being red, yellow, blue, orange or any other name that identifies their hues.

complex — composed of many interconnected parts.

composition — the arrangement of the parts in a work of art, usually according to the principles of design.

communication — the methods of letting others know what you are thinking, saying and feeling. It may be verbal, visual, musical or physical.

conceptualized art — a style of painting or sculpture. The artist communicates what is known of the subject (a general idea), not how the subject actually looks. An African tribal mask is a conceptualized face.

contemporary art — refers to the art of today; the methods, styles and techniques of artists living now.

continuum — a continuous chain or series of events. You are now involved in the continuum of art, a chain that started in the caves of early man and continues until today.

contrast — a principle of design that refers to differences in values, colors, textures, and other elements in an artwork to achieve emphasis and interest.

contour drawing — a single line drawing which defines the outer and inner forms (contours), of people or objects.

conventional materials — drawing tools and media that are intended for that purpose, as opposed to drawing with materials that are not intended to be art materials at all, such as electronic components

crosshatching — a method of shading with fine lines. Many parallel lines are first drawn in one direction, and are then crossed with many parallel lines in other directions to create a dense pattern.

Cubism — a style of art in which the subject is broken apart and reassembled in an abstract form, emphasizing geometric shapes.

culture — refers to those elements which add to the aesthetic aspects of our lives, enriching them with beauty and enjoyment.

distortion — to deform or stretch something out of its normal shape.

231

doodling — an absentminded type of drawing in which the person is often preoccupied with other thoughts.

drawing style — a particular way of drawing that would define the artist or certain period of time.

elongated — stretched out lengthwise; drawn in a way as to exaggerate height or length.

emphasis — a principle of design by which the artist or designer may use opposing sizes or shapes, contrasting colors, or other means to place greater attention on certain areas or objects in a work of art.

engraving — the process of incising lines into a surface to create an image.

expressionism — any style of art in which the artist tries to communicate strong personal and emotional feelings to the viewers. If written with a capital "E," it refers to a definite style of art begun in Germany early in the twentieth century.

eye level — a horizontally drawn line that is even in height with your eye. In perspective drawing, it can be the actual distant horizon line or an imaginary line, but it can also be drawn in a close-up still life.

fashion illustrator — a person who draws fashion designs for advertisements in magazines, newspapers, etc.

figure drawing — drawing which uses the human figure as its chief subject matter.

fixative — a substance which is sprayed over charcoal, pastel or pencil drawings to make those materials adhere permanently to the paper and to prevent smearing.

form — an element of design, similar to shape which encloses area, but three-dimensional (cube, sphere, pyramid, cylinder and free flowing) and encloses volume.

fragmented — broken or divided into several parts. A fragmented drawing may have several separated parts that are arranged to complete the composition.

fresco — a painting technique in which artists apply wet colored plaster to a wet plaster wall. A type of mural painting.

gallery — a commercial enterprise that exhibits and sells art. Sometimes it may refer to an art museum.

geometric art — refers to a type of art that uses lines and shapes that recall geometry: triangles, squares, rectangles, straight lines, arcs, circles, etc.

gesso — a plaster-like, white material that can be brushed on a ground as an undercoating for drawings or paintings.

gesture drawing — a scribbly type of line drawing that catches the movements and gestures of an active figure.

graphics — refers to the art of drawing, and techniques which stress the use of lines and strokes to portray images and ideas.

graphic artist — a person who designs packages, advertisements for newspapers and magazines; illustrates for ads, books, magazines; draws cartoons; designs displays and signs; produces any kind of art for reproduction.

graphite — a greasy, natural carbon material that is used in making lead pencils.

ground — the surface on which a drawing (or painting or collage) is done, such as paper, canvas, cardboard, etc.

hard edge — refers to a style of art in which the artist uses crisp, clean edges and applies the values or colors so that they are even and flat.

horizontal line — an actual or imaginary line that runs across the work defining the place where sky and earth come together.

horizontal — a line or shape that lies down and is parallel to the top and bottom edges of the paper.

hue — the name of a color, such as yellow, yellow-orange, blue-violet, green, etc.

Impressionism — a style of drawing and painting (1875 and following) begun in France, which stresses an off-hand (candid) glimpse of the subject, and an emphasis on the momentary effects of light on color.

landscape — a work of art that shows the features of the natural environment (trees, lakes, mountains, flowers, etc.)

line — an element of design that may be two-dimensional (pencil on paper), three-dimensional (wire or rope), or implied (the edge of a shape or form).

linear perspective — a system of drawing to give the illusion of depth on a flat surface. All straight, parallel lines receding into the distance are drawn to one or more vanishing points in such a drawing.

logo — a visual design which symbolizes and stands for a company, industry or individual. It usually (but not always) uses letters, numbers or some recognizable visual element.

manuscript illumination — the decorative drawing and painting that filled the illustrated pages of handwritten books in the Middle Ages.

mixed media — a two-dimensional art technique that uses more than one medium; for example, a crayon and watercolor drawing.

moiré — a wavelike pattern that develops when certain lines are overlapped. It occurs in some Op Art designs.

monochromatic — of only one color. Most drawings are monochromatic, using one color of ink or lead.

movement — a principle of design that refers to the arrangement of parts in a drawing to create a slow to fast flow of your eye through the work.

museum — a place in the community where art is collected and placed on view. Works belonging to the museum are not for sale, but are for study and enjoyment.

nibs — pen points, used on pen holders which provide for the removal of tips.

negative space — the area around the objects in a drawing or painting, often called the background.

non-objective art — art which has no recognizable subject matter, such as trees, flowers or people. The real subject matter is the composition of the drawing or painting itself.

Op Art (Optical Art) — a style of art (middle of Twentieth Century) that uses optical (visual) illusions of many types. These works of art are composed to confuse, heighten or expand visual sensations.

opaque — the quality of a material that will not let light pass through. The opposite of transparent.

organic — free form, or a quality that resembles living things. The opposite of mechanical or geometric.

Oriental papers — handmade papers from the Orient that have an absorbent quality that makes them useful for certain drawing, collage techniques and printmaking. There are many types, some having fascinating textures.

painterly quality — that quality of a work of art that allows brush strokes to show and lets us see that it is really a painting.

papyrus — a paper-like material (made from the papyrus plant) that was used as a writing and drawing surface in ancient Egypt, Greece and Rome.

pattern — a principle of design in which combinations of lines, colors and shapes are used to show real or imaginary things. It may also be achieved by repeating a shape, line or color.

perspective drawing — a method of drawing on a flat surface (which is two dimensional)

to give the illusion of depth, or the third dimension.

pigment — the coloring material used in painting and drawing media. Pigments may be natural (from earth, plant dyes, etc.) or from laboratory prepared chemicals.

Pop Art — a style of art that features the everyday, popular things around us. A drawing of a large Coke bottle might be considered Pop Art.

positive space — the objects in a work of art, as opposed to the background or area around the objects.

portrait — a piece of art work featuring a person, several people or an animal. Portraits are usually facial, but can also be full figure.

Post-Impressionism — the style of art that immediately followed the Impressionists, in France. Paul Cezanne was a leader of this style which stressed more substantial subjects and methods than those used by the Impressionists.

preliminary sketch — a planning sketch, usually on a smaller scale, to determine the basic arrangement of a design or larger work of art.

proportion — a comparative size relationship between several objects or between the parts of a single object or person. In drawing, for example, watch for the correct relationship of the size of head and body.

radial balance — a design based on a circle with the features radiating from a central point.

Realism — a style of art that attempts to realistically show actual places, people or objects. It stresses actual colors, textures, shadows and arrangements.

reed pens — pens made from natural materials, such as reeds or bamboo shoots, which are carved to a point.

refraction — the change in appearance or the visual distortion that often occurs when objects are viewed partly through water, glass or other transparent media. A spoon half in and half out of water may appear bent.

relief — the raised parts of a surface which are often noticeable by the feeling of texture.

rendering — the careful and complete drawing of an object, place or person, to make it appear realistic.

Renaissance — a period of time (1400-1600) following the Middle Ages that featured an emphasis on human beings and their environment and on science and philosophy. A

renewal of Greek and Roman thinking regarding art and humanity.

representational drawing — the drawing of objects, people or places in such a way that they can be recognized for what they are.

rhythm — a principle of design that indicates a type of movement in an artwork or design, often by repeated shapes or colors.

rice paper — same as Oriental paper.

Rococo — a style of art (1700's) following the Baroque, which featured decorative and elegant themes and style.

Romanticism — a style of painting (middle Nineteenth Century) that featured adventure, action, imagination and an interest in foreign happenings and people.

rubbings — a technique that transfers the textural quality of a surface to paper by placing the paper over the textured surface and rubbing the top of the paper with a crayon, pencil, etc.

seascape — a drawing or painting that features some part of the sea as subject matter. It often refers to a coastal environment.

sepia — a brown pigment (originally obtained from the secretion of cuttlefish) used as ink or in wash drawings. It is also the name of a brownish hue.

set-up — a group of objects which are arranged to be drawn or painted. A still life grouping.

sgraffito — the process of scratching lines into the surface of a work of art in order to expose the surface underneath.

shading — using the drawing or painting medium to form darkened areas (shadows) that will help produce a feeling of space and depth.

shape — an element of design described as two dimensional and enclosing area. Shape can be divided into two basic classes: *geometric* (square, triangle, circle) and *organic* (irregular in outline).

silverpoint — a tool which has a point made of silver. It is drawn over an abrasive surface to create delicate lines which darken as they oxidize.

sketch — a quick drawing. One that catches the immediate feeling of action or the impression of a place. Probably not a completed drawing, but one that may be a reference for later work.

sketch book — a book with blank pages in which students and artists record visual notes of many of the things they see and imagine.

space — an element of design that indicates areas in a drawing (positive and negative) and/or the feeling of depth in a two dimensional work of art.

spectrum — the complete range of color that is present in a band of light (and seen when that light is refracted through a prism). The colors of the rainbow.

still life — an arrangement of inanimate objects to draw or paint.

stippling — a drawing technique (usually done with pen and ink) in which dots are made to create shaded areas or textures.

structure — the constructive elements of a work of art. The underlying arrangement (foundation) of the parts of a composition.

style — the distinctive character contained in the works of art, period of time or geographical location.

stylization — to conform to a certain style or "look" which has developed in art.

subject matter — the things in a painting about which the artist is communicating.

subtle — in art, it is used to describe the delicate appearance or gradual change contained in the work of art. It is hardly noticeable, unless a person looks carefully.

Super Realism — a style of drawing and painting in the late Twentieth Century that emphasizes photographic realism. Many times the objects are greatly enlarged, yet keep their photographic appearance.

Surrealism — a style of twentieth-century painting in which the artists relate normally unrelated objects and situations. Often the scenes are dreamlike or set in unnatural surroundings.

symmetrical balance — a design in which both sides are identical.

technique — any method or system of working with materials.

texture — an element of design that refers to the surface quality as being rough, smooth, soft, etc. It can be actual or implied.

tooth — the textural "feel" of a sheet of paper. Charcoal paper has more tooth than smooth paper needed for pen and ink.

traditional art — any style of art that treats the subject matter in a natural (rather realistic) way. A style similar to those used for many years.

unity — a principle of design that relates to the sense of oneness or wholeness in a work of art.

urban environment — refers to your surroundings when you are in a town or city.

value — an element of design that relates to the lightness and darkness of a color or shade.

vanishing point — in perspective drawing, an imaginary point or points on the eye level, toward which parallel lines recede, and will eventually meet.

variety — a principle of design concerned with difference or contrast

vertical — upright and parallel to the sides of the paper.

visual environment — everything that surrounds you; usually divided into two groupings: the *natural* environment (trees, flowers, water, sky, rocks, etc.) and the *manufactured* or *people-built* environment (buildings, roads, bridges, automobiles, schools, etc.)

wash — a color of ink or watercolor that is diluted with water to make it lighter in value and more transparent.

wax resist — a technique that makes use of the fact that water and wax do not mix. Watercolor paint is brushed over a wax drawing, remaining only where there is no wax.

white glue — any of the poly-vinyl-acetate glues on the market, each having its own trade name (Wilhold, Elmers, Sobo, etc.).

Index

Acknowledgements

The work of many students from twenty-seven high schools fill the pages of this book. Their work is extremely important in showing examples of techniques, subject treatment, experimental directions and visual interpretations. Their teachers are listed separately, but the schools are listed here. All of us are indebted to the talented students whose work is such a vital part of the text.

Baltimore City Schools; Birmingham High School, Van Nuys, California; Bishop McGuinness High School, Oklahoma City; Fremont High School, Los Angeles; Gardena High School, Gardena, California; Granada Hills High School, Granada Hills, California; Hollywood High School, Hollywood, California; John Marshall High School, Los Angeles; John Marshall High School, Oklahoma City; Los Angeles County High School for the Arts; Lutheran High School, Los Angeles; Nightingale Junior High School, Los Angeles; Nimitz Junior High School, Los Angeles; Norman High School, Norman, Oklahoma; Northeast High School, Oklahoma City; Oklahoma Christian School, Edmond, Oklahoma; Otis-Parsons Scholarship Class, Los Angeles; Putnam City West High School, Oklahoma City; Paul Revere Junior High School, Los Angeles; Reseda High School, Reseda, California; Seoul American High School, Seoul, Korea; Vo-Tech #22 High School, Oklahoma City; Wheaton High School, Wheaton, Maryland.

Putting together a book such as this is not a one-person job, by any stretch of the imagination. The author becomes an information gatherer, filing photographs that pour in from willing art educators across the country. Without such concerned help, editing this book would have been impossible. My sincere thanks to these excellent teachers: Jim Burke, John Marshall High School, Los Angeles; Allen Evry, Wheaton High School, Wheaton, Maryland; Jacklyn Faulkner, Norman High School, Norman, Oklahoma; Grace Garcia, Hollywood High School, Hollywood, California; Joseph Gatto, Granada Hills High School, Granada Hills, California; Otis/Parsons Scholarship Classes, Los Angeles, and Los Angeles County High School for the Arts; Gene Gill, Reseda High School, Reseda, California; George Horn, Art Supervisor, Baltimore City Schools; Helen Luitjens, Paul Revere Junior High School, Los Angeles; Mary Ruth Mayfield, Putnam City North High School, Oklahoma City; Steve McConnell, Bishop McGuinness High School, Oklahoma City; Judi Scott McGee, Oklahoma City Vo-Tech 22; Mitch Mertes, John Marshall High School, Oklahoma City; Tom Nielsen, Birmingham High School, Van Nuys, California; Michael F. O'Brien, Seoul American High School (DOD), Seoul, South Korea; Rene Parola, John Marshall High School, Los Angeles; Al Porter, California State University, Fullerton; Phyllis Seiter, Cassady School, Oklahoma City; Wes Soderberg, Kentridge High School, Kent, Washington; Vernice Stroud, Fremont High School, Los Angeles; Roland Sylwester, Lutheran High School, Los Angeles; Bill Tara, Los Angeles City Schools Scholarship Classes; Ted Wessinger, Gardena High School, Gardena, California; Richard Wiegmann, Concordia College, Seward, Nebraska.

Several artists were very helpful and cooperative, wishing to share their talents with young people around the country. All are specially gifted and their work adds zest to the visual content of the book. My grateful thanks to: William A. Berry, Donna Berryhill, Bet Borgeson, Lawrence Brullo, Sam Clayberger, Louis F. Dow, Clarice Embrey, Arthur Geisert, Corinne Hartley, Ralph Hulett, George James, Roger Kutz, Valerie Love, David Mesple, Joseph Mugnaini, Al Porter, Celeste Rehm, Guenther Riess, Roland Sylwester, Tom Sylwester, Paul Taylor, Charles White, John M. White, Richard Wiegmann, and Robert E. Wood.

Museum and gallery directors were particularly kind in helping me obtain materials that greatly enhance the book, especially in its historical content. My sincere thanks to: Rita M. Cacas, National Gallery of Art, Washington, DC; Margaret Anne Cullum, Dallas Museum of Fine Arts; The Director of the Albertina Museum, Vienna, Austria; Ebria Feinblatt, Los Angeles County Museum of Art; Bob Gino and Phil Orlando, Orlando Gallery, Sherman Oaks, California; Nora Halpern, Frederick R. Weisman Foundation of Art, Los Angeles; Darryl Isley, The Norton Simon Museum of Art, Pasadena; Lynda B. Kershow, Boston Museum of Fine Arts; Linda Loving and Richard Tooke, The Museum of Modern Art, New York; Linn Orear, Fogg Art Museum, Harvard University; Joseph Young, Los Angeles County Museum of Art.

Thanks also to the following people and their companies for graciously allowing me to use some of their published material in the book: Moya Brennan and David Herbert of Studio Vista Limited, Publishers, London, England; Mrs. Jimmie Kromas of California Computer Products, Inc., Anaheim, California; Michelle Mehterian, Aegis Development, Inc. (computer art), Santa Monica, California; Hanna Barbera Productions, North Hollywood, California; Robert Petersen Designs, Chicago; Walt Disney Productions, Burbank, California.

Special thanks to the staff at Davis Publications for their continuing efforts to bring meaningful materials to the teachers and students of America. And an extra special thank you to my wife, Georgia, who graciously tolerates the long hours it takes to compile a book such as this.

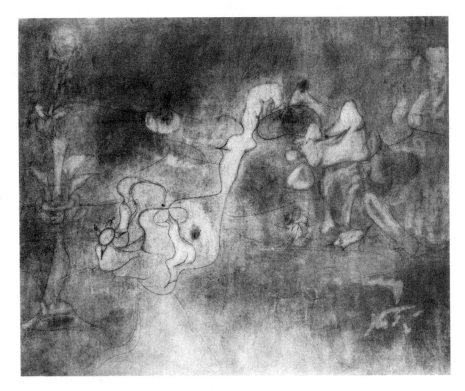

Arshile Gorky drew biomorphic shapes that seem to float in space. Although the title implies objectivity, the drawing seems to be completely nonobjective and imaginative. The artist was also creative in the use of media. *The Plow and the Song,* **1947. Pencil, charcoal, pastel and oil, 48 × 59″ (122 × 150 cm). National Gallery of Art, Washington, DC, gift of the Avalon Fund.**